ur Book

loyd

THE CROWOOD PRESS

First published in 2007 by
The Crowood Press Ltd
Ramsbury, Marlborough
Wiltshire SN8 2HR

www.crowood.com

British Library Cataloguing-in-Publication Data
A catalogue record for this book is available from the British Library.

ISBN 978 1 86126 974 4

Acknowledgments

I would like to express my thanks to the following people, who very
generously read and commented on the book in its various drafts:
John Boyce, Tony Brennan, Lucinda Denning, Guy Eaglesfield, Richard Else,
Andy Hamilton, Beth Heatley, Chris Heatley, André Lewis, Mima Lewis,
Peter Niven, Nick Roscoe, Becca Thackray, Richard Thackray, Keith Ward.
The finished work has benefited greatly from their many helpful suggestions.
The remaining errors are, of course, my responsibility.

For her constant love, support, patience and encouragement in this, as in
all my endeavours, my special thanks go to Becca.

Typefaces used: text, Stone Sans; headings, Frutiger; chapter headings,
Rotis Sans.

Typeset by Simon Loxley

Printed and bound in Singapore by Craft Print International, Ltd.

CONTENTS

INTRODUCTION

Who Should Read this Book?

I have always derived a lot of enjoyment from drawing. And I wanted to paint and enjoy it to the same degree. However, for a very long time this was impossible as one crucial aspect of painting seemed set to remain forever beyond my grasp – mixing colour accurately and reliably was beyond me. In spite of reading many accounts of colour mixing, and having spent a lot of time on exercises to try putting those accounts into practice, I found myself no better off. There was a gulf between colour-mixing theory and practice that no one was able to help me to bridge. If you've encountered this gulf, and you work with paints, coloured inks, pencils, pastels or any other coloured artists' materials, then this book is definitely for you.

This book is for you if:

- your experience of colour mixing so far leaves you puzzled, frustrated and doubting your own ability to follow simple instructions;
- you have trouble mixing colours in general – if it always takes you multiple attempts to get the colour you really want;
- in spite of having some control over your palette, you always have trouble mixing a particular colour – there are some colour mixing tasks that never seem to go as planned;
- you can't get the colour theory you've read about to work in practice; you've been taught colour theory but you can't get this to work in practice; or you suspect there may be some crucial aspect of practical colour mixing that you still don't know about.

The view presented in this book resolves all these issues and will get you to the point where you understand colour mixing in a straightforward way. As well as systematically explaining how different aspects of colour mixing fit together, my account also demonstrates why the established web of theory fails. And unlike other accounts, mine never abandons you with the ominous words '… at least, that's what's supposed to happen in theory, but it doesn't necessarily work this way in practice…'

There is Another Way…

Many of the ideas in this book can be found scattered throughout the literature on colour, although these ideas have been variously ignored, denied, misrepresented and distorted by established colour theory. So when anyone goes looking for help with the business of colour mixing the truth is, for the most part, nowhere to be seen. This may be the only place where you will find the principles you need organized into a single interconnected framework for colour mixing.

Reading this book is not the only way to arrive at a good working knowledge of colour mixing. For those prepared to stick at the task for long enough, the know-how contained in the suppressed principles can be acquired by experience, through trial and error. But unless you are remarkably lucky, this will mean a *lot* of error. Even if certain parts of the truth do emerge from such hit-and-miss efforts, they may never be fully coordinated or properly related to each other. For example, it may become apparent that a certain violet paint mixed with a certain green paint produces a shade of brown, even though this is not at all what established theory predicts. You can make a note of such discoveries for use in the future. These little 'islands' of insight are useful, and over a long period of time they may provide solutions to every colour mixing challenge you face.

However, from such a fragmentary list of recipes, no genuine understanding of the colour-mixing process is likely to emerge. For that, we need a unified framework of general principles that can be applied in all circumstances. This book is intended to short-circuit the miserable process of aimlessly poking paint about on the palette in the hope that precious nuggets of mixing know-how might spontaneously materialize. You will find

here a *systematic* account of the truth about colour mixing, resulting in a framework that is easy to understand and to apply in practice.

The Structure of the Book

Chapters 1–8 provide the *essential background* in which I clearly identify the problem, set out some key terms and concepts, introduce the materials needed to do the exercises and demonstrations, and say why I suggest – perhaps surprisingly – that you do these with coloured pencils in the first instance.

Chapters 9–15 present the *four crucial colour-mixing principles* including simple exercises to illustrate the principles in practice, an explanation of how to construct a colour wheel that really does help to guide mixing practice in a helpful way and a critical survey of objections to the claims I make about the results of the exercises.

Chapters 16–20 look at further applications of the principles.

This section includes a look at how the principles can help you to select a suitable palette, how their application extends from the two-dimensional colour wheel to the three-dimensional colour cylinder, how to break down complex mixing tasks into simple stages and it considers some important physical aspects of artists' materials apart from colour that may influence your palette selections.

Chapter 21 reviews the results of the exercises. This final chapter gives a summary assessment of the superiority of the colour mixing framework that has been discussed over the established view.

How to use this book

It's a book. Having got this far, it's probably safe for you to assume that you know how to use it. No need to do anything fancy: read it, do the exercises, and get what benefit you can from the experience. That's all there is to it.

THE TROUBLE WITH COLOUR-MIXING THEORY

Introduction

Artists, art students, schoolchildren and many other groups of people having an interest in colour will at some stage encounter colour-mixing theory of some sort. Unfortunately, almost all versions of colour-mixing theory presented to these groups are wrong. In this chapter I explore what is wrong with established colour-mixing theory and what we should do about it, and I identify the basic shift in thinking required to bring about improvements in colour-mixing practice.

My First Colour Theory Lesson

Let me reminisce for a moment. The only tutoring I recall being given on the topic of colour mixing was in my first year at school. Swamped in one of my dad's old shirts to minimise the damage art lessons tend to inflict on a child's clothes, I stood in front of a blank sheet of coarse, off-white paper mounted on an easel, concentrating as hard as I could to take in the wisdom of my teacher. Like my classmates I was equipped with two glass jars of water, a gigantic kiddie-grade bristle brush and a white plastic palette containing five hard cakes of kiddie-grade paint: red, blue, yellow, black and white.

The status of black and white was never really pinned down in these early years. Sometimes they were regarded as colours, at other times they were 'not really colours'. As I got older, I encountered various attempts of varying plausibility to fit black and white into the traditional theory. My own account of how best to deal with this issue appears in Chapter 18, 'Colour in Three Dimensions'.

And so, the lesson began: 'With these primary colours, children, you can make any colour you need. First, we will make green..., and then orange..., and purple...' and so it went on, in the fashion that we all know so well. Without this information, so I was encouraged to believe, I would not be able to paint beautiful pictures.

Following the instructions of my teacher as diligently as I could, I managed to produce three specimens that looked

Figure 1. **My first palette.**

This space was left empty for mixing colours

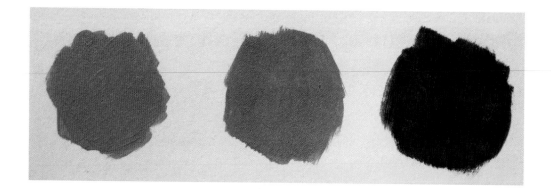

FIGURE 2. **My 'kiddie-mixes'.**

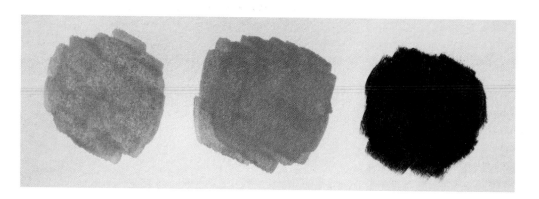

FIGURE 3. **My expectations.**

more or less like those shown in Figure 2. Now, in spite of my teacher's generous praise and encouragement at this accomplishment, I wasn't entirely happy with the results. Having been told to expect green, orange and purple, I had naively expected rather more vibrant and unsubtle representations of those colours – something more like those in Figure 3.

Interpreting the results

Did our teachers mislead us? Well, not entirely. The resultant green *is* most plausibly regarded as green rather than any other colour. This 'kiddie-mix green' is more like the highly saturated sample of green than it is like, say, the highly saturated sample of orange, although it would be difficult to specify exactly the basis of the likeness. It is undeniably darker or duller than the second green sample. However, whether we are aged five, thirty-five, or sixty-five, we don't have too much trouble accepting this as green once we are reminded that there are many dark and relatively dull greens to be found in nature. And as children, 'kiddie-mix green' seems to serve as a perfectly acceptable leaf-green for our landscape masterpieces.

What about 'kiddie-mix orange'? Well, this one isn't too bad in the purity stakes, although the 'kiddie-mix violet' is another matter. Again, this is more deserving of the description 'violet' than it is any other, but it is without doubt dull in comparison with many naturally occurring instances of violet. When we

encounter objects and surfaces of this 'kiddie-mix violet' colour, we tend to qualify our description of them as 'dark violet', 'violet-grey' and so on. There is nothing wrong with these less-than-brilliant varieties of violet; all I am suggesting is that as children our expectations, and often our intentions, are thwarted in the process of mixing these 'kiddie' colours.

The Problem in Outline

Colour mixing is a very useful phenomenon that enables us to produce a range of colour effects from a relatively modest range of source materials – mix two different colours together and a third one appears. It is difficult to recapture fully the sense of wonder that accompanies the initial realization of this piece of magic, though I suspect that, like me, many people never tire of seeing it happen.

At least, that's how we feel when the process goes as intended to give us the result we wanted. However, since you are reading this book, there is a good chance that you will find the following frustrating experience all too familiar. Taking two of your unadulterated tube or block colours, you start mixing a new colour. It doesn't quite turn out as you expected or wanted. You add a third colour, but the mix starts to go muddy, so you add something else; maybe some white, or perhaps some more of the colours you started with. But this just makes things worse.

You might tinker with the mix a bit more, but eventually you admit to yourself that it's a disaster. You scrap it and start again, no more confident that this time you will end up with what you want. You may strike it lucky, but maybe you won't. The chances are you'll end up settling for a colour mix that isn't really what you want. There's nothing very satisfying, much less magical, about *that*. And I, for one, got thoroughly disheartened by seeing it happen time after time. Why is colour mixing such a trial?

In theory this, but in practice that

After a few experiences like this the obvious thing to do is to start looking around for some help – practical help. For most of us interested in colour, colour mixing is mainly a practical business, not merely an exercise in abstraction. From this perspective, theories of colour mixing have little value unless they connect with and guide practice in a useful way. Nevertheless if you have ever turned to a book for advice on this subject, I'm sure you will have seen this sort of thing: 'In theory, mixing *x* with *y* should produce *z*, but in practice it doesn't; instead, it produces *u*, *v* or *w*'.

Thus on the admission of its own proponents, established colour theory fails to provide an adequate guide to practice. And yet those responsible for statements like this still commend their inadequate theory to us. Perhaps they like the theory because it is simple, or aesthetically satisfying, or stimulating in some other intellectual respect. That is fine if the only point of the theory is to be admired as an elegant, formal exercise – but what *use* is a theory that fails to fit practice?

The answer to this question is obviously 'very little'. Unfortunately, discovering that there is very little help available may lead some people to abandon colour work entirely. This is more or less what I did for years. But with luck, I hope to catch your attention before you decide to do the same.

The Role of Criticism

I hope that this book will serve as an antidote to the practical failure of established colour-mixing theory. To fulfil this useful role it is not sufficient simply to point out that the established theory is wrong, booing, as it were, from a comfy armchair. Such mere expressions of disapproval certainly have a purpose, since they sound an alarm, suggesting that the prevailing view may be questionable. Nonetheless they can be met with the perfectly reasonable challenge, 'It's all very well picking holes in what everyone else says, but do *you* have anything better to offer?'

Without a proper response to this question, the critic's job is only half done. What's required is *constructive* criticism, and to be constructive, criticism should be able to satisfy two condi-

tions. First, more than saying that the theory is wrong, the critic should point out precisely the deficiencies of the theory. That is, we need to specify *how* and explain *why* the theory is wrong. Second, this negative, destructive process needs to be accompanied by a positive phase presenting something demonstrably better. In the case of colour theory, the test of a rival view's superiority is how well it performs in practice; does it help or hinder our colour mixing?

Therefore the alternative to the established theory, for which I argue, is essentially pragmatic in construction and intent. It is a cluster of practical principles; a framework, oriented towards the practical task of mixing colours. I won't be arguing the point as to whether this framework constitutes a better colour-mixing *theory*. I am much more interested in the better colour mixing *results* that it enables us to obtain. Nevertheless, regardless of whether the framework is or isn't itself a theory, in common with good theories in general it also makes use of whatever fragments of truth feature in the theory it replaces and is able to explain what was wrong with the old theory.

What Sort of Colour Theory? Or 'Horses for Courses'

Theories can serve different purposes. Some are explanatory, others are predictive, and some have both of these characteristics. Theories can be abstract, or concrete. And theories can exhibit these characteristics at different levels of complexity. As far as colour is concerned, there are theories about the human visual system, about the physics of light, about the psychology of colour, and so on. You may have noticed that many presentations of the established view in artists' instruction books start out with crude and confusing summaries of such theories, the practical relevance of which never emerges. However, the main problem is not that the science is poorly rendered in these books, though this does tend to be the case. The point is that detailed accounts of the physics of light or colour vision, be they elaborate, or interesting, or accurate, will be virtually no help in improving your grasp of colour mixing. They are simply the wrong sort of theory for that purpose.

The crucial concern for those of us who want to mix colours is the nature of the phenomenon of colour *as it presents itself to us*. For the colour mixer, knowledge of the physics of light and the physiology of the eye are of limited use in comparison with the knowledge of what we actually see when coloured light sources or pigments are mixed. If the manipulation of paint on the palette is the focus of our interests, then that is the level at which our explanations have to work. Thus, those explanations should be given in terms of factors that can be manipulated

themselves directly in the context of our work. For the most part artists don't carry out their work in physics or biology labs, and unlike physicists and biologists they don't have the means to take control of things like individual photons or neurons. Recognition that the central concern for colour mixing is the phenomenon of colour as it presents itself to us should make it clear that our framework needs to be practical, at a level that we can deal with in a direct, hands-on way.

Degrees of accuracy

One possible hostage to fortune in all this is the criticism already levelled at the established web of theory – that the predictions based on the principles worked out here don't fare well when put to the test in the real world. For established theory this sort of failure is so apparent and pervasive that it constitutes a devastating defect. Not all theories run aground in such an obvious way, but none of them fit reality perfectly. Any theory that makes predictions about the physical world has to be understood as being accurate within specified margins of error, and the concept of exactitude for any given theory only has a place within those limits, whatever they happen to be. For example, the weights and measures in domestic cookery are less precise than those typically used in molecular biology labs. With this in mind it is worth asking how accurate a practical colour-mixing theory we are likely to obtain.

In commercial, scientific and industrial contexts the business of colour mixing is highly developed and very accurate results are achievable. Judgements in these spheres are guided by industry standards such as the **Pantone** colour-matching system and the **Munsell** colour classification scheme. Such resources, however, are not suitable for most art and craft applications. The industrial production of colour and colouring effects using these systems provides a forensic degree of precision that can be rendered repeatedly and mechanically. But the ends of artistic endeavours are generally distinct from industrial ones and the processes for achieving those ends tend to be different too. The artist working with hand, eye, brush, knife, paint, crayon and so on makes a multitude of fine discriminations that allow for almost infinite flexibility in the mixing of colours. The cost of this flexibility is the need to take control of the multitude of physical characteristics of real-world materials.

An accurate theory needs to take account of those variables as far as possible. Established theory either ignores them or specifically excludes them from consideration. This is presumably because the specific physical properties of coloured materials lead to results that are frequently in conflict with the predictions of established theory. In contrast to this the view presented here harmonizes well with what you will see in practice.

'If it's broke, fix it'

These observations lead to an important point about the relationship between theory and practice. Theories are our inventions, and they approximate the way things are arranged in the world more or less accurately. The more accurate a theory – that is, the better it describes how things happen in the world – the more we can rely on its predictions. It is nevertheless worth repeating that no physical theories describe the world with 100% accuracy; there are always margins of error to be considered. Scientists and engineers are quite familiar with this idea, and this is generally what they have in mind when conceding that in practice results may depart from what theory predicts. However, in common conversation this idea gets reinterpreted, so that people often tend to talk as if there is no point in expecting any theory to bear any relation to practice *at all*. Consequently, faced with a breakdown in theory, many people entirely overlook the possibility that a better theory might be constructed.

If there is a gross mismatch between a theory and the reality it purports to describe then we should look for a new theory; reality isn't going to do us any favours and fall into line with our existing *faulty* theory. So when we find, as most of us have, that the established colour-mixing theory breaks down badly in practice, this is our cue to jettison the theory. It certainly should not be taken as a cue for a rousing chorus of that old favourite, 'In theory we should see such and such, but in practice we see something else'. There is often a lot to be said for the adage 'if it ain't broke, don't fix it'. However the colour theory that most writers want to deliver to us *is* 'broke'. I say we should fix it.

Colour Mixing Need not be Mysterious

Contrary to widespread belief, colour mixing is a relatively easy business. I say 'relatively' since although there is no magic involved, there is a handful of principles that need to be mastered in order to achieve consistent and predictable results. The things you need to know and apply in order to become confident in your colour mixing, however, are very simple. Directions for even the most complex of journeys can be broken down into a series of simple directions: 'head north 100m'; 'turn left'; 'take the third exit from the roundabout', and so on. The principles of colour mixing can be reduced to directions of similar simplicity. However, no matter how good the directions are in themselves, they won't get you to your destination unless you start from the right place.

Table 1. Theoretical Opinions on Primary Colours

THEORIST	DATE OF THEORY PUBLICATION	PRIMARY COLOURS
Democritus	c.460 BCE	4: black, white, red, green
Plato	c.400 BCE	3/4: 'bright', white, red, blue
Aristotle	c.340 BCE	3: black, white, yellow
Leonardo Da Vinci	c.1500	6: black, white, red, blue, yellow, green
Telesio	1528	12: black, blue-grey, green, grey-black, purple, red ('ruber'), red ('rufus'), rose, rust, sky blue, tawny, white
Forsius	1611	2: black, white
D'Aguilon	1613	3: red, blue, yellow
Newton	1704	7: red, orange, yellow, green, blue, violet, indigo
'C.B.'	1708	4: red, crimson, blue, yellow
Mayer	1775	3: red, blue, yellow
Young	1801	3: red, green, violet
Hering	1875	4: red, blue, yellow, green
Munsell	1899	5: red, blue, green, yellow, purple
Ridgway	1912	6: red, blue, yellow, green, violet, orange
Murray	1934	3: cyan, magenta, yellow

Starting at the wrong place

There is an old folk tale about a traveller who asks a villager for directions to the coast. 'Ah, well', laments the villager, 'If I were going to the coast I think it'd be best not to start from here'. In one sense, that's the way I tend to view the difficulties that many people have in putting colour-mixing theory into practice. The problems of the sort I mentioned at the outset are almost entirely due to the way in which we were introduced to colour mixing as soon as our hands were big enough to hold a paintbrush or crayon. Sadly, most of us have been badly misdirected from the outset in our attempts to navigate our way around the colour landscape.

So if you want to get the hang of colour mixing then it is best not to start from where most people would have you start. And regardless of which variant strand of the tangled web of established colour theory they are introduced to, the starting point for most people's colour adventures is the acceptance of a fundamental distinction between primary and secondary colours.

The major stumbling block

The idea behind this distinction is that colours divide into two categories, **primary colours** and *the rest*, and that these different sorts of colours have different properties. Among 'the rest' of the colours the so-called **secondary colours** will be most relevant here, but elsewhere you will often meet with 'tertiary' and, very occasionally, even 'quaternary' colours.

Primary Colours: Which Colours are They?

This book is chiefly about the mixing of physical materials like paint, ink, pastels and so on. According to the most common version of the primary–secondary colour distinction as it applies to materials like these, red, blue and yellow are primary colours, and violet, green and orange are secondary colours. Many people recall this as the first thing they were taught about colour, and often it is the only thing they can remember about it. Although the idea of primary colours has long been accepted as the foundation of colour theorizing, as the examples in Table 1 above show, the colours reckoned to be primary have varied considerably from one theorist to the next.

The theorists listed in the table are, as far as I can tell, the earliest proponents of the sets of primary colours with which they are associated. Hence some notable figures in the history of colour, such as Goethe and Runge, are not listed here, as someone else first advanced their favoured primary colour sets.

The identity of the mysterious 'C.B.', author of the influential *Traite de la Peinture en Mignature* [*Treatise on Miniature Painting*] of 1708, remains unknown.[i]

One important point to note about the table is that most of the theorists in it differentiate between two species of colour-mixing phenomena: on the one hand, those involving pigments and pigmented substances like paints and inks, and on the other hand, coloured lights. (There is more about this difference in Chapter 3, 'Additive and Subtractive Mixing'.) Some of these suggested sets of primary colours are meant to be applicable to both sorts of phenomena, but most are exclusively sets of primary pigment colours.

We might conclude that many people have had a use for such a distinction even if their choice of colours in each of the 'primary' and 'secondary' categories has been different. However, even if there may be uses for the distinction (though I confess I don't know what they are) it does us no good if we are concerned with the business of mixing colours. In fact, I maintain that the distinction is the most significant hindrance to successful colour mixing. In view of this, I will argue, it should be abandoned.

The basis for the distinction

For over two thousand years, the distinction was usually defended on either spiritual or aesthetic grounds. Since the seventeenth century the distinction has been supported principally on the basis of scientific theory and experimentation. For example, some theorists (Newton, notably) have attempted to show that the relationships between colours are somehow linked to the relationships between the notes in a musical scale. Such associations are at best merely coincidental, however, and any theoretical significance that was once claimed for them is ignored by science today.

Of course we should beware of assuming that the state of science in our own era is the last word. Some ideas currently accepted as orthodox will eventually be discarded, and colour research will not be immune from these revisions. For example, disagreement about the details of colour vision between theorists in many different disciplines is as lively as ever. One continuing area of controversy is whether we have a psychological predisposition to recognise the primary–secondary colour distinction. Goethe's writings on colour and Hering's influential theory of opponency both point in this direction. But some of the existing mix of views with this ancestry may well eventually fall out of favour as new ones emerge. It is a fundamental part of the way that science is normally conducted that ideas are subject to test, criticism, revision, and may have to be withdrawn. Any aspects of a practical colour theory for artists that depend on prominent scientific conjectures are therefore only as secure as those conjectures are themselves.

The framework of pragmatic principles I advance here does not suffer from this sort of dependence. It is not beholden to any particular scientific theories about the physics of light, or of colour vision. Even if the current theories about how we see were totally revised overnight, this would not affect in any way what we see when we mix, say, some blue and red paint. The framework is chiefly a tool for making accurate and reliable predictions about what we will see when we mix materials of this sort.

The popularity of the distinction between primary and secondary colours is not confined to common use. Even among those who work with colour professionally, the primary–secondary hierarchy typically serves as the cornerstone of the rest of their colour knowledge. That is, everything else they know about colour either rests on or is filtered through the belief that this distinction between colours has to be respected. Even very recent publications on colour mixing and colour theory still cling to this idea. However at best the distinction is arbitrary – even if you really find it helpful to divide colours into a primary–secondary hierarchy, the red/blue/yellow and violet/green/orange division is only one of many ways of doing so. As we will see, over and above the difficulties with any particular variant, the very idea of a primary–secondary colour distinction really isn't a helpful place to start for anyone who wants to master colour mixing.

Fundamental and derivative colours

Even though there appears to be no obvious rationale for maintaining the primary–secondary distinction, its influence is undeniable. So it is worth asking exactly what sort of influence it exerts. What does this distinction amount to?

Generally speaking, primary things come first; secondary things come afterwards. With this in mind, it seems, we are supposed to regard primary colours as in some sense before, or in advance of, secondary colours. There are two principal ways in which this adversely affects our thinking about colour. First, one connotation of the primary–secondary distinction is related to ideas of hierarchy, to evaluative terms like 'superior' and 'inferior'. Thus, thinking about colour in terms of the distinction has the psychological effect of prioritising red, blue and yellow, of regarding them as somehow better ('stronger', perhaps?) than their secondary counterparts. However the assumption that there is an evaluative priority of this sort among colours, that some colours are 'better' than others, undermines practical colour-mixing skills. Accurate and reliable colour mixing depends on a proper understanding of the relationships between colours, and these relationships are most effectively thought of as relationships of *equivalence*. The nature of these equivalences and their implications for mixing will be demonstrated through the rest of the book.

The second problematic connotation of the primary–

secondary colour division has an even more powerful adverse effect on our attempts to mix colours. When we think of primary factors we are thinking of things that are in some sense *fundamental*, whereas secondary ones are *derivative*. In practical colour-mixing terms, this way of interpreting the distinction results in a **genetic priority** being assigned to red, blue and yellow. By this I mean the idea that primary colours are the 'ancestors' of the secondary colours, that green, orange and violet carry within them their primary colour origins, whereas primaries themselves contain no traces of violet, orange or green. (Another apt word for the primaries used by some theorists is 'primitives'.) While this ordering of the colours remains in place a full appreciation of many creative mixing possibilities will be overlooked because the supposition that violet, orange and green are derivative forecloses on their use in certain ways. This genetic priority is expressed in two myths that are commonly associated with the primary–secondary distinction.

The Sufficiency Myth:
All Colours can be Mixed from the Three Primaries

One rationale for calling red, blue and yellow primary hues is the supposed fact that all other hues can be mixed from these three. Now, although there is some truth to this, it is not true in quite the way that most advocates of the primary–secondary distinction would have us believe. (And as we shall see, to the extent that it is true, it contradicts the second Myth.) Although this Myth is still widely believed, it has been exposed previously in various places. My introduction to these critiques was Michael Wilcox's book *Blue and Yellow Don't Make Green*.[ii] Wilcox is one of several writers who base their approach to theory on the idea of colour **biasing**. In practical terms this amounts to exploiting the fact that there are different versions of red, blue and yellow that behave differently in mixes. Biasing is a helpful idea that has been made much of by Wilcox and others, and I examine it in more detail in Chapter 6. However although it offers a peep through the obscuring veil of established theory, biasing alone doesn't give us an unimpeded view of the truth. In order to see the full picture we need to be more radical in our thinking.

The falsity of this Myth should be apparent to anyone who has tried to put what it says into practice. In spite of this, many people believe (as I used to) that their inability to mix all hues from just three paints is due to a personal failing. But the fault lies with the Myth, and with the primary–secondary distinction from which it emerges.

The Irreducibility Myth:
The Three Primaries Cannot be Mixed from Other Colours

The first Myth has, as I say, been challenged before. Its companion however, as far as I can tell, shows no sign of loosening its grip; almost everyone who has anything to say about colour seems to reiterate it. And repetition is a very effective means of keeping an idea alive, even if the idea in question is false.

The claim that red, blue and yellow are primary gets its most powerful expression in the idea that these hues themselves cannot be the product of the mixing of any other hues. On this understanding red, blue and yellow are *irreducible*. Like true atoms, they have no simpler components; they cannot be mixed, but are rather the basic elements from which other hues are derived.

Unlike the Sufficiency Myth, which is put to the test every time we attempt to mix a colour, the Irreducibility Myth is shielded from scrutiny simply because it has become an article of faith, part of the culture of colour, so to speak. Most people wouldn't even consider it possible to challenge this Myth, and so it survives, handed on from one generation to the next. For any adventurous soul who does wonder whether this Myth really is true, how are they to proceed to test it? That, of course, is one of the questions that this book answers. If you haven't already skipped ahead for a sneak preview, just pause for a moment to consider how you would go about mixing one of the primary hues. Do you have any idea how to go about it? Don't worry if you can't at present imagine how this might be done. The Irreducibility Myth is so widely propagated, and so deeply ingrained in our consciousness, that any opposition to it may sound initially as flatly preposterous as denying the force of gravity – and yet not only is it possible to mix the so-called primary hues, there is no mystery as to how or why it can be done.

Summary

The most heavily entrenched ideas about colour mixing are false. These false ideas disrupt and undermine attempts to mix colours reliably. A better framework or theory is required to replace the established web of colour-mixing theory.

The replacement theory should be pragmatic; that is, it has to be judged solely on its success in aiding colour-mixing practice. It doesn't need to explain or unify such diverse aspects of colour as the physics of light, the chemical composition of pigments, or the neurophysiology of the eye. A better understanding of these scientific topics has no positive impact on our specific area of interest – the capacity to predict accurately what we will see

when we mix particular paints, inks, and so on. Insofar as compressed snippets of physics, chemistry and biology find their way into accounts of colour-mixing theory, they tend to be either distracting or confusing, or both.

The chief source of the problems we encounter with established theory is the conceptual distinction between primary and secondary colours. Anyone who accepts this distinction is liable to fall under the spell of the two Myths of Sufficiency and Irreducibility. These Myths seriously misdirect colour-mixing practice.

The **Sufficiency Myth** says that all colours can be mixed using primary colours alone. If you believe this, you may well find yourself constantly wondering why your mixing skills are deficient; established theory says you should be able to do this and that, but, try as you might, you find you can't. Rather than challenge the Sufficiency Myth, which is where the problem really lies, most people locate the fault in themselves.

The **Irreducibility Myth** says that there are some colours that cannot be mixed. There could scarcely be a more effective obstacle to acquiring full control of colour mixing than this falsehood, that (for reasons usually left unstated) certain 'special' colours cannot be produced by mixing. The Irreducibility Myth has attained so much power that virtually no one even bothers to try to put it to the test.

In fact, both of these Myths have become rather like articles of faith that *define* the process of colour mixing. To reject them might seem to some people to be either contrary to commonsense, or to run counter to established scientific fact. However as I explain in what follows, the primary–secondary hierarchy on which the two Myths are founded is arbitrary, and deserves no privileged status among the different ways in which we could classify colours.

Fortunately the void left once we have let go of the primary–secondary hierarchy can be filled with much more useful ideas – that is, genuinely *helpful* and *practical* principles. To illustrate these principles, there are many exercises throughout this book that I believe will help you make sense of colour mixing. By doing these exercises and carefully following the instructions for viewing the results, you should acquire an understanding of the mixing process that will enable you to achieve the practical results you want.

IMPORTANT PRELIMINARIES

Introduction

The ideas in the book are not very difficult to grasp. However, because the artist's interest in colour intersects with the study of colour in other disciplines – physics, philosophy, physiology, anthropology, to name just a few – there are many potential ways in which the discussion could be stalled or thrown off-track. To prevent this happening, we need some initial points of reference and clarification to keep us properly focused on the main topic. It will also help to start as simply as possible, and introduce complications only when they are absolutely necessary. So in this chapter I do two things. First, I set out how the most important basic terms of the discussion should be understood. Second, in order to pave the way for the colour-mixing principles without distractions, I specify some significant 'real-world' considerations that will be temporarily suspended. As the discussion progresses, the simplifications will gradually be replaced with more accurate representations of real-world complexity.

The Language of Colour

The language used to discuss colour is complex, subtle, and has many 'dialects', some technical, some colloquial. We need to take steps to avoid confusion arising out of linguistic misunderstandings that can arise when these different vocabularies overlap. The most obvious thing to do in this respect is to state as clearly as possible how key terms – the ones most liable to misunderstanding – are being used. I will be doing this in two ways. First, there are some terms that are so basic to the discussion that they need to be properly established from the outset. These are dealt with in the latter part of this chapter. Second, throughout the remainder of the book there are some additional terms that warrant a special introduction. I use *key term* boxes for this purpose.

Key Terms

Wherever you see one of these boxes throughout the book you will find an explanation of how a key term is being used.

Steering clear of a big confusion

As well as being misdirected by the two great Myths, anyone in pursuit of a proper grasp of colour mixing is also thwarted by a persistent confusion that can be found in the work of even the best writers on the subject. All too often assertions or recommendations about *colours* are confused with claims or recommendations about *paints* or **pigments**. Strictly speaking, we can't mix 'blue' with 'red', for example, or 'yellow' with 'red'; we can only mix physical things like coloured paints or pigments.

Colours are rather like numbers in this respect. You can hold five objects in your hand, but not the number five itself; 'five' is not the sort of thing we can ever encounter in the world. Similarly, we never encounter 'colours themselves' as we might put it, but only coloured particular things. For example: a blue patch of sky, a piece of blue fabric – even a blue after-image is a blue *something* rather than 'blue' itself. Colours themselves – blue, red, yellow and all other colours as such distinct from their physical manifestations (if indeed it makes any sense to talk of such things) – cannot be manipulated because like numbers they are ideal, abstract and intangible. (Confusingly however,

Pigment

A pigment is a substance capable of imparting a specific colour to an object. It is important to remember that pigments are not ideal abstract colours. They have physical properties that govern their behaviour. So, for example, two red pigments of similar appearance may differ significantly in other respects.
The properties commonly of interest to most artists include permanence, staining power and transparency.

mathematicians make use of a distinction between 'real' and 'imaginary' numbers.)

Imagine the following bizarre scene. An art teacher instructs the class, 'I want you to start by mixing some blue with some orange' and the students accordingly reach for their paints, and mix away. 'No,' says the teacher, observing them, 'I can see what you've all done; you've mixed blue *paint* with orange *paint*. That's not what I asked you to do. Please put away your paints … come along, hurry up … good … now, the task is to mix some *blue* with some *orange*.' The students exchange bemused and confused looks until one brave soul calls out, 'I have no idea what you're asking us to do…'.

The students' confusion here is hardly surprising. When we do what we call 'mixing blue with red' we are always mixing a blue something-or-other – say, a paint, ink or dye – with a red something-or-other. When we ask questions like, 'What happens when we mix orange with blue?' we need to remember that they cannot sensibly be asked or answered literally. In spite of the multitude of times that orange paint or ink has been mixed with blue paint or ink no one has ever mixed 'orange itself' (an idea of orange abstracted from our experience of orange things) with 'blue itself' (an idea of blue abstracted from our experience of blue things). Our colour-mixing practice is never an abstraction but is always the manipulation of things that stimulate colour experiences in us. So our talk about the behaviour of colours, say, that blue mixed with yellow makes green, must always be read as a shorthand for 'blue paint mixed with yellow paint makes green paint'.

Physical Substances and their Colouring Properties

Not all blue and yellow materials behave like paints, so not all physical mixtures of blue and yellow materials produce green results (optical mixing is a different matter – *see* Chapter 4). Chemical reactions resulting from mixing coloured substances together may produce results not predicted by colour theory. This is clearly not what we want from our paints. The more chemically inert a pigment is, the more reliably it will serve as the colouring component in paint. But even the most chemically inert blue pigment is not 'blue itself'; it is still a blue substance with physical properties that affect the way it performs its colouring function in paints.

Paint

Paint is a composite substance in which a pigment (or mix of pigments) is suspended in a vehicle (such as oil, or polymers) with binding materials (gums, resins and so on) to make a convenient means of applying and fixing pigment to an object. I will be extending the familiar use of 'paint' (in tubes, tins, watercolour pans and suchlike) to include other dry pigmented art media, such as coloured pencils, crayons, pastels and oil pastels.

Distinguishing abstract ideas of colours from coloured substances

Some people may think that it is merely nit-picking to point out this slackness in our ordinary use of language. On the contrary, it is important because whatever properties we may suppose colours themselves have, we don't have direct access to these things, only a kind of mediated access via the properties of materials like pigments and paints. The physicality of these materials – their viscosity, transparency and so on – influence to a lesser or greater extent how a substance behaves when mixed with other substances. Talking about 'mixing *colours*' encourages us to forget that our pigments and paints have these other properties too, from which their colour properties cannot fully be separated.

Referring to colour: reverting to common usage

It is very cumbersome to keep on making this distinction between 'colour' and 'coloured substances' so, having alerted you to the danger of confusing these concepts, I won't continue to make the distinction from this point. However, as already emphasized, it is important to remember that in practical terms references to 'colour' are references to colouring materials – pigments, paints, pastels and so on – and to coloured objects and surfaces.

For the Sake of Discussion (I): Defining Some Basic Terms

As the previous point clearly illustrates, the language we use in talking about colour can lead us into various sorts of confusion. Some of this confusion is merely verbal; we may find, for example, that a disagreement develops because two people are using different words for the same colour. For example, Jack tells Jill he

wants to paint the bathroom 'Sandalwood'. She objects, and expresses her preference for 'Sahara'. Comparing their respective colour charts, they discover that 'Sandalwood' and 'Sahara' are the names that two different paint manufacturers use for the same colour. Clearly, such disagreements can be resolved simply by agreeing common terms for the things in dispute.

If we are to cut through the web of confusion that stands between us and a full grasp of colour mixing, then we will have to be prepared to make more of a concession to 'strict speaking' than we usually do. So, in order to keep all potential confusions to a minimum, I shall now set out definitions of some important terms that will feature in the rest of the book. And they really are just for the sake of discussion. Nothing much turns on the choice of these terms and definitions rather than others, and the definitions given here do not always accord exactly with how they are used elsewhere. The important thing is not so much what term is used for which concept, but that the terms are used consistently.

Colour

It is widely conceded that colour is such a basic aspect of most people's experience that it is hard to find words to describe or define the phenomenon in a comprehensive way. So, with that reminder of inadequacy, let me offer a few observations about colour in its most general sense. These comments are intended to indicate the aspects of colour on which my discussion focuses and a catch-all definition is not necessary for that purpose.

Colour is that quality of a visual experience that enables the identification of and discrimination between the surface appearances of objects. The extension of an object in space – its shape – is revealed to us visually by contrasts between its colour and the colour of its environment. In a literal monochrome world (one in which, for example, everything was yellow) it would be almost impossible to visually distinguish one thing from another. Variations in the strength and direction of light as it strikes objects would offer some clues to their shape, but even then we would find ourselves in very challenging circumstances in which vision would be of very limited use.

Nevertheless, if we did live in such a world we might still be able to register differences in colour stimuli. We could do this in a monochrome world if its chromatic character changed abruptly from time to time. (Suppose, for example, that yesterday everything was yellow and today everything is blue). Colour vision would allow us to detect this change even if it didn't improve our ability to discriminate between objects. The variations we can detect in this very basic aspect of visual phenomena are for the most part what I mean by the term 'colour'.

Hue

There are many factors that can be used to differentiate between coloured surfaces, and many schemes have been devised in order to formalize these differences. Being able to make precise, reliable and repeatable discriminations between different sorts of colour sensation is of great importance in fields such as colour photography and printing. The most familiar property that features in virtually all colour vocabularies, whether scientific, philosophical or informal, is **hue**. It is very difficult to give a satisfactory verbal definition of hue, though it is the characteristic most often in people's minds (at least, in the minds of present-day Westerners) when the matter of colour difference is raised. For example, 'shall we have *blue* curtains or *green* ones?' and 'will *orange* shoes go with this *yellow* suit?' are queries based on differences in hue.

Typically, we appeal to samples in order to demonstrate these differences, though there are doubts about the usefulness of this process of ostensive definition. (That is, the process of pointing at the thing you want to define whilst saying 'this is x'.) For example, merely pointing at something whilst saying 'this is blue' does not make it clear to someone who doesn't already know what 'blue' means that a colour rather than, say, a shape or a location is being pointed out. In spite of these philosophically motivated worries, there is a large measure of agreement among colour theorists as well as a more general informal acceptance of the idea that colour experiences fall naturally into one or other of a small number of basic hue categories. However, although there has long been agreement that there are basic categories of this sort, their exact number and character throughout the history of colour theory, like the list of primary colours, have been by no means static.

We can be reasonably confident that the nature of the human visual system has not changed significantly since the emergence of our species. Thus we can presume that, biologically speaking, human colour vision is much the same as it has always been. The World Colour Survey initiated in the 1970s by the ethnologists Brent Berlin and Paul Kay following their book *Basic Colour Terms* (1969)[iii] aimed to show that there are eleven 'basic' colour categories recognized universally by human beings. Their findings reinforce the idea that we are all hard-wired to respond to and classify colour stimuli in the same way.

However, the evidence about hard-wiring only maps the extent of our colour categorizing capabilities; it doesn't show that we all do in fact classify colours in the same way. A common potential for recognizing colour categories still allows for significant differences in our actual classificatory practices. We know for example that the actual colour categorizing practices of communities at different times in different places have indeed exhibited some striking differences from ours. The colours we differentiate as blue and yellow were frequently grouped

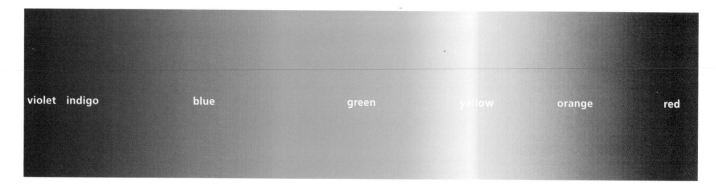

violet indigo blue green yellow orange red

FIGURE 4. **The Newtonian seven-hue spectrum.**

together by medieval French speakers as 'bloi', and red and green were both known as 'sinople'.[iv]

It seems plausible to suppose that, throughout human history, there has been little significant change in our physiological responses to the data presented to our senses. However, our *interpretations* of the data have changed, and may for all we know change again in future. We don't have to wait for change to support the truth of this observation, since contemporary non-Western cultures can be seen to vary significantly in their interpretations of colour phenomena from those that currently dominate colour theory in the West. In particular, the Western preoccupation with hue is not universally shared even though it is a reasonable assumption that all human beings with biologically normal colour vision have the same physical capacity to distinguish one hue from another. (This thought is followed up briefly in Interlude 1.)

HOW MANY HUES?

The classical, Newtonian view claimed that there are seven distinguishable bands of colour visible when white light is directed through a prism: violet, indigo, blue, green, yellow, orange and red. It is always open to us, however, to label our visual experience of the spectrum in a different way, and this is in fact what has happened. A large part of contemporary opinion no longer regards indigo as a distinct colour, leaving us just six of these **spectral hues.**

Were Newton and his associates mistaken about how many colours emerge from the prism? Maybe we should recognize that there are different ways of drawing hue boundaries and these need not be judged correct or incorrect.

In any event, the precise number of hues we recognize will not be an impediment to implementing the colour-mixing principles worked out here. If, as seems very plausible, cultural concerns determine our conceptions of colour and its classification, it would not be surprising for cultural development in the West

to bring about revisions in the ways in which Westerners use and appreciate colour. At present, however, the hue classification derived from the six qualitatively different types of visual experience labelled 'blue', 'violet', 'red', 'orange', 'yellow' and 'green' forms the basis of a significant part of talk about colour in the West. I shall be using this classification as the anchor for introducing the colour-mixing principles. This is partly because this six-fold division is familiar, and should thus provide an easy way into the discussion. It is also partly because adopting this scheme helps to show how the established theory fails to make the best possible sense of its own assumptions. However, it will become clear once the mixing principles have been laid out that even this well-entrenched division of the hues can be abandoned without any untoward practical consequences.

Clearly, the six-hue model crudely compresses the variety of the hues we can identify. As we all know, there are many reds, many blues and so on. We get a better impression of this variety from a **colour wheel** that depicts the idea of six ranges of related hues, as shown in Figure 5. (Note how each hue range develops smoothly into its neighbours', rather than changing abruptly.)

Although we can explain quite a lot about the operation of the mixing process using this simple schematic layout, a colour wheel needs careful construction if it is to provide a genuinely useful practical aid. In fact, the standard colour wheel familiar to most artists has some serious shortcomings. I discuss these deficiencies in Chapter 12 and explain how they can be corrected, to make the colour wheel a genuinely useful reference.

Spectral Hues

The hues visible in the spectrum, as typically seen in a rainbow. Note also that there is a range of violet or purple hues that do not occur in the spectrum and are thus classified as non-spectral hues.

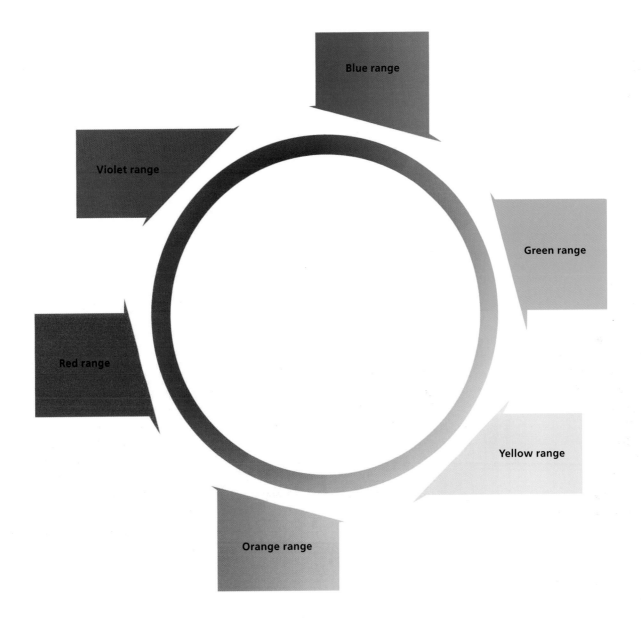

FIGURE 5. **Six hue ranges.**

FIGURE 6. **Three blue samples.**

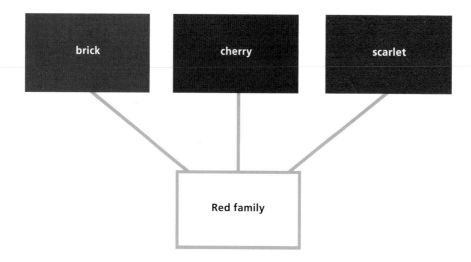

FIGURE 7. **Three members of the Red family.**

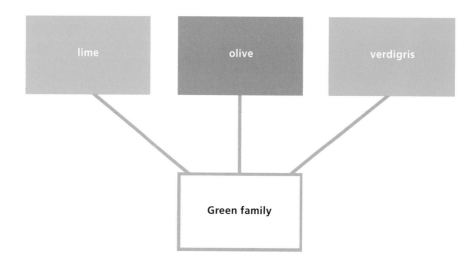

FIGURE 8. **Three members of the Green family.**

HUE FAMILIES

Even when we talk about the six hue groups in the abstract it is difficult not to call to mind some representative sample or other. Think of a blue patch, and you think of some specific variety of blue. Now, however, if I ask you to think of another blue patch that can be distinguished from the first one you can do this with no effort at all. (As an aside, try this with 'olive green', 'dark brown', 'blueish-green'. How do you get on? What conclusions could you draw from this exercise?) The samples shown in Figure 6 are all blue, but they differ considerably.

The common features in question are rather like family resemblances; they are clearly visible, though it is often difficult to sum up exactly or define those features. Some samples are closely related; others are only distant cousins, and so on. Accordingly, in general terms it makes sense to consider 'blue', 'violet', 'red', 'orange', 'yellow' and 'green' as names of hue families, rather than as names of specific isolated hues. When talking about colours we use a wide range of modifiers ('dark', 'deep', 'pale') and specific objects (as in 'sky blue' and 'lemon yellow') to help us distinguish one sort of blue from another, one sort of yellow from another, and so on. However, in spite of their differences, the family resemblances among different blues lead us to group them together, and another set of resemblances among different yellows leads us to group them together, and so on.

Throughout the book I refer to hue families using capitalization. Think of 'hue' as referring to the familiar colour names or

Chroma; Chromatic

The degree or intensity of a colour's hue, as distinct from its other characteristics such as lightness/darkness or transparency/opacity. There are nuances that distinguish 'chroma' and 'saturation', though in our discussions they can be treated as more or less synonymous.

hue families such as Red, Blue, Yellow, Green, Orange and Violet. Specific members of those families are referred to in lower case, for example 'light red', 'navy blue' or 'primrose yellow'. Other colour names – magenta, mauve, teal, ultramarine, and so on – also pick out hues. The particular named hues all relate to the six hue families in the way shown in Figures 7 and 8.

The primary–secondary colour distinction is a way of classifying colour by hue. Thus, the primary–secondary distinction is also a way of classifying hue families, and encourages the idea that some hue families are fundamental to colour mixing while others are derivative.

AMBIGUOUS AND UNAMBIGUOUS FAMILY MEMBERS

In some cases it isn't easy to say which family a given hue belongs to. We often have no option but to resort to vague descriptions such as greenish-blue, bluish-green, and so on. Also, we frequently disagree with each other about which description in a particular case is best. This affects, among other things, our selection of hue samples when we are teaching children hue family names. We choose unambiguous samples from a restricted range within a family, as indicated by Figure 9.

The 'good teaching samples' within a hue family tend to take on the status of paradigms or icons, exerting a powerful influence over our judgements about hue classification. Nonetheless once we start to see hues in families, it becomes apparent that in each family some members are distantly related, others are closely related. This is an important point, and we will see that it contributes significantly to the collapse of the two Myths, and eventually to that of the primary–secondary distinction itself.

Other attributes of colour

In normal conversation we tend not to differentiate between 'hue' and 'colour'. However, in our discussions here it is very helpful to draw a distinction between the two because there are other important features to take into account in colour mixing besides hue. Three additional features that will be of particular interest to us are **saturation**, **paleness** and **lightness**.

FIGURE 9. **Suitability of hues for teaching colour names.**

SATURATION

Saturation refers to the intensity of a hue in a colour sample. Highly saturated samples are variously described in such terms as 'vivid', 'rich', 'powerful' or 'sumptuous'. They display a lot of what makes colour 'colourful'. Saturation can also be expressed in terms of *colour purity*. The purer a colour, the more prominent the identity of its hue; the less saturated a colour then the darker and the more muted, grey or 'dirty' its hue becomes (*see* Figure 10).

As colours get darker they tend towards black, as this sequence shows. Reducing the saturation of a colour as in this sequence produces **shades** of that colour. This is a departure from common usage, in which 'shade' is often used to refer to hue, or 'member of a hue family', as those terms have been explained previously.

The obvious way to produce different shades is simply to mix a hue with black in varying proportions. However, many artists avoid this practice and produce all the dark colours they need from members of the six spectral hue families. I favour this second practice myself and I explain why in Appendix 1.

PALENESS

Paleness as it applies to colour is simple enough to understand. Increasing the paleness of a colour sample produces tints. In common usage 'tint' frequently means 'hue'. However, in the way that I shall be using the term, 'tint' refers to the quality of

FIGURE 10. **A sequence of Red hue samples decreasing in saturation from left to right.**

FIGURE 11. **A sequence of Red hue samples increasing in paleness from left to right.**

FIGURE 12. **From left to right: a bright saturated hue, one of its shades and two progressive tints of that shade.**

paleness as illustrated in Figure 11. Pale, tinted colour samples are what we call 'pastel colours'.

When using watercolour, tinting is normally brought about by dilution with water in different proportions. As the sequence suggests, when paleness is increased to 100% there is no trace of the hue left, which on the watercolourist's palette would correspond to 100% water. Alternatively, you could think about this in terms of the relatively opaque medium of oils, in which tinting can be achieved with the addition of white paint. In this case, 100% paleness would be provided by pure white paint. (The question of whether we should think of white in either case as a colour or hue needn't worry us for the moment, but is considered in some detail in Chapter 18.)

LIGHTNESS

Don't confuse paleness with lightness. Lightness is a characteristic associated with hue. Yellow is generally regarded as a lighter hue than blue, and violet is the darkest of all hues.

Note also that variations in shade (the degree to which a sample is muted) are independent of variations in paleness. That is, darkness and paleness don't stand in relation to each other in the way you might initially be inclined to suppose. For example, reducing darkness (increasing colour purity) doesn't increase paleness. And tinting a shade doesn't change its colour purity, as seen in Figure 12.

INTERACTION

Although these three factors – saturation, paleness and lightness – vary independently of each other it is not always easy to appreciate this. Our normal use of language makes it difficult to keep them independent, since reductions in saturation (hue purity), paleness (tint degree) and lightness (brilliance of different regions of the spectrum) are all typically liable to be described with the single term 'darkening'. Even within technical vocabularies the different variations that we tend to lump together under this single term are not always clearly separated.

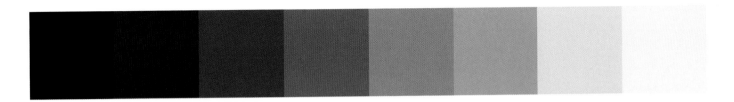

FIGURE 13. **A black–grey–white scale.**

It is far easier to appreciate the differences involved in a three-dimensional model – but in the interests of simplicity I am postponing this discussion until Chapter 18. For the time being, when I refer to **darkening**, I will be talking about the effect of reducing a hue's saturation.

TONAL VALUE

As if things weren't already confusing enough, in addition to considering darkness in the way outlined above we can also do so without reference to hue. We can assign tonal values to a coloured area by reference to a black–grey–white scale of discrete steps, usually 9, 10 or 11 in number, as in Figure 13.

It is widely maintained that nine steps are the practical limit discernible by the human visual system. I refer to the black end of the scale as being the lowest, and the white end as the highest tonal value. Variations in hue, saturation and brightness all influence tonal values. Figs 14–17 show some of these relationships.

There are further aspects of the relationship between these factors that can be most easily appreciated when we consider three-dimensional colour space in Chapter 18.

For the Sake of Discussion (II): Some Simplifying Assumptions

In addition to the help given by the foregoing clarification of our basic terms, the discussion will be easier to follow if we enlist some temporary simplifications. Colour mixing is a practical business in which many variables influence each specific outcome. It would be easy to get constantly side-tracked by these details, and to make endless lists of exceptions and qualifications in order to produce formulas about the precise proportions in which x should be mixed with y in order to produce the result

z. This is not that sort of recipe book. So, although I use specific colour references to describe experiments that demonstrate the principles at work, this is always with the intention of laying out the *general* features of colour mixing. It is by understanding how those general features apply in each case rather than memorizing or referring to vast colour-mix charts that you can gain creative control of your palette.

As we advance through the exercises, each of the following assumptions will eventually be revised or eliminated to take account of the complications encountered in real situations:

UNIFORMITY OF PHYSICAL MIXING CHARACTERISTICS

For the time being I will suppose that all pigments and their encapsulations in paints behave consistently. I will assume that a 50%:50% mix by volume of two differently hued paints will produce an intermediate hue positioned halfway between the source hues on the colour wheel (whereas real pigments vary considerably in their relative 'strength').

THE COLOUR WHEEL REPRESENTS THE SPECTRUM

The colour wheel will be imagined to represent the entire visible spectrum. It can't actually do this; our eyes are sensitive to colour stimuli far more intense than the range that existing pigments can represent.

LINEAR REPRESENTATION OF HUES IN THE SPECTRUM

Each hue family will occupy the same amount of space on the colour wheel. Since we are also assuming that the colour wheel represents the spectrum, this is equivalent to the assumption that each hue family occupies an equal portion of the visible spectrum.

FIGURE 14.
Tonal value
comparison (1):
On the left of the
detail, a shade;
on the right, the hue
from which it is
derived.

FIGURE 15.
Tonal value
comparison (2):
In this version of the
same detail, all hue
information is absent.
The tonal values
can be judged
more easily.

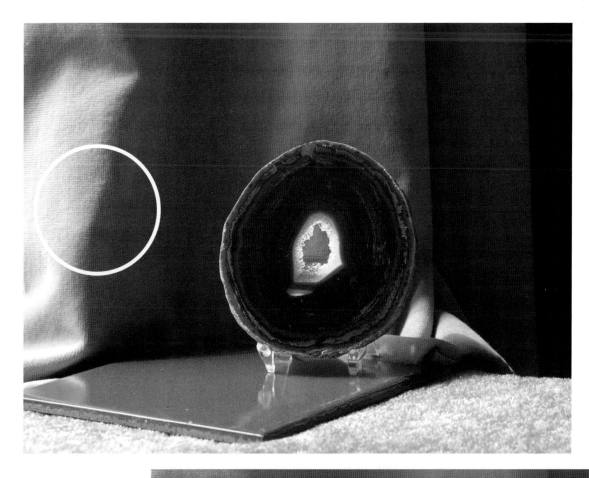

FIGURE 16.
Tonal value comparison (3): On the left of the detail, a tint; on the right, the hue from which it is derived.

FIGURE 17.
Tonal value comparison (4): Again, the tonal values of the detail are seen more starkly without its hue information.

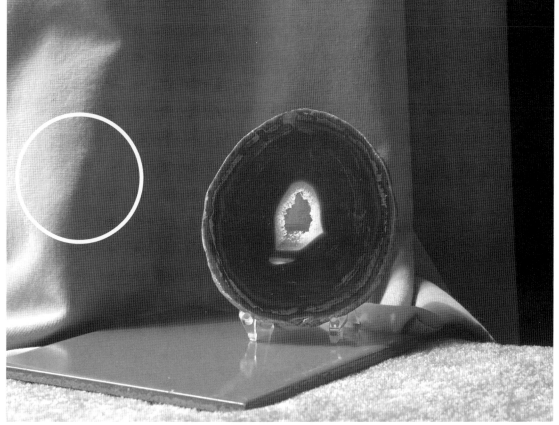

FULL SATURATION OF HUES IN PAINTS
All paints used in our initial mixing demonstrations will be regarded as representing the hues at their respective maximum saturation.

UNIFORM SATURATION OF HUES IN PAINTS
Paints of different hue also differ considerably in their saturation characteristics, but we will overlook this for the most part.

OPACITY
For now, I shall assume that all paints are entirely opaque.

Scientific Theory vs. Practical Framework

It is worth emphasizing that none of these preliminary reference points presupposes any specific scientific account of the causes of our experience of colour. Here, I am not concerned with *why* our visual experience has the chromatic character it actually has, as far as physics, chemistry or biology is able to answer that question. Success in mixing colours does not depend on what science has to say about questions like 'Why does mixing colour *A* with colour *B* produce colour *C*?'. In fact, the best scientific explanation available today of why things appear to us the way they do may be supplanted with a superior, more plausible or more compelling explanation tomorrow. But the data we are presented with – that is, what we actually *see* – will not change as a result of a better explanation of its nature. Neither will the behaviour of the materials we use in colour mixing change as a result of our theorizing about the causes of that behaviour. Colour mixing is about manipulating the appearance of things, and a sound practical grasp of this does not depend on an understanding of causal mechanisms that purport to explain what, and why, we see.

So the theory or framework set out here is not scientific in any rigorous sense, though the occasional appeal to science is used to help construct a kind of story, so to speak, that helps with the practical business of colour mixing (but I'm not that concerned about whether those fragments of science are true). What matters is whether the colour mixing results that the framework predicts are achievable and repeatable, regardless of the ultimate physical basis for their production.

Summary

Much linguistic confusion threatens to interfere with our grasp of colour concepts, not least in regard to the fundamental idea of colour itself. For instance, we talk about mixing colours, and this can suggest that colours exist to be mixed quite separately from the coloured substances we use. However, coloured substances have properties – *physical* properties – that colours considered in the abstract don't have. Talking about mixing colours can thus lead us to expect results that we can't obtain, since strictly speaking we only ever mix coloured substances. I have thus defined the most important terms of the discussion to minimize confusions of this sort.

In addition, several initial assumptions have been made in order to get the discussion underway with as few qualifications and distractions as possible. You should regard them as part of the scaffolding around which the main discussion of the book is built. By the time we reach the end of book, all the scaffolding will have been stripped away and replaced with more accurate accounts of how things work in practice.

The following chapters describe and explain the general principles that govern colour mixing, and as such provide a solid practical guiding framework for successful colour mixing practice. You will also want to add to this your detailed knowledge of the specific materials in your palette. So part of your own mastery of colour mixing will emerge from familiarity with your particular materials. An understanding of the general framework will make it easy for you to evaluate, select, adapt, substitute and – above all, I hope – exploit your materials with greatly enhanced creativity.

ADDITIVE AND SUBTRACTIVE MIXING

Introduction

As well as the primary–secondary hue distinction perhaps you also recall some rather later encounters with colour and colour theory, something about a distinction between **additive** and **subtractive colour mixing**. This need not detain us for long, since it is not the main topic of interest to us, but an appreciation of this second distinction will be necessary from time to time in what follows.

Into the Dark

Our first teachers could have made it easier for us to understand a great deal about colour mixing by making one simple observation. They should have told us that mixing pigments produces colours that are darker or duller than the brightest one used in the mixture. (My apologies to your teacher if that *is* what she or he told you.) Of course, there are limits on how much colour theory one can heap on a five-year-old child. I'm not suggesting for a moment that grand-sounding concepts like 'the darkening principle' could be introduced in kindergarten, although even young children can be expected to grasp the concepts of 'colourful' and 'dull', and 'cause' and 'effect'.

We could have been told to expect this darkening phenomenon, and could thus have usefully incorporated it in our early colour-mixing adventures. We could easily have been given this information whilst being spared the explanatory details that admittedly are probably more than a five-year-old child could cope with. Similarly, we don't want or need a chapter on physics at this point, but it will be helpful for our purposes to consider in outline what is going on here.

Adding and Subtracting

The mixing of light sources – of coloured lights – is referred to as an additive mixing process. Additive mixing is not the chief topic of this book but, since it is part of the phenomenon of colour as a whole, it has some bearing on our present concerns. When the light from two or more sources is combined the resulting emission is lighter, brighter and more luminous. Clearly, adding more light sources increases the available light. As a general observation this is hardly a surprise. In the unlikely event that you are in any doubt about this, turn on progressively more lights in a room. Does the room get darker, lighter, or maintain its previous level of illumination? It gets lighter, of course. As far as mixing goes, certain combinations of coloured lights in the appropriate proportions produce white light.

In contrast to this, the mixing of pigments is generally referred to as a subtractive mixing process. Pigments (and pigmented surfaces) are coloured by virtue of absorbing light from some parts of the spectrum and reflecting light from the other parts. As objects and surfaces absorb and reflect light from different parts of the spectrum, so they appear to us as having different colours. That is, of the light that strikes a pigment, only some of it is reflected. A pigment (or pigmented surface) 'consumes' (absorbs) some of the light that comes its way and gives back (reflects) the remainder to us. Since this process 'consumes' or otherwise fails to give up some of the light striking an object, then the net light that appears to be emanating from its surface must be *less* than the light striking it. (As an exception to this, some highly polished surfaces are near-perfect reflectors, absorbing virtually no light. So although they do not provide a net increase in illumination, they 'give back' almost all of the light that strikes them. No pigments have this property, although there are specially formulated metallic and pearlescent pigments that are more reflective than most.)

For example, a mixture of two different pigments, *A* and *B*, results in a composite that absorbs the light from the region of the spectrum absorbed by *A* on its own, plus that absorbed by *B* alone. That's to say, the mixture absorbs more light than either

A or *B* do alone. Our mixture absorbs or *subtracts* more of the light striking it than each of its components, so the resulting mix is *darker* than the lightest component. That's pretty simple, isn't it?

The primary–secondary distinction gets applied to additive mixing just as it is does to subtractive mixing. It is often maintained that with regard to additive mixing there are three primary colours: red, green and blue. This is as inaccurate and misleading as the corresponding claim about subtractive mixing. Fortunately, we won't need to worry much about that.

Summary

It is possible to go a lot deeper into the physics and chemistry of additive and subtractive mixing phenomena, but very little is gained by this excursion given our central concern with how to produce specific colouring effects. The tendency of many writers to superimpose scientific theory on the artist's concerns is at best distracting, but often has the more negative result of breeding unnecessary confusion. For the time being, all we need to remember is that additive mixing relates to light sources, and subtractive mixing – our major concern – is the process of mixing physical substances, pigments, paints and the like. More details of the subtractive mixing process will become apparent as we introduce and examine the principles that will constitute our improved framework.

OPTICAL MIXING

Introduction

When we mix paints of two different hues – say, blue and yellow – the material combines to produce a coloured mass that differs in hue from blue and yellow. In this case, depending on the precise members of the blue and yellow hue families we use, the product will be more or less green. There is another way, however, in which we encounter colour-mixing effects that does not rely on the physical integration of the materials from which the mixture is produced. In this chapter I will show how this **optical mixing** phenomenon is useful in demonstrating colour-mixing principles. This will include a brief look at how the phenomenon is exploited in commercial colour printing.

Optical Mixing

Consider the three checkerboards illustrated in Figure 18. In each case the checkerboards are constructed from squares of two hues. Viewed at close quarters the separate squares show up clearly – but there is a **viewing distance** at which we are no longer able to resolve the separate colours. They merge or fuse so that we see a hue that combines the chromatic properties of the individual components. This is 'optical mixing', or 'optical fusing', of colours.

To see these effects to their best advantage you'll need to take up a suitable viewing distance from the examples. This is between 2m (6ft) and 3m (10ft). At this distance it becomes difficult, even for people with excellent vision, to resolve the individual dots. The separate colours blend together to form a new intermediate colour. The optical mixing effect can often be exaggerated by adding a **viewing angle**. To add this angle, stand slightly to the side of the patches so that you are not looking at them head-on. I call the combination of viewing distance and viewing angle the **viewing position**.

By breaking the blocks of colour down and adding some white space to the optical mixture we get a paler result, with more thorough integration.

An optical illusion?

Some people might be inclined to regard optical mixing as a kind of cheap party trick, a way of fooling us to believe something that isn't true. We think we're looking at patches of green, orange and violet, but some observers might say, 'really, it *is* a trick, because we're looking at patches of totally different colours laid side by side'. This could be the trigger for another very long philosophical discussion (and this is not the last such opportunity we will encounter in the book). However, since the emphasis of the book is on practical matters, we will have to be content with a rather short response to this critical view of optical mixing.

FIGURE 18. **Optical mixing: the basic idea.**

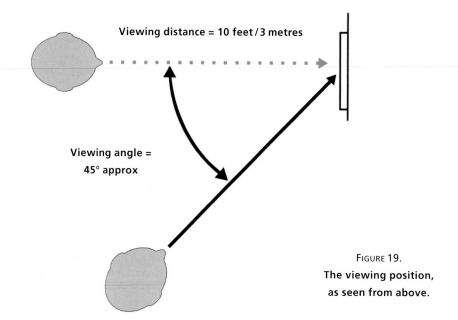

Viewing distance = 10 feet / 3 metres

Viewing angle = 45° approx

FIGURE 19.
The viewing position, as seen from above.

Recall that the perspective of the framework being developed here is that of our experience of colour as it presents itself to us. That is, I'm much less interested in the underlying physics, chemistry and biology as causes of the colours we see than I am *in what we actually see*. Accounts of the causes of colour phenomena convey nothing about the nature of the visual experience we have when those phenomena are presented to us. And the causal mechanisms invoked in these explanations reveal no fundamentally colourful constituents of reality. For example, the physicist has an explanation of colour in terms of electromagnetic vibrations, but these vibrations themselves are not coloured. The chemist has an account of the composition of coloured pigments, the molecular constituents of which are not coloured. The biologist may offer us an account of how the colours we see are coded by neural activity in our nervous system, but the individual neural firings and the networks they form collectively are not coloured.

All of these scientific perspectives might claim to tell us 'what we're *really* looking at' or 'what really happens' when we look at a coloured patch, but they are in a crucial sense powerless to convey what we *see*. Therefore for our present purposes these scientific explanations are beside the point. We see what we see regardless of what explanations we can offer as to how the experience of seeing is caused. So, you might be inclined to think that the phenomenon of optical mixing involves some kind of trickery; but this is no more a case of 'trickery' than finding out that the subatomic particles that compose an opaque red pigment are colourless. When viewed from a distance, variegated coloured patches mix in such a way as to obscure the separate coloured elements within them. That's no 'trick'; it's just the way our visual systems process the data with which they are presented.

Familiar Uses of Optical Mixing

Textile manufacture has long exploited optical mixing to produce colouring effects, by twisting and weaving strands of different coloured thread together. When seen from a distance, the resulting small flecks and dashes of the differently hued threads merge to give swathes of mixed, fused colour. Laying mosaic

FIGURE 20. **Optical mixing: with refinements.**

tiles of different hues side by side in a similar way to that outlined at the beginning of this chapter can produce optical mix effects. Additionally, optical mixing is one of three key factors contributing to one of the most common uses of colour, that is, in billboard advertising.

Billboards

Our perception of the pigments on billboards changes in relation to the distance at which we view them. Close up, these components can be seen separately, just as they can in the checkerboard examples above. At the distance from which they are designed to be seen, the separate blobs of colour merge to form colour mixes. We can regard this form of optical mixing as a kind of *subtractive* mixing, similar to the physical mixing of wet media such as paint and ink. This is because the resultant mixes depend on the absorption of light by the pigments used to print billboard posters.

A second factor involved with colour mixing in billboards is the use of a white ground on which coloured inks are printed. The amount of white left showing between the coloured dots controls to a great extent the richness or paleness of the resulting colours. This is further affected by a third factor, the fact that the inks used are semi-transparent, the layering of which also contributes to mixing. Of course, all these factors – the use of tiny colour fragments, the use of a white ground and semi-transparent pigments – are not limited to commercial printing and can be put to use in artworks of various kinds.

Electronic displays

A similar optical mixing effect contributes to (though does not provide a full explanation of) the working of colour television screens and computer monitors. Although different technologies may be used to realize the effect, the surfaces of the screens are composed of clusters of tiny cells that can be activated to emit red, blue or green light. When seen at a distance, the coloured light emitted by individual dots merges to produce colour mixes. By varying the proportion of their illumination, the dots can, at a suitable viewing distance, collectively display a wide range of colours beyond their individual native red, blue and green emissions.

Because the mixed colours produced by these dots arise from their combined light emissions, their combination is regarded as *additive* in contrast to the subtractive mixing of pigments. Combining colour subtractively produces mixes that are darker than their components; additive mixes are lighter than their components. Thus, whereas subtractive mixing on billboard posters (printing) and all manner of painting relies on a white ground

to generate tinting and desaturation effects, so additive mixing in electronic television and computer displays relies on black backgrounds to produce darkening and shading effects.

Optical mixing in fine art painting: pointillism and op art

The figure in the history of Western painting who is most frequently associated with optical fusion techniques is Georges Seurat. Seurat produced several well-known works constructed from dots and short strokes analogous to the marks required in our experiments. Other artists, notably those connected with the 'Op Art' movement in the 1960s, have exploited optical fusion to produce startling kinetic visual effects. More recently, David Mach has used the phenomenon to great effect in collage.

Try It Out

There are many exercises in the remainder of the book that involve optical mixing, but why not have a go now? Take a couple of different coloured pencils, pens, pastels, or paints – whatever materials you like – and make some patches similar to the checkerboard patterns shown in this chapter. Have a look at the results from the viewing position, and you should be able to see the optical mixing effect clearly.

Reproduction of Colour in Instruction Books

Colour printing is now a mature technology and there can be no doubt that the quality of colour reproduction is in many instances very impressive. However, despite many casual claims to the contrary, it is not possible to reproduce the full range of spectral hues and their tints and shades with the standard four-colour printing process. In this process the colour information in any image is divided into four separate components. Three of the components approximate the familiar primary colours of established subtractive theory, and match the secondary hues of additive theory. These hues are shown in Figures 21–23.

The inks used to reproduce these spectral components are semi-transparent, so when they are laid in thin layers an upper layer doesn't entirely obliterate a lower one, but produces a mixture according to the rules of subtractive mixing. For example, a thin layer of cyan transparent ink printed over yellow will result in an area of green. Heavy or successive light applications of

FIGURE 21. **Cyan: a member of the Blue family with a pronounced green bias.**

FIGURE 22. **Magenta: a member of the Red family with a violet bias.**

these inks can produce dense opaque layers. When all three are combined in equal hue strength proportion (which may not be equal volume of ink) the resulting hue is dark, but is not regarded as sufficiently near black to provide the sharpness and density of shadow for many reprographic purposes. Because of this (and other reasons) a fourth genuine black ink is used to overcome these limitations.

Crudely speaking, to reproduce a colour image using this process a separate plate – called, not surprisingly, a **separation** – is made for each of the colour components. That is, each plate is effectively a version of the image printed in one of the process colours. The printer then separately applies each of the inks in the proportions and areas specified in the four plates. When the four plates are printed, their combined effect is to reconstitute the original full-colour image.

The four-colour process is customarily referred to by the acronym **CMYK** (usually pronounced 'smike'), which is taken from letters in the hue names **C**yan, **M**agenta and **Y**ellow. There are two common explanations for the addition of **K**. According to some sources, 'K' is used to designate black; the last letter of 'black' is used rather than 'B' so as to avoid confusion with blue and brown. Other sources maintain that 'K' stands for 'key', since that is how printers refer to the black plate in the process.

For most purposes a satisfactory colour balance can usually achieved within an image created using CMYK. However, the **gamut** afforded by just three spectral hues, plus black, is restricted and a high level of accuracy of hue reproduction over

FIGURE 23. **Yellow: from the middle range of the Yellow family.**

a broad range of material is not possible. Compromises have to be made, and if you doubt that this is the case then try comparing several different reproductions of a single piece of artwork from a few books, posters, postcards and so on. If possible, make the comparison in front of the work in question. It is to be expected that the copies will not reproduce the original exactly, but in addition to this in most cases there will be striking differences between the copies. Not all of these discrepancies will be attributable to the limitations imposed by the gamut, but this certainly plays a major part in determining how well the hues of an original image are reproduced by CMYK. More accurate results are possible, but the processes involved are more complex, require additional transparent inks, with correspondingly more separation layers, and are thus considerably more expensive than CMYK.

Awareness of these limitations should make it clear that you shouldn't rely on any of the illustrations in this book – or any other book printed using CMYK – as absolutely accurate guides to the colour properties of the materials under discussion. Yet in spite of these limitations the general principles can still be illustrated clearly enough, since the differences between the hue variants that form the main focus of attention can be reproduced with sufficient accuracy. The reliability of the illustrations of the *results* of mixing hues is a different matter, however. In fact, some sceptics may suspect that I have exploited the reprographic process to support claims that aren't true. For example, I could have said that brown and blue make green, and could have supported this with an illustration in exactly the same way that I have done with my genuine claims throughout the book (*see* Figure 24).

Of course, I haven't done anything of the sort, but you can see how some people might imagine that the results presented here are supported by fakery. So I emphasize that you should neither accept the claims nor reject them without carrying out the experiments and exercises yourself.

One further consequence of the limitations of CMYK is that the accuracy of colour-mixing dictionaries for artists cannot be relied upon and this makes such dictionaries and charts of very questionable value. The good news is that if you get to grips with the colour-mixing theory developed in this book it is unlikely you will ever again need a colour dictionary or swatch chart for mixing purposes.

Gamut

For our purposes, 'gamut' will refer to the chromatic range that a specific palette of paints can reproduce. The term is commonly used in professional printing and electronic image rendering to indicate how well a system (say, a specific palette of four printing inks, or a particular design of computer monitor) reproduces our direct experience of colour. The concept of a gamut gives us a way of comparing the range of hues we can mix using one palette with the range available from another.

Summary

The focus of this book is on what we see rather than what we know to be the case. In mixing colours, we are more concerned with the effects we can produce rather than with the specific causes of those effects. Optical mixing provides a good illustration of this contrast between what we see and what we know. From a suitable viewing position we may *see*, for example, a green patch, even though we *know* that the green patch is composed of blue and yellow dots. From the viewing position we don't see blue and yellow; we see green. Optical mixing effects can be created with both additive and subtractive mixing materials, and these effects will be exploited in the demonstrations and exercises throughout the book.

Commercial printers exploit this phenomenon by using the CMYK process to produce a wide range ('gamut') of colours from cyan, magenta, yellow and black inks alone. It produces good general-purpose results. Contrary to claims often made for it, however, this system has a limited gamut and cannot be relied upon for accurate colour-matching results in all circumstances. So do not rely on any of the illustrations in this book as precise colour references that prove or disprove the validity of the principles I put forward. I encourage you to generate your own evidence, by doing the exercises and demonstrations for yourself.

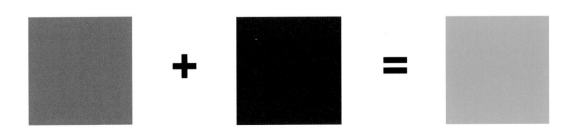

FIGURE 24. **A fake result.**

USING COLOURED PENCILS

Introduction

I am keen that you try out the exercises in this book for yourself – it is the only way for you to test what I say. There is a problem, however: I appreciate that not everyone will want to spend a lot on materials merely to carry out these tests. I urge you to resist the temptation to get around this in the most obvious way, which is to use very cheap paints. The impurities in poor-quality paints tend to give rise to a number of problems such as low covering power, lack of saturation and highly erratic physical handling characteristics.

These are general impediments to pigment mixing, and some people's difficulties with putting established colour theory into practice undoubtedly can be pinned on deficiencies of this sort. So how can the exercises be conducted without a big outlay on materials?

Using Coloured Pencils

Fortunately, the colour-mixing ideas presented here can be applied to any pigmented colouring medium – good quality oils, watercolours, acrylics, pastels and others. You can of course use your favourite medium to put the ideas into practice but to get us started in the simplest way possible, the demonstrations and exercises are carried out using coloured pencils. Although they are widely used by graphic artists and illustrators, coloured pencils tend to be neglected as a 'serious' artistic medium, possibly because of concerns about their long-term lightfastness. However, ranges of pencils that meet stringent standards in this respect are now available from some manufacturers and these may tempt more people to explore their potential. Even if you don't currently share my enthusiasm for this medium, I recommend that you try the exercises with them before moving on to the more popular media.

Why use pencils?

The fact that I like pencils and think they are underrated hardly adds up to a compelling case for their use in colour-mixing exercises. So here are some rather more compelling reasons for recommending them:

QUALITY OF PIGMENTS NOT CRITICAL

The beauty of using coloured pencils to demonstrate the principles of colour mixing is that they combine largely as a result of optical mixing. We can thus avoid most of the problems that would compromise the process if we were to use paints of indifferent quality. As long as the pencils we use make good colour marks, we can get satisfactory results without spending a fortune because the mixes depend less on actual physical interaction between the coloured materials than they do on the 'virtual' mixing that takes place in our visual system.

Fortunately for us, inexpensive coloured pencils can make adequate colour marks. However, like all other materials used for arts and crafts, coloured pencils vary enormously in quality so we will still need to choose our pencils with care. Although artists' quality pigments don't find their way into most ranges of pencil, the best brands have saturated, clear pigments sufficiently lightfast for demonstration purposes. They handle consistently from hue to hue, imparting their colour in a smooth, even way, capable of being layered into dense blocks. Cheaper alternatives, having an inferior pigment–vehicle ratio, tend to lack 'punch' and brilliance. Nevertheless many of these – often labelled 'student' grade – will be adequate. Beware of the really cheap end of the market where there are some pretty nasty specimens, the only truly colourful aspects of which are gaudy exteriors bearing little resemblance to their dull, feeble and crumbly contents. Having said that, there are some bargains to be had, so don't dismiss low-cost, humbly packaged pencils out of hand – some are surprisingly good.

MINIMAL ACCESSORIES REQUIRED

Apart from the pencils, you will only need a means of sharpening them, some white paper on which to make your marks and perhaps an eraser.

PAPER

Standard grade, white photocopier paper will be adequate for the exercises. However if your budget allows, I recommend you get a pad of 180 gsm^2 cartridge paper, which will provide a more pleasant and durable surface for your work.

SHARPENING

Use a good-quality sharpener or a knife to maintain a fine point on your pencils for all the exercises. This will help to ensure that the optical mixing effects are seen to their best advantage.

ERASING

You may want to keep an eraser handy to tidy up any minor slips. However, since the outlay on pencils and paper should be quite modest, if you make a mistake it may be best simply to start again.

PHYSICAL STABILITY

Standard coloured pencils have a further advantage over pastels and pastel pencils, in that their marks are moderately resistant to accidental smudging, so they don't need to be stabilized with fixative. This makes pencils more suitable for these exercises than pastels because the application of fixative to pastel may cause additional unpredicted hue changes in the work.

Do not confuse this permanency of the marks with the permanency of their colour. As indicated above, although there are some exceptions, most varieties of coloured pencils use pigments that are not as lightfast as artists' quality paints or pastels.

However, their lack of longevity in this respect won't compromise the assessment of the exercises and demonstrations.

CLEANLINESS

Pencils are about the cleanest physical materials there are for subtractive mixing colour work. As they are dry and the coloured material is relatively hard, there are no problems with spillage and there is very little chance of accidentally marking anything with them. No solvents are required for using dry media and so there is no mess to clear up afterwards. Other dry media – such as pastels or wax crayons – though better than wet media in these respects, are not as clean as pencils.

Summary

As far as the exercises in this book are concerned, don't worry if you don't have access to a large range of expensive artist-quality paints. The principles of subtractive colour mixing apply equally to all media, so the exercises can be carried out just as well using modestly priced coloured pencils.

Inexpensive coloured pencils are preferable to similarly rated paints because of the mixing techniques each medium most naturally invites. The weaknesses of cheap paint tend to be easily exposed when they are mixed because this is normally done by physically blending them. In physical combinations, the high proportions of binder and extenders that add bulk (but no colour) have a deadening effect on the mixed colours. Of course, it is possible to exploit optical mixing with wet media of indifferent quality by using pointillist painting techniques. But mixing is so much easier to do with coloured pencils as they mix naturally with techniques in which the optical mixing effect is prominent and physical mixing is minimal. Thus, as low-cost materials for demonstrating the principles, coloured pencils are preferable to cheap paints.

A PALETTE FOR THE EXERCISES

Introduction

As previously discussed, the names 'blue', 'green', 'yellow', 'orange', 'red' and 'violet' correspond to regions of the spectrum that are supposed to produce distinct colour experiences. There is some dispute about the sense in which this is true; for instance, there are no natural division points in the spectrum from one colour to its immediate neighbours – all the transitions are seamless. However, the six colour names are widely regarded as identifying recognizably different hue types and I have adopted them in the hope that they will be familiar to most readers. The six hue types or families will yield us twelve reference hues for our experiments.

A Bewildering Choice

Choosing materials for an art project can be a fun business, though established colour theory can make it a confusing experience. Here is one particular problem. You go into an art materials store to buy some pencils or paints. You are mindful of the schooling you have had in the Sufficiency Myth – that any colour at all can be mixed from just the three primaries, blue, yellow and red. If you happen to be in a reflective mood, maybe your first thought on being confronted with the extraordinary choices for each hue is to wonder why there are so many *different* blues, yellows and reds. Surely, if the Sufficiency Myth is true, then everyone would mix whatever they needed from a single blue, yellow and red, so there would be no need for such a vast array. Even allowing for the fact that colouring materials have properties other than hue – for example, their transparency – the choice seems a little excessive.

However, maybe you don't have this thought, and that wouldn't be too surprising since there is a more significant one that can easily overshadow it. As there is a huge range of blues, yellows and reds to choose from, which three should you buy? Does it matter, or will the Sufficiency Myth hold good for

any combination of blue, yellow and red? If it does matter which ones you choose, then on what basis should you make the choice? Many accounts of colour mixing based on the primary–secondary colour distinction fail to answer these questions satisfactorily.

Bias and Chromatic Proximity

In spite of the few game attempts that have been made to deliver a specification of three primary hues that fit the bill, you will be waiting a very long time for any such answers that work out in practice since the Sufficiency Myth is a falsehood. Some writers, having realized that this myth just doesn't deliver the results it promises, have sought to preserve the essence of the established theory by saying that two variants of each primary hue are required to mix all other hues. Although still rooted in the false distinction between primary and secondary hues, this is a significant advance in practical terms.

The idea is usually expressed in terms of **bias**. That is, individual members of a hue family can be thought of as being closer in hue to or 'biased' towards one or other of their neighbouring hue families. The concept of biasing is similar though not equivalent to the concept of **chromatic proximity** used throughout the book. I prefer this concept since it not only captures an important aspect of the relationship between one hue

Chromatic Proximity

The spectrum is laid out in a linear succession and so it should be easy enough to appreciate that some pairs of hues are close together whereas others are widely separated. This greater or lesser chromatic proximity is a key factor in determining the result of mixing hues, and it plays an important part in explaining the results of the exercises and demonstrations throughout the book.

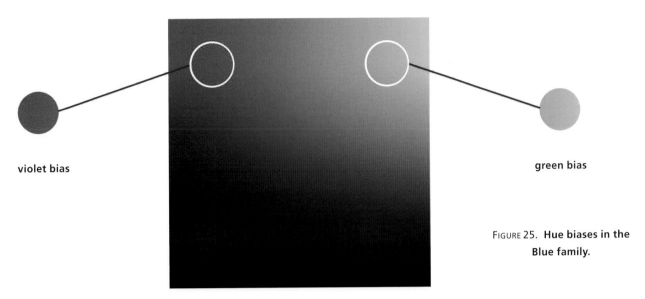

The Blue family

violet bias

green bias

FIGURE 25. **Hue biases in the Blue family.**

family and another, but also makes it easy to understand the relationships between different members of a single hue family.

We will be using two versions of each hue for our experiments. If you are familiar with the idea of colour biasing you may like to think of the members of each hue pair as biased away from each other. Consider the green region of the spectrum, for example: this has two immediate neighbours, the blue region on one side and the yellow region on the other. Our two green pencils will differ in regard to which of these neighbouring hues they are closest to in hue. To put it another way, we will be using two different members of the Green family. Repeating this requirement for each of the six basic hues means that we will need twelve pencils in total.

As you might suspect, the choice of hue members from each family is not a random affair. We need members of each hue family drawn from the boundaries, rather than from the middle, of their respective ranges. Fortunately, these hues have very obvious biases that, with a bit of practice, you should find increasingly easy to identify.

Introducing the Twelve Palette Hues

Except for the very few ranges that have been certified for lightfastness (one of these is included in the pigment listing in Appendix 2), coloured pencils tend to be identified by more or less fanciful names rather than by any useful standard pigment information. The use of names varies widely from one manufacturer to another and therefore these are an unreliable basis for comparison. In the listing below, the hues are described in terms of one or more familiar, colourful aspects of the natural world that should give you a general idea of the 'chromatic fingerprint' of each one. The listing also gives references to Faber-Castell Polychromos pencils, one of my favourite ranges.

I hope these references help you to select pencils of suitable hue from whichever range you prefer. I have omitted the Polychromos catalogue names because of two factors that could lead to confusion: first, the names are liable to change from time to time and second, other manufacturers use the same or similar names for pencils that are significantly different in hue. I do give some suggestions about choices from other specific ranges of colours in Appendix 2. If your stockist has the brands in question, you may find it helpful to save yourself a bit of time by adhering exactly to these palettes. However, it is not essential to do so. I have suggested these palettes because I used them in devising the exercises for this book and so you should be able to replicate my results very closely if you use them too. But other selections will work just as well in conveying the general thrust of the ideas as long as the hues share the characteristics of the family members outlined above.

The listing includes suggested pigments to represent each of the twelve hues. You may find this useful when you want to move from mixing with pencils to mixing with wet media. (There are more details on pigment choices in Appendix 1.)

Palette Hues

The twelve numbered hues 'Blue 1' to 'Violet 12' used in the exercises and demonstrations throughout the book.

FIGURE 26. **Blue 1: Polychromos no. 143 – Ultramarine Blue.**

FIGURE 28. **Green 3: Polychromos no. 161 – Pthalo Green (BS blue shade).**

FIGURE 27. **Blue 2: Polychromos no. 110 – Pthalo Blue (GS green shade).**

FIGURE 29. **Green 4: Polychromos no. 171 – Permanent Green Light.**

Numbering the hues

I will now introduce a simple numbering scheme that will help with identification of the hues. Since there are six hues and we are using two members of each family, there are twelve elements in this classification. Note that although we do need some such system, there isn't one that is naturally 'correct'. So this scheme – like any alternative scheme – is an arbitrary one; there is nothing special about numbering the colours in this particular way. It does serve however as a consistent and simple way of referring to the hues. I have also included (on the right-hand side) typical names given to paints of each of the hues.

1 AND 2: BLUE

As well as being a member of the Blue family, Number 1 is closer in hue to violet than it is to anything else. As it is commonly said, this is a blue *biased towards* violet. In its 'raw' state it might be called 'royal blue'; darker shades of this hue might be described as 'navy blue'. Number 2 has a bias toward green. Heavily tinted (diluted or mixed with white), it produces 'sky blue'.

3 AND 4: GREEN

'Sea green' might be used to describe Number 3 with its blue bias, though in its shades and desaturated forms it can also

FIGURE 30. **Yellow 5: Polychromos no. 105 – Hansa Yellow Light.**

FIGURE 32. **Orange 7: Polychromos no. 111 – Cadmium Orange.**

FIGURE 31. **Yellow 6: Polychromos no. 108 –
Cadmium Yellow Medium.**

FIGURE 33. **Orange 8: Polychromos no. 115 –
Transparent Pyrrole Orange.**

generate the kind of green seen in various sorts of vegetation. Number 4, biased towards yellow, is a more 'fruity' kind of green, the sort we see in limes (at full chromatic intensity) and white grapes (when pale).

5 AND 6: YELLOW

Think of primroses, lemons and sweetcorn in connection with the green-biased Number 5. When tinted, this yellow produces a straw-like variation of the hue. With Number 6 by contrast, think buttercups, or perhaps mustard; this is a deeper, more 'golden' yellow, biased towards orange.

7 AND 8: ORANGE

In comparison with other hues we detect far fewer discrete hue transitions from one side of the Yellow and Orange families to the other. So the range of difference between each of the palette hues in these cases is smaller than that seen in other hue families. One consequence of this is that some people are likely to judge that certain candidates for yellow-biased Number 7, the typical colour of concentrated orange juice, is in fact yellow rather than orange. Similarly, some pencils that might serve as the red-biased Number 8, reminiscent of pumpkin, might be judged by some people to be red, not orange. The only way to settle disputes of this sort is to compare orange candidates alongside agreed red and yellow references.

FIGURE 34. **Red 9: Polychromos no. 118 – Napthol Red Light.**

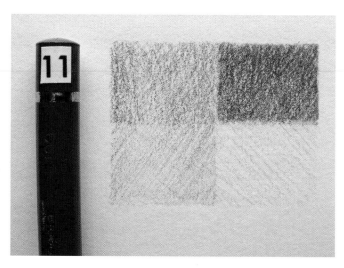

FIGURE 36. **Violet 11: Polychromos no. 125 – Quinacridone Magenta.**

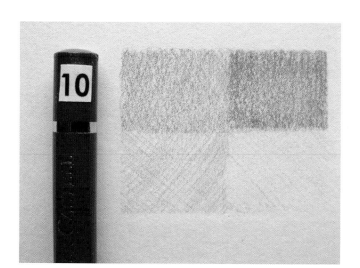

FIGURE 35. **Red 10: Polychromos no. 226 – Napthol Red Medium.**

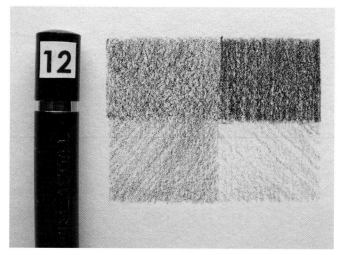

FIGURE 37. **Violet 12: Polychromos no. 249 – Dioxazine Violet.**

9 AND 10: RED

Number 9 is the colour of just ripe tomatoes, biased towards orange. Number 10 might be described as claret, burgundy, and the like; it has a violet bias. Its shades include deep ripe-cherry hues.

11 AND 12: VIOLET

A variety of names can be applied to the different members of the Violet family. 'Maroon' could be used to describe Number 11, since this name intimates its red bias. Alternative names for the blue-biased Number 12 might range from 'purple' to 'mauve'.

Choosing a New Set of Pencils

As far as I know, no manufacturer offers a pre-selected set of twelve pencils that meets our requirements, so you will almost certainly have to make up your own set. Use the classifications above as a guide and select your twelve pencils from one of the broad ranges available in any good art or graphic materials stockist. Don't rely on printed catalogues, the paint on the out-side of the pencil, or even on the apparent colour of the pencil 'lead' as a guide to its hue. Pencil lead compacted at the end of a pencil often has a different appearance to the same material applied in thin layers to paper, and the lead of unused 'factory-fresh' pencils from some manufacturers have a tendency to look

duller than they do in use. So inspection by eye alone won't be sufficient to make a satisfactory selection; you will have to try them out to make sure you get the hue family members you want.

Making up the numbers

If you already have some coloured pencils of reasonable quality to hand then you may find that you only need a couple of additions to make up your palette of twelve. Regardless of whether you are making up the numbers from your existing pencils or starting from scratch, there are a couple of considerations to bear in mind when you set off to the art store.

Which brand?

Different brands have different characteristics – in the way they handle, their hardness, covering power and so on – all of which may influence your choice of which pencils to use. The only way to find out what works best for you is to try out some of the alternatives for yourself. As with paints, it is possible to mix pencils of different brands. It may be the case, for example, that in order to get the best differentiation between the two members of the Orange family that Number 7 should come from one brand and Number 8 should come from another. However for the purposes of these exercises, you might find it easier to avoid this if possible. Consistency of application from colour to colour is an important aspect of the exercises and this is easier to achieve if all the pencils behave in more or less the same way. Although consistency within a brand is unlikely to be absolute, it tends to be greater than that between brands. If you mix brands, you will probably have to keep adjusting your 'touch' as you move from one pencil to the next, and this additional complication can be distracting.

What about water-soluble pencils?

Good results can be obtained with water-soluble pencils that meet the quality considerations outlined above. I suggest that you don't use them wet for the exercises in this section, however. If combined when wet these pencils behave like paints, so that they *physically* mix, and this would negate the advantages of conducting the demonstrations using optical mixing. For the time being, we want to observe the colour-mixing phenomenon without the complications that arise when handling wet media. The additional factors that need to be taken into account to do this successfully are discussed in Chapter 20.

FIGURE 38. **When wet, water-soluble pencils mix just like watercolour and other wet media. This nullifies the advantages of doing the experiments in a medium that allows the exploitation of optical mixing.**

Summary

In order to conduct a systematic investigation into colour mixing, we need a standard set of materials with which to carry out all exercises and demonstrations. The twelve palette hues have been introduced for this purpose. It is important to remember, however, that these are twelve hue *types*, each of which can be adequately represented by various different hues from various different manufacturers – so there is no need to have exactly the same Polychromos pencils used as a reference in the listing.

The next chapter is devoted to the techniques that will help you get the best out of the exercises and demonstrations. If you are already comfortable with the use of coloured pencils you will probably want to skim it, but I recommend that you don't omit it entirely.

COLOURED PENCIL APPLICATION TECHNIQUES

Introduction

After a fair bit of preliminary discussion we have selected our palette of pencils. At last, it's time to put pencil to paper and try a few things out. What is the best way to use pencils for the forthcoming exercises? If you are used to working with coloured pencils you may want to skim this short chapter quickly, as much of it will probably be familiar to you. If coloured pencils are a bit of a novelty for you then these notes will help you to get the best out of the exercises.

Coloured Pencils and Colour Printing

As explained in Chapter 4, optical mixing combines hues mostly by the juxtaposition of coloured marks rather than from their physical integration. On printed billboards, this phenomenon is used in conjunction with two other features, a white ground and transparent inks (plus opaque black) to produce a wide range of familiar effects. The same three considerations can be applied to the use of coloured pencils. Making marks close together on a white ground in a simple fashion presents no great difficulties. And although the material in coloured pencils doesn't have ink-like transparency, layering effects are still possible.

When we lay a pencil layer of one colour over a layer of

FIGURE 39. **Blue marks combine with the whiteness of the paper to produce a tinted hue at a distance.**

FIGURE 40. **Red and blue marks mix optically on white paper to make a magenta hue.**

FIGURE 41. **The previous two samples seen from a greater distance.**

another colour, the same two factors contribute to the overall mixing effect. First, unless a technique is used that prevents it from doing so, a second layer of pencil will colour some of the white areas left untouched by the first layer. Thus there will be marks of one hue juxtaposed with another, which gives us our optical mixing effect. Second, some parts of the second layer will lie on top of the existing pencil marks, and in line with the behaviour of secondary mixing phenomena the result will be a composite of the two hues. There are different techniques that we can use to accomplish this.

Stippling

By stippling (that is, laying short dots and dashes) in one colour in close proximity to similar marks in another colour we can produce an area of colour that fuses the two in the fashion shown in Figures 39–41.

Distance between marks

Obviously the greater the distance between the marks on the working surface, the more of the surface we leave exposed. Consider the difference between hatching, cross-hatching and layering.

HATCHING
The technique of hatching involves laying lines close to each other, more or less parallel. Varying the distance between the

lines varies the density and thus the apparent intensity of the colour.

CROSS-HATCHING
Areas of optically mixed colour can be produced by laying a series of lines in one colour at an offset angle to lines in another colour. The density of the colour can be built up by successive applications of lines, varying the angle of application in each case.

FIGURE 42. **A sample of blue hatching, with red and blue lines cross-hatched on top.**

FIGURE 43. **A layer of blue pencil made by densely packed hatching.**

LAYERING

It is possible to apply pale layers of colour on top of each other in something like the way that one would build up transparent washes of watercolour. The mechanics of the process in the case of coloured pencils is much like that of hatching or cross-hatching, though on a smaller scale.

In the case of layering, the lines are laid much close together than they are in standard hatching. Two key factors of the process are worth considering in detail.

Using the whiteness of the paper

In order to produce a similar range of effects using coloured pencils to those available in other media, we want to be able to dilute our colours to produce tints. One way of doing this would be to use a white-coloured pencil alongside the other colours in our palette. This would be the only way of getting white onto a coloured or tinted ground or support. However for work on a white surface it generally involves less effort to use the ground itself to produce these effects, as is the case with 'traditional' watercolour technique. The proportion of white that shows through the coloured marks determines the amount of dilution. This proportion can be controlled by varying first the distance between marks, and second, the pressure of application.

Obliterating the whiteness of the paper

Getting pencil marks into the valleys of the paper can reduce the white ground's contribution to the optical-mixing effect. One way of doing this is to put a hard fine-textured material underneath the paper. Then apply each layer with moderate pressure, moving the paper to a different spot on the textured base between layers. This tends to push out the hollows in the paper so that they can receive the pencil marks.

Pressure of application

White paper is the most widely used surface for working in coloured pencil and I will assume that you will be using it too. However with suitable adjustments to take account of non-white grounds, the following observations apply broadly to any surface on which pencils can be used. Pencils leave marks on paper because the surface is abrasive; the pencil lead is literally rubbed or scraped off the pencil and lodges in the paper fibres. Papers vary enormously in abrasiveness and the choice of paper is a determining factor regarding the range of effects that will be achievable with any given set of pencils. Hard pencils yield their colour less readily than soft ones.

FIGURE 44. **Clockwise, from bottom right: multiple layers of blue; plain paper; multiple layers of yellow; alternating layers of blue and yellow. The optical mixing effect is augmented by a partial 'glazing' of each successive layer on the one underneath.**

FIGURE 45. **The speckled effect is created by lightly stroking the pencils on rough paper.**

FIGURE 46. **This enlarged section of the picture above shows the marks have been made on the 'peaks' of the paper, leaving the 'valleys' untouched.**

Irrespective of pencil hardness and paper abrasiveness, the pressure with which the pencil is applied to the paper can control the density of colour on the surface. Very light pressure only deposits lead in the uppermost fibres of the paper so that a high proportion of white shows. Pressing a pencil hard on the working surface pushes the lead into its crevices, thus reducing the amount of white visible.

Colour dynamics

In music, the notion of *dynamic range* is used to refer to the spread of sound, from the quietest, barely audible solo sound, to the ear-splitting sonic shock of an ensemble at full tilt. A similar notion of dynamics has some use in regard to colour, to denote the visible range from the barely perceptible tint of a hue to its full eye-searing chromatic intensity. In translating this idea into coloured-pencil technique, it is not too difficult to get the hang of the 'loud' end of things, but the 'quiet' delicate wash is a little more tricky to achieve.

THE LIGHTEST TOUCH
The way to approach this is to let the weight of the pencil and gravity do most of the work. That is, as far as possible, push the pencil from side to side across the paper without applying any

FIGURE 47. **Gradation strip.**

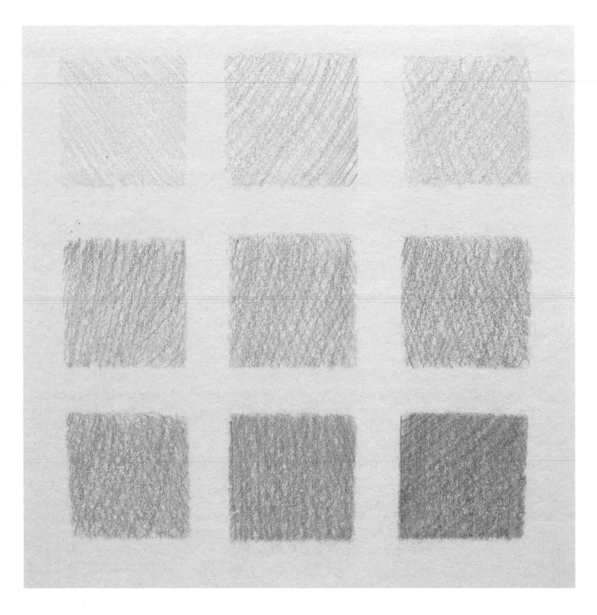

FIGURE 48.
**Building a mix by
alternating layers
of two hues.**

downward pressure at all. Depending on the materials involved and lighting conditions, an initial application of a wash like this may be almost invisible to the naked eye. To discover how such washes can be built up using successive layers to produce dense areas of colour, however, try making a few gradation strips using only the very lightest of strokes (*see* Figure 47 on page 45).

available surface to which subsequent layers may adhere properly. The sequence in Figure 48 shows the technique being used to produce a two-hue mix. Note that for this combination, the pencils are used in strict alternation. In some cases, the proportions of each component will not be equal, and you will need to follow single layers of one hue with two or three of another.

Making Patches for the Exercises

Most of the exercises in this book are best tackled by means of multiple cross-hatch layering. This technique, if used carefully, allows us to use optical mixing to great advantage. You need to apply each layer with no more than a moderate pressure. If you press hard then the fibres of the paper will flatten, reducing the

Summary

In some ways the techniques outlined here imitate the way commercial printing exploits optical mixing, in juxtaposing and overlaying coloured marks. You may wish to practise these methods before going on to the exercises.

CONSTRUCTING THE EQUI-SPACED COLOUR WHEEL

Introduction

For practical purposes, an understanding of the phenomenon of subtractive colour mixing can be derived from four simple principles. The source of these principles is the colour wheel, a modified way of presenting the spectrum. But what, exactly, is the colour wheel? How is it usually constructed? How accurate a guide to colour mixing is it? This chapter shows how the spectrum gives rise to the colour wheel and examines some important compromises that are typically made in presenting hue relationships in this way.

The Spectrum

Having berated other writers for their loose appeals to science I now have to go down that unappealing road too. My justification is that it allows me to expose faults in the standard colour wheel more easily than would otherwise be the case.

We see different colours by virtue of light – that is, electromagnetic radiation of different wavelengths – reflected from or emitted by the objects around us. The longest wavelength we can see appears to us as violet-blue, and the shortest wavelength

Standard Viewing Conditions

Standard viewing conditions are the controlled conditions under which an object can be viewed without interference from variables. The most important part of this specification for the purposes of this book is the quality of the light under which observations are made. Different sources of illumination introduce hue shifts that can affect colour judgements significantly. In scientific contexts, it is crucial to specify illuminant sources very precisely. For our purposes, it is sufficient to ensure that observations and comparisons are made in moderate-intensity daylight. Daylight simulation light bulbs can be used to boost ambient lighting on overcast days.

we can see is red. Imagine we had a light source whose wavelength we could vary. If we set this source to shine a violet-blue light on a white surface and gradually shortened the wavelength, we would see the colour of the surface change to blue, then green, yellow, orange and finally to red. This sequence of hue succession with decreasing wavelength is invariable and under standard viewing conditions it appears the same to all observers with normal colour vision.

FIGURE 49. **The linear spectrum.**

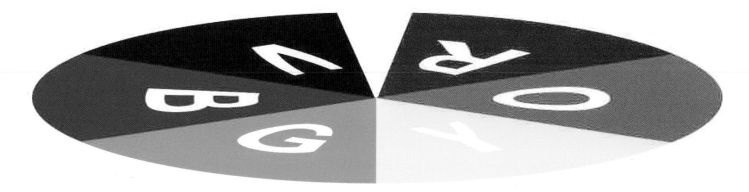

FIGURE 50. **The curved spectrum.**

The Colour Wheel

The spectrum can be used to demonstrate some interesting hue relationships diagrammatically. However we can make things easier for ourselves by bending it, as Newton did, into the more familiar form of the colour wheel. A spectral colour wheel is constructed by bending the ends of the spectrum diagram to face each other, transforming what you see in Figure 49 into what you see in Figure 50.

Note the gap. We cannot simply join the ends together because the colour wheel is intended to display the entire range of the hue families, but not all the hues we can see are represented in the spectrum. Suppose we set up a projector to shine long-wavelength light from the blue-violet end of the spectrum onto a black background. Then we set up a second projector to shine short wavelength light from the red-violet end of the spectrum so that it overlaps the light from the first projector. If the strength of illumination from the two lights is equal, we will see a hue that is a member of the Violet family, though people who are professionally concerned with additive mixing customarily call this hue *purple*.

Varying the proportions of the two lights produces a range of similar hues in a gradation from the blue-violet to the red-violet ends of the spectrum. Again, among those working in optics and illumination, collectively these hues are referred to as the *line of purple(s)* or the **Purple Line**. It is worth emphasizing that

FIGURE 51.
The result of mixing red and blue lights; this purple hue does not appear in the spectrum (it is non-spectral).

FIGURE 52. **The crude spectrum.**

FIGURE 53. **An improved spectrum.**

these purple hues do not appear in the spectrum. There is no single wavelength that corresponds to these hues; they are **non-spectral** and result from the combination of long-wavelength and short-wavelength light from the ends of the spectrum. These are the hues that are required to fill the gap when we construct a colour wheel.

So, we know that we have a gap to fill in our colour wheel, and we now also know the identity of the hue(s) required to fill that gap. There is an outstanding problem, however.

Inequalities

The spectrum is frequently depicted as shown in Figure 52. This is a crude representation of the hue sequence in the visible spectrum. It is crude on one count because it shows clear bands between successive sections of the spectrum, whereas there is in fact a smooth continuous succession of hue transitions from one end to the other.

However, there is a further inaccuracy in this simple diagram. Although it is correct in terms of the ordering of the hues from left to right, it portrays them as being equally distributed throughout the spectrum. In fact, the distribution is unequal. Recent published sources do not quote exactly similar figures down to the last decimal place, but they agree that the distribution is roughly in these proportions:

violet	blue	green	yellow	orange	red
8%	25%	25%	3%	22%	17%

According to these figures the sequence should look more like Figure 53.

This ordering and distribution of relationships of hues in the spectrum are at the heart of colour-mixing theory. However, although the ordering is respected by all colour theorists since Newton, very few acknowledge the strikingly unequal hue distribution. Typically theorists make the assumption that all spectral hues occupy equal-sized portions of the spectrum.

(Newton himself wasn't guilty of this, though the proportions of the spectrum he assigned to each hue differ from those quoted above.)

Mind the Gap

So if the spectral hues don't occupy equal space on the spectrum, they shouldn't occupy equal space on the colour wheel. We can allocate appropriate space to each hue over the spectral part of the colour wheel since we know the rough proportions of the hue distributions in the spectrum – although the purple line is composed of non-spectral hues so measurements of spectral hue distributions won't tell us how big a gap to leave between the ends of the spectral hues. We need to leave a gap to accommodate the non-spectral purples to complete the Violet family and thus close the wheel, but how big should that gap be?

We might consider taking an average of red and blue, but this would be an entirely arbitrary decision. We already know that the distribution of spectral hues is non-uniform, so the simple averaging of these hues will not necessarily produce the purple line in the correct proportion. (Having raised this problem, we are going to set it to one side for the time being. But we will see in Chapter 12 that this difficulty can be resolved by establishing the complements of the spectral hues.)

As far as the artists' community is concerned, the standard response to the gap problem is to ignore it. It just gets absorbed in the assumption that all hues occupy an equal proportion of the colour wheel. The traditional artists' wheel, therefore, is constructed usually in the following way:

The Spectral Colour Wheel

The relationship between the spectral hues can be shown in a variety of ways. Most people will be familiar with one or other version of the colour wheel, which is formed by effectively bending the two ends of the spectrum around to meet each other. A familiar sight from the pages of innumerable books on colour and colour mixing, the simplest form of colour wheel sets out the separately identifiable spectral hues in a kind of pie chart.

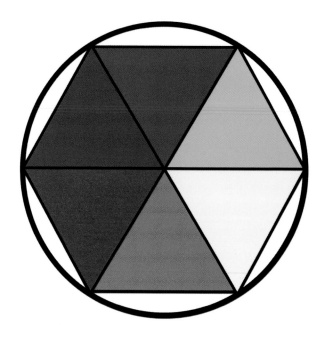

FIGURE 54. **The spectral colour wheel.**

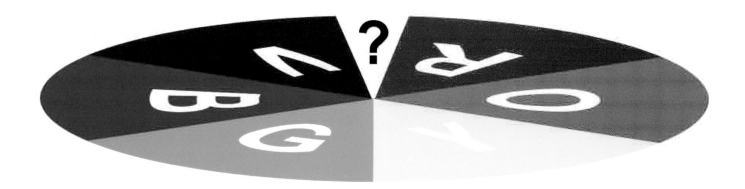

FIGURE 55. **The gap to be filled with non-spectral hues.**

FIGURE 56. **'Primary' and 'secondary' hue alternation throughout the spectrum.**

- respecting the ordering of the hues in the spectrum;
- assuming that the subtractive primary hues are red, blue and yellow;
- assuming that each primary hue and the secondary hues mixed from them will occupy equal space in any map or diagram of the spectrum;
- joining one end of the spectrum diagram to form a circle;

and voilà, we produce the spectral colour wheel, with the purple-line gap taken care of by mixing red and blue, which creates the Violet family.

It is very unlikely that you will even see the purple-line gap mentioned in other accounts of colour theory aimed at artists. However, ignoring the unequal distribution of hues in the spectrum is another factor that helps explain why results predicted by established colour theory fail in practice. Nonetheless such a simplification is not necessarily a bad thing and is justified if:

- it makes the explanation of basic principles more economical and easier to understand than would otherwise be the case;
- it merely results in omissions of detail and doesn't distort any crucial part of the basic principles;
- once the basic principles in question have been set out, the constraints imposed and caveats suppressed by the simplification are clearly identified; and
- adequate means of applying the principles without making the simplifying assumption are proposed.

Regrettably, in most cases, only the first of the above conditions is satisfied. I made the decision to work with the uniformity assumption in the early part of the book because it really does make the explanation of the principles easier. However, unlike other approaches to these issues, you will find that as the book proceeds all of the other conditions are satisfied too.

What Established Theory Gets Right

I want to persuade you to reject colour-mixing ideas based on the primary–secondary colour distinction, although the traditional claims about colour mixing have held sway over general opinion for a long time. And they are not merely regarded as ideas that are correct. They have attained the status of axioms; that is to say, if we throw out the Myths it looks as if we have to throw out all we thought we knew about mixing colours. How could these false ideas become so well entrenched? When false ideas achieve this degree of acceptance it is often because they are wrapped up with some demonstrable truth. So, we should see if it is possible to sort the wheat from the chaff and isolate whatever truth the established theory has to offer.

How established theory exploits the colour wheel

What is correct in the traditional colour-mixing story that manages to persuade so many people to accept the false primary–secondary colour distinction? Looking along the spectrum, we see that the 'primary' and 'secondary' hues alternate (*see* Figure 56).

So, starting at blue ('primary'), we then get green ('secondary'), yellow ('primary'), orange ('secondary'), red ('primary') and violet ('secondary'). Now, we are told that every secondary hue is a mixture of two primary hues, but what is less often mentioned is that the primaries required to mix a given secondary hue are the primaries that flank it. For example, to mix green, we use its immediate neighbours blue and yellow (*see* Figure 57). If we mix blue and red, the two primary hues at the ends of the spectrum, the result is violet, our third 'secondary' hue.

Thus, on the colour wheel, every secondary hue has two primary neighbours. You will recall that traditional theory gives us familiar recipes for mixing secondary hues from primary ones:

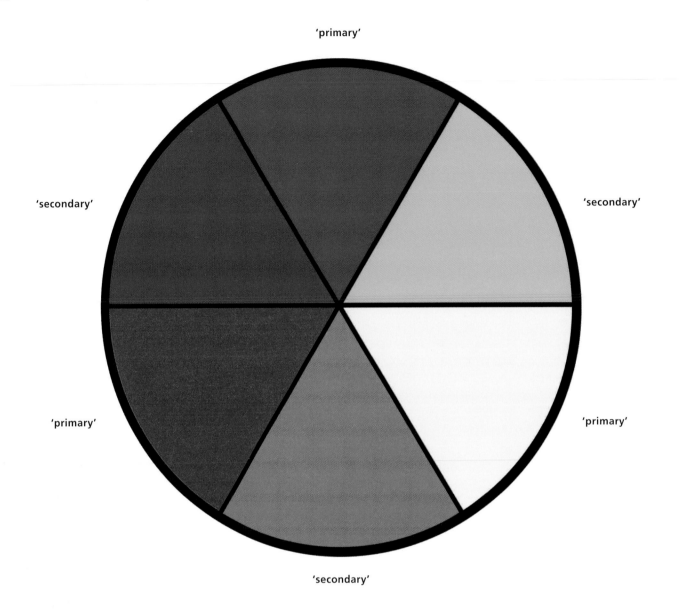

FIGURE 57. **'Primary' and 'secondary' hue alternation around the colour wheel.**

FIGURE 58. **Colour wheel predictions for 'primary' hue combinations.**

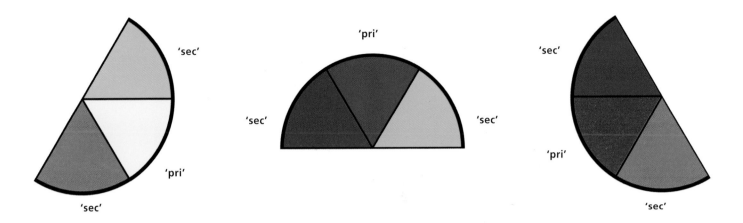

FIGURE 59. **Colour wheel predictions for 'secondary' hue combinations.**

blue and yellow make green, yellow and red make orange, red and blue make violet. And these recipes correspond to the primary–secondary alternations around the circle. So each secondary hue can be produced by mixing its two immediate neighbours. Most people are familiar with this claim, but let's verify it (*see* Figure 58).

No surprises there, I hope. But if each secondary hue in the colour circle has two primary neighbours then this implies that each primary hue in the circle has two immediate secondary neighbours. this is certainly true: blue is flanked by violet and green; either side of yellow we see green and orange; red is sandwiched between orange and violet. This in itself is not particularly exciting. However, consider for a moment the mixing principle we have just used. That principle says that each secondary hue can be produced by mixing its immediate primary hue neighbours. Now, suppose for the sake of argument we ignore the primary–secondary distinction, and construct a more general mixing principle. This principle says simply that each hue can be produced by mixing its immediate neighbours. It leaves unchanged what we have verified above with regard to blue, yellow and red. But it tells us in addition that orange and violet will mix to produce red, violet and green will produce blue, and green and orange will give us yellow:

According to the orthodox view these outcomes are impossible. One reason why blue, yellow and red are regarded as 'primary' colours is because, it is claimed, they cannot be mixed. Most people just accept this claim at face value; for a long time I certainly did. However, if we put this claim to the test we can show it to be false.

Tertiary Hues

There is a question worth asking about the way colour mixing is generally approached in other books: if the primary hues cannot be produced by mixing, what do these authors suppose happens when we mix two secondaries? Although many writers claim that mixing secondaries with primaries produces **tertiary** hues, you are likely to search in vain for any indication of what to expect if you mix secondaries together.

Clearly, we can mix a green paint with an orange one, so why does virtually no one mention what happens when we do? (One of the few exceptions is Harald Kueppers, in tabulating the relationships between his version of the 'primary' and 'basic' colours.[v]) This blind spot is all the more remarkable given the recognition given to 'tertiary' hues. There are no obviously satisfactory explanations for this extraordinary omission. Maybe the primary–secondary distinction and the two Myths encourage the belief that secondary hues are so inferior that mixing two together produces no worthwhile result. Whatever the explanation, we will see that mixing secondaries produces results that undermine the Irreducibility Myth. Since this allows us to take more control of the palette, this is in fact a *very* worthwhile process.

More Non-Spectral Hues on the Colour Wheel

The colour wheel we have constructed so far includes the spectral hues, each of which we regard as belonging to one of the six hue families (Violet, Blue, Green, Yellow, Orange and Red).

FIGURE 60. **The Blue family and its shades.**

We have also accommodated non-spectral purples; some assigned to the Red family, most to the Violet family. However there are many other non-spectral hues within each family that for subtractive mixing purposes we need to include on the colour wheel also. Each hue family has highly saturated, vibrant members but also darker, murkier members too; these are the family's shades. If we take a section of the spectrum – say, the part where the Blue family is located – we could represent the hues and shades in the family as shown in Figure 60.

As part of the colour wheel, the square becomes a pie-shaped segment, as shown in Figure 61.

Put together with all the other hue family segments, the colour wheel we will be using to demonstrate the basic principles of colour mixing looks like Figure 62.

Because it takes no account of the differences in hue distribution throughout the spectrum and assigns equal space to each hue family, I call this the **equi-spaced colour wheel**.

As well as shades, there are also paler, whitened tints in each hue family. Although it is possible to depict all the tints and shades on the same two-dimensional diagram, this is not very helpful for the purposes of demonstrating colour-mixing principles. Fortunately, it will become apparent that the principles can be demonstrated adequately by reference to shades alone. Of course, a comprehensive account of mixing practice still needs to incorporate tints and we will see how to do this in Chapter 18.

The Colour Wheel Arranged for Our Exercises

The reference for all our exercises is the twelve-piece palette we have selected from the extremities of the six hue families arranged in the familiar colour-wheel fashion (see Figure 63). The numbers on the perimeter correspond to the twelve hues, two from each family, as described in Chapter 6. Each of the first series of exercises will use one or more sections of this wheel to illustrate the simple principles involved in subtractive mixing.

FIGURE 61. **The Blue family and its shades as a segment of the colour wheel.**

FIGURE 62. **The equi-spaced colour wheel.**

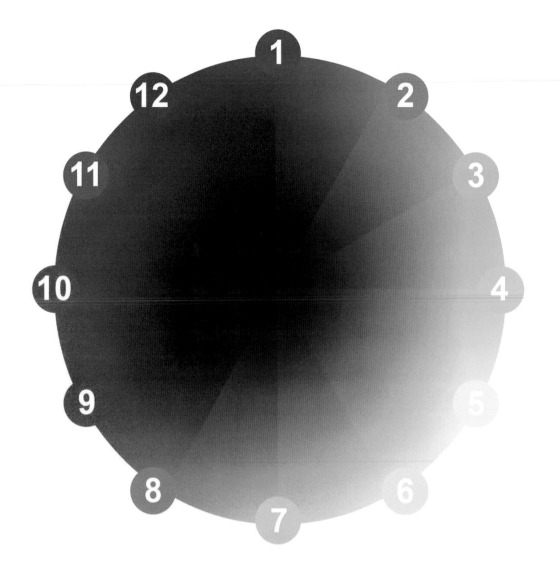

FIGURE 63. **The equi-spaced colour wheel showing the position of the twelve palette hues.**

Summary

The colour wheel is a transformation (in fact, a distortion) of the linear representation of the spectrum. The circular layout provides a convenient way of depicting various relationships between hues. The layout of the wheel lends some support to certain aspects of established colour theory. Typically, however, significant inaccuracies are introduced into the construction of the wheel. We have identified two such distortions. First, the equal spacing of the hues around the wheel does not reflect the distribution of hues in the spectrum. Second, the non-spectral purple range of hues is arbitrarily assigned a share of the wheel. We will see that most of the basic principles of colour mixing can be explained with the equi-spaced wheel even though it has these inaccuracies. However, they have to be corrected in order to construct a wheel that can serve as a genuinely useful guide to colour-mixing practice. We will examine how to make the necessary improvements in Chapter 12.

PRINCIPLE 1: IN-BETWEENING

Introduction

Consider two points, *A* and *B*, close to each other on the circumference of the colour wheel (Figure 64). We could measure two distances around the wheel from *A* to *B*. Starting at *A*, we can trace the wheel a short distance clockwise to *B* to get one measurement (Figure 65) and then from *A* to *B* going counterclockwise to get the second, longer measurement (Figure 66).

Unless *A* and *B* are directly opposite each other across the wheel (a case considered in Chapter 12), one of these measurements will be shorter than the other. In all other cases we can say that when *A* and *B* are two hues, the result of mixing them

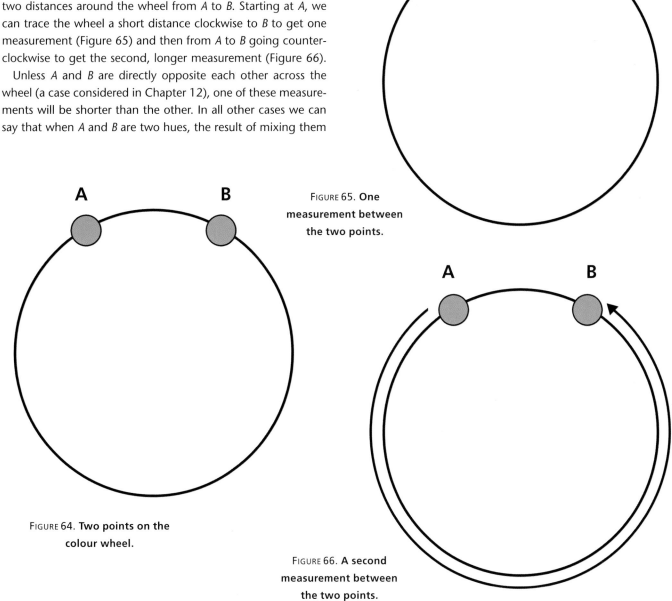

FIGURE 65. **One measurement between the two points.**

FIGURE 64. **Two points on the colour wheel.**

FIGURE 66. **A second measurement between the two points.**

will lie somewhere in the region marked out by the shortest distance between them on the colour wheel. This is what I mean by 'in-betweening'.

Exercise 1: Mixing within Families

In this first exercise we will see how in-betweening works by mixing the two members of each of the six hue families and evaluating the results. So we will be mixing Blue 1 and 2 together, Green 3 with Green 4, and so on.

Blue 1 and 2

First prepare a faint pencil-ruled grid of 2.5cm (1in) squares on your paper. Using the cross-hatching technique, lay a rectangular patch of Blue 1 in one of the boxes on the grid, leaving a little space below for labelling. Apply four to five layers with a light pressure. Then, leaving a blank box in the middle, lay a similar patch of Blue 2 to the right of the first patch. You will then have an arrangement similar to that illustrated in Figure 67 (minus the question mark).

In the blank box between these two patches we will lay a

Blue 1 **Blue 2**

FIGURE 67.

third, a mix of Blue 1 and Blue 2. But before you go on to do this, pause for a moment and think about the likely result. If we mix two members of the Blue family which hue should we expect to produce? (Orange, perhaps? No? Why not?)

With your prediction in mind, pick up your materials again and let us find out what happens with the mixed patch. To do this start with a layer of Blue 1, then a cross-hatched layer of Blue 2, another cross-hatched layer of Blue 1 and finish with a layer of Blue 2, again cross-hatched in a different direction. Now adopt the previously specified viewing position in relation to the patches. Recall that this should be between 2m (6ft) and 3m (10ft) and slightly off-centre so that optical mixing can make its full contribution to the total effect. (If you are using a wet medi-

um rather than coloured pencils then don't worry about the viewing angle. However, you should still assess all your results from the viewing distance – *see* page 30.)

There we have it: there is no doubt that that is blue. I'm pretty confident that most people will have predicted just that result. But it's hardly a surprising outcome, is it? If you mix blue with blue there aren't that many reasonable alternative results to choose from.

Now make whatever minor adjustments are required – maybe a little more Blue 1, perhaps a touch more Blue 2 – to ensure that in terms of its placement in the spectrum or on the colour wheel the hue of the mixed patch is equidistant between Blue 1 and Blue 2. Another way of putting this would be say that we are aiming at a result that exhibits no bias towards either of the hues we started out with. Again, view the patches from a distance and at a slight angle to allow the full effect of optical mixing to do its work.

Blue 1 **Blue 2**

FIGURE 68.

The centre patch is definitely a member of the Blue family, bearing a family resemblance to both Blue 1 and Blue 2, but it is sufficiently different from them both to be regarded as a distinct hue in its own right. We have brought about a **hue shift**. Thus, in-betweening may alternatively be thought of as 'the hue shift principle'.

Wait a moment! We *mixed* two hues together to produce a third different hue, and that mixed hue is member of the Blue family. And yet the Irreducibility Myth says 'blue', being a primary hue, cannot be mixed.

Hue Shift

When two or more different hues are mixed together, yet another hue results. I think of this in terms of the position of the hues on the colour wheel. If we mark the positions of the hues we start with on the wheel, we invariably find that the mixing process shifts the resulting hue to a point between them. Gaining control of the colour mixing process is thus a matter of being able to predict hue shift accurately.

If we take a hard-line interpretation of this result, it looks like it could be time to abandon the Irreducibility Myth, at least in the summary form in which it is usually presented. It alleges that none of the 'primary' hues can be mixed, and blue is one of these. We've just mixed blue, so the Myth is false. However, some people might think this is a bit harsh. They might *say* 'Ok, so what the advocates of the Irreducibility Myth typically say is that no 'primary' hues can be mixed, but it's not exactly what they *mean*. What they mean is that no primary hue can be mixed using any *other* hues.' Since I don't want to be accused of claiming an easy victory with a cheap trick, I am fully prepared to give the Irreducibility Myth a sporting chance. But I should point out that the fact that mixing two members of a hue family produces a third member of that family is by no means a trivial finding. As will become clear, it is an inevitable and important aspect of the process of colour mixing as a whole.

There is another interpretation of the Irreducibility Myth that might be invoked at this point. This is the idea that there are special hues within the Blue, Yellow and Red families, 'primary blue', 'primary yellow' and 'primary red', and it is *these* hues that defy any attempt to mix them. Ultimately, we will find that there are hues that cannot be mixed subtractively, but this limitation has nothing whatsoever to do with the primary–secondary hue distinction. I will have more to say about this in Chapter 12. Until then, I simply invite you to start thinking about the sort of reasoning that might make sense of this defence of the Irreducibility Myth: the idea that, among all the members of the Blue family, there is one special member that cannot be reproduced even though the others can be. See what you come up with.

FIGURE 69.

FIGURE 70.

FIGURE 71.

FIGURE 72.

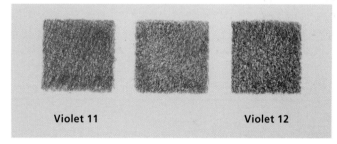

FIGURE 73.

To complete this exercise, carry out the foregoing procedure with each of the remaining hue families (Green 3 and 4; Yellow 5 and 6; Orange 7 and 8; Red 9 and 10; and Violet 11 and 12).

Reviewing the Results

There are two things I want to bring out explicitly about the mixes we have made in this exercise. First, our palette hues were selected, remember, from the extremities of the spectral regions they represent (*see*, for example, Figure 74). Note that the mix does not lie outside the range enclosed by these hues, but within it (Figure 75).

Second, note that the subtractive colour-mixing process imposes a penalty on the saturation of the mix in comparison with Blue 1 and Blue 2. When we mix pigments, whether

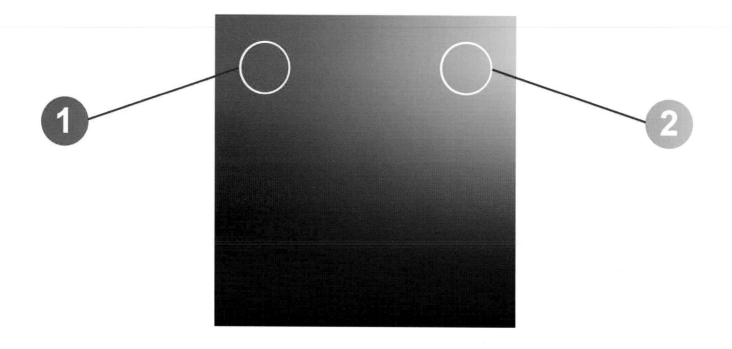

FIGURE 74. **Location of Blue 1 and Blue 2 within the Blue family.**

mechanically (as we do with wet media) or optically (as we are doing with pencils), the result is always greyer and darker than the purest, most saturated of the components being mixed. In the exercises in this chapter, you may find the darkening effect of mixing your Blue 1 with your Blue 2 is barely perceptible; this will depend on exactly which materials you have in your palette. (Remember that, for example, one manufacturer's pthalo blue may differ perceptibly from another's.) Bear in mind, however, that even if you can't see much in the way of darkening in the blue mix, this effect will definitely be more prominent in many of our subsequent demonstrations. Before you move onto them, you may like to ponder a point relevant to the results of all the exercises in the following 'Interlude'.

FIGURE 75.
Position of the Blue 1 – Blue 2 mix on the colour wheel.

DO WE ALL SEE THE SAME COLOURS?

The development of colour-mixing theory and the thought that it can help colour-mixing practice lean heavily on the supposition that our colour experiences are broadly the same. Rival views to this assumption involve one or another form of relativism. Questions about relativism arise in all manner of contexts, but here it implies that one or another aspect of our experience of colour is not the same for all people, at all times, in all communities. For example, it might be suggested that a person's colour experience is dependent on the culture in which she or he is raised.

In whichever sphere it may arise, people tend to be suspicious of relativism. Certainly, there doesn't appear to be much going for the thought that *all* aspects of our experience of colour are malleable and relative. Nonetheless there is a lot of plausibility in the thought that, in spite of each of us having the same sort of visual apparatus, visual experiences may still differ appreciably from one person to another. If we are willing to entertain this possibility, it should occur to us that there is a lot of cultural input that may contribute to our colour experiences.

It would be remarkable if we were unable to find any common, universal aspect of our experience of colour. We can surely count on a great degree of similarity in our visual sensations due to our common neurobiology – but to what extent is this 'hard-wiring' modified by cultural influences?

We also need to separate out the raw phenomenological features of colour – the individual blocks, splashes and streaks of colour that we see – from our evaluations of them (our judgements that this surface colour is the same as that, and they are both different from this third one, and so on). That is, there may be a case for saying that human colour phenomenology is uniform – in the obvious and rather uninteresting sense that we are all presented with the same visual stimuli. But the importance that we assign to different aspects of those stimuli may vary from culture to culture and from person to person. In some cultures, people may simply not care enough about hue differentiation to bother to analyse and classify their experience of colour in the ways familiar in Western societies. The passage from our undeniably common neurobiology to *expressions* of our experience of colour is not seamless; rather, it is mediated by the cultural filters of language, ritual and history.

The Western preoccupation with hue identification and classification overshadows other components of the experience of colour that feature more prominently in many cultures, both ancient and current. Qualities such as texture and shininess have often assumed much greater importance than hue in responses to the surface appearance of things. However, when peoples of non-Western cultures have good reason for making fine hue distinctions (between cattle or horses when these animals are key components in the local economy, for instance) they make them easily, often with a sensitivity to subtleties that would pass most Westerners by.

So, do we see the same colours or not? We should say, I think, that when each of us is exposed to the same visual stimulus, the joint contributions of our shared neurobiology and our specific cultural conditioning produce experiences of colour that cannot be presumed to be universal. We notice different things about the data we are presented with and so the same physical phenomenon is interpreted more or less differently by each of us – and differences in culture can have a huge bearing on these interpretations.

Thus we should be wary of being misled by the possibility of equivocation on the word 'see' in the question 'do we see the same colours?' If we just think about the stimulus of light of a specific wavelength impinging on the visual system, then by and large we do 'see' much the same colours under any given set of circumstances. However, if we think about how we situate a given chromatic sensation in our experience as a whole, it is clear that we need to take account of the judgemental and interpretative faculties that inevitably come into play. I say 'inevitably' because no one is able to simply and passively 'see' raw visual data, unconditioned and unmediated by any categories of experience. As cultures differ, so the contributions they make to the way individuals order and structure their experiences differ also. Because this leads to variations in how judgement and interpretation are carried out from person to person, we should not be surprised that there can be significant

variations in the colour experiences of different individuals. In this active sense of 'seeing', we frequently do see things, including colours, differently.

The extent to which these differences matter at the level of entire communities is from a practical point of view determined, as ever, by our purposes, by the goals we are aiming at. Some frameworks are better than others for certain purposes and inferior for other ends. There is no framework for colour classification and identification, however, that is intrinsically superior to all others. At a cultural level, each framework develops in ways that are relevant to supporting the community in which it emerges.

However, we should be wary of running away with the idea that these differences allow us to say anything we like about colour 'because it's all culturally relative'. For people within a community who share the same cultural influences, there are clearly criteria of correct judgement concerning colour. Such criteria depend on there being prospects of agreement in colour judgements – and this means those people do see the same colours.

PRINCIPLE 2: DARKENING

Introduction

As we have already discussed, the result of a mix is always darker than the most saturated of the individual hues being mixed. The further apart on the colour wheel the mixed hues, the more pronounced the darkening effect. Consequently, in order to mix a given target hue, at least one of the materials (pigment or paint) must be more saturated than the target.

Exercise 2: Mixing Adjacent Families

For our second exercise, we want to explore the effects of mixing members of neighbouring hue families. We will start with the Blue and Green families.

Blue 2 and Green 3

As before, lay out a patch of each of the hues Blue 2 and Green 3, with enough space between them to add a mixed patch. Before you go ahead with the mix, think about the factors that determined the results of the previous exercise and then make a prediction as to what the result will be this time. When you have made a brief note of your prediction, go ahead with the mixed patch.

Blue 2 **Green 3**

FIGURE 76.

Remember to assess the result from the viewing position. I suspect there will be no real surprises: you will probably find you have something that can accurately be described as bluey-green or greeny-blue. However, depending on the pigments in your selected representations of hues Blue 2 and Green 3, your particular patch may deserve a more specific description such as 'turquoise', 'cyan' or 'teal'. As with the previous exercise, try to make whatever minor adjustments are required to eliminate any green or blue bias from the mixed patch; its hue should be made to lie exactly midway between the other two.

The saturation and clarity of this mixed patch will be similar to that of Blue 2 and Green 3. That is, the product of these two

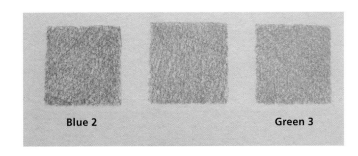

Blue 2 **Green 3**

FIGURE 77.

will exhibit only minor darkening. We should expect the darkening to be slight even though they are from different families. Blue 2 and Green 3 are close together on the spectrum and, depending on the particular examples of these hues in your palette, you may find that they are closer together than your examples of Blue 1 and Blue 2.

Insofar as there is darkening in this case, it will be mostly due to any differences in the relative saturation and clarity of Blue 2 and Green 3. However, as we increase the chromatic separation between hues, the darkening phenomenon becomes more apparent in the mixes.

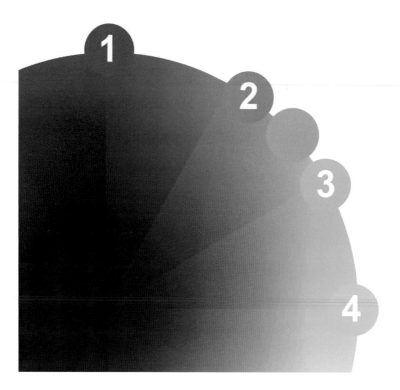

FIGURE 78. **The chromatic proximity of Blue 2 and Green 3, with the mix shown in between.**

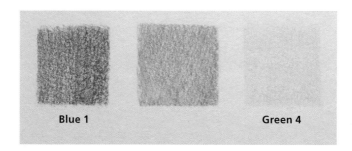

Blue 1 **Green 4**

FIGURE 79.

Blue 1 and Green 4

This time we are going to assess the outcome of mixing the two palette hues from the Blue and Green families that are furthest apart on the spectrum. Don't rush for the pencils yet; first, it's prediction time. What will the result be in terms of hue? And how saturated will the result be relative to Blue 1 and Green 4? What explanation can you give for your conclusions? Once you have settled on some answers to these questions and made a note of them, proceed as before and lay out patches of Blue 1 and Green 4 with a gap in between for the mixed patch. Then complete the exercise with the mixed patch, which should be adjusted as necessary to show no bias to either the Blue family or the Green family (Figure 79) and consider the result from the viewing position.

The fact that there are two factors at work here – hue shift *and* darkening – should be much more apparent than it has been in any of the examples we have tackled so far. In terms of hue the mid-point between Blue 1 and Green 4 is, unsurprisingly, bluey-green. However the relative darkening and 'murkiness' of this bluey-green mix in comparison with the previous one should be readily apparent. The reason for this pronounced darkening is the spectral distance between Blue 1 and Green 4. This is a much greater distance than that involved in the earlier exercises.

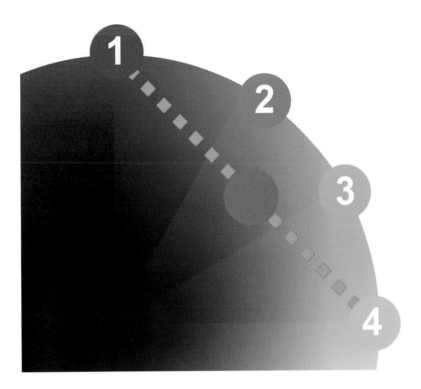

FIGURE 80. **Blue 1 and Green 4 mix on the colour wheel.**

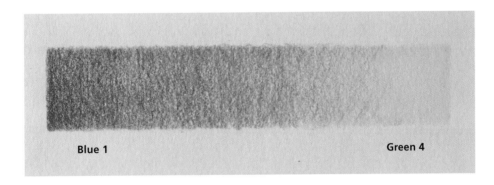

Blue 1

Green 4

FIGURE 81. **Gradation strip**

Gradations Using Two Hues

So far we have specified that the mixes should have each component hue in equal proportion. It should be apparent, however, that when we mix two hues in different proportions we can get a range of gradated hues. Try it with Blue 1 and Green 4 (*see* Figure 81).

We can do the same with Blue 2 and Green 3, but this time the range of different hues we can make is reduced in comparison to the Blue 1 to Green 4 gradation. And it is easy to explain why this is so. The chromatic distance between Blue 1 and Green 4 is much greater than that between Blue 2 and

Green 3, so there is potentially more of the colour wheel to be represented by mixing the first of these pairs than there is by mixing the second.

Note also the extent of the darkening in the Blue 1–Green 4 gradation example in comparison with what we get in the Blue 2–Green 3 example. What will happen when we mix the other two possible combinations of Blue and Green family members? Make a short note of what you expect to see when Blue 2 and Green 4 are mixed, and when Blue 1 and Green 3 are mixed. Then proceed as before and assess the results from the viewing position.

Blue 2 and Green 4; Blue 1 and Green 3

I expect you will have correctly predicted that these results would be rather similar to each other (Figures 82 and 83). Depending, once again, on the pigments in your representatives of the Blue and Green families, it may be possible to adjust the patches in these two exercises to appear almost exactly similar when seen from the viewing position. You will see comparable results if you repeat these exercises for each of the four other adjacent hue family pairs on the spectrum: Green–Yellow; Yellow–Orange; Orange–Red; and Red–Violet. Try at least a couple of these to confirm the combined effects of in-betweening and the darkening principle.

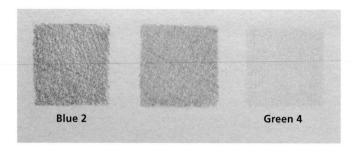

FIGURE 82.

Review

A simple pattern is starting to emerge. Mix any two hues, *A* and *B*, in equal proportion and the result will lie in between the boundaries marked by *A* and *B* on the colour wheel. Also the saturation of this result (in comparison to *A* or to *B*, whichever is the most saturated) is reduced as the distance between *A* and *B* on the wheel increases; this is our darkening principle. The exercises in this chapter show clearly that, as the spectral separation of *A* and *B* increases, we obtain increasingly darker results. The darkening principle implies that to mix a specified target hue then either *A* or *B*, or both, must be more saturated (or pure) than the target.

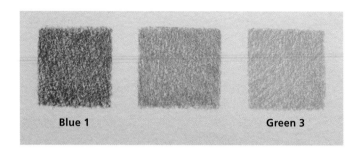

FIGURE 83.

We have two other principles to look at, but first you may like to reflect briefly on the problems we sometimes have in assigning names to colours, in another Interlude.

ASSIGNING NAMES TO HUES

Apart from recognition of the six spectral hues as red, orange, yellow, green, blue and violet, there is no single precise and commonly agreed naming convention for hues. There are commonly used modifiers, such as 'light', 'dark', 'bright', 'pastel' and so on. However, the effect that hues have on us is a subjective business, and consequently so is our classification of them. Our judgement about these matters is affected by such psychological considerations as our mood and expectations, as well as by external factors like context and ambient lighting conditions. Since all these things can affect each of us differently and in varying amounts on any given occasion, we do not always agree in our identification of hues.

Even if we take stringent measures to hold all these variable factors constant, we will still disagree about colour identification in some cases. This is to be expected, because hue gradations around the colour wheel or any other coloured surface are seamless, smooth progressions with no rigidly marked boundaries. Whereas, for example, some hues fall unambiguously into the red region, others inevitably lie at the interface between red and orange. In such cases some people might classify a particular instance of such a hue as red, others will reckon it to be orange. Some people will appeal to a hybrid term, such as 'orangey-red', and some might withhold judgement: 'well, I really couldn't say for sure – it's sort of red, but also sort of orange too'. Also, these borderline judgements are very likely to change in the face of minor variations in the factors mentioned above. For example, a marginal change in the level of illumination can shift a judgement that a borderline colour specimen is red to the judgement that it is orange.

There is a further consideration here, and it is a pretty important one. So far, we have noted the difficulty in classifying hues in regions of the colour wheel where one spectral hue gives way to another, and we have assumed that identifying shades in the middle of each spectral hue region is unproblematic. Well, it may be relatively trivial insofar as we can easily distinguish say, red from yellow, but when we talk about red and yellow in this context we are not talking about a single unambiguous point. Each of the spectral hue names we recognize refers to a *region* of the colour wheel – a hue family that has a multitude of members. The transition from, say, one member of the red hue family to the next is just as seamless as the transitions in areas where one hue family gradates into another. So even though there are cases where we have no trouble identifying a hue as red, this doesn't eliminate the possibility of disagreement about *what sort of red it is*. That is, the problem of borderline judgements doesn't go away just because we are considering a portion of the colour wheel that lies unambiguously within an area occupied by a single hue family.

As well as the spectral hue names that we commonly use – red, violet, green and so on – we also refer to hues by their resemblance to objects or substances that have a more-or-less uniform surface appearance: lemon, lime, tangerine, avocado, mustard, emerald, terracotta, azure, cream and suchlike. We should remember that each of these hues can be regarded as falling within the range of one or other of the spectral hues. So someone unfamiliar with citrus fruit could reasonably ask, 'What colour is lime?' and we could quite reasonably call it 'green' (though strictly speaking this should be understood as shorthand for 'a member of the Green family'). There are also examples on the black–grey–white continuum (for example, ebony, charcoal, milk(y), smoke(y), slate and graphite). Descriptions of the appearance of these substances usually analyse down to 'grey' plus a modifier to establish whereabouts on the continuum the sample lies: 'pale grey', 'light grey' and so on.

Colour Names and Emotional Impact

Naming is important. Commercially produced colour products tend to have very specific names, and this helps re-identification when we want to order and buy more paint, ink, paper or cloth of a particular colour. The names of colours chosen for consumer products are also intended to be emotionally suggestive: 'Sahara', 'Sandalwood' and 'Butterscotch' may all be names for

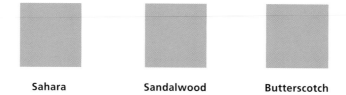

Sahara Sandalwood Butterscotch

FIGURE 84. **The influence of names on our conception of hue.**

the same muted member of the Yellow family, for example (Figure 84), but the connotations of each name are quite different. (Consider for example the impressions created by applying these colour names to different objects, say to food colouring, a cocktail dress, cosmetics, home furnishings or cars.)

What's Your Favourite Colour?

Emotional reactions of this sort seem to play a role in the idea of 'favourite' colour. Lots of people claim to have a favourite colour. Perhaps you do too. What exactly does it mean to have a favourite colour, though? What sort of preference is in question when people talk about their favourite colours? Having a 'favourite' colour generally tends to mean having a preference for certain particular things to be that colour, such as clothes or home decoration. There are limits, however; no one wants *everything* to be their favourite colour. If your favourite colour were blue, would you like the appearance of oranges and lemons better if they were that colour? Would lawns or beaches be improved in your eyes if they were dyed blue? This seems very unlikely. (So what things do you like to see rendered in your favourite colour? Do you have any explanation for your choices, or are they entirely fortuitous, like your taste in food?)

To my mind the idea of a 'favourite colour' is as strange as the idea of a 'favourite musical pitch'. It would be rather peculiar to profess a particular liking for, say, F# over B, or for G over D♭. There may be some people with perfect absolute pitch (in contrast to perfect relative pitch) for whom some pitches are preferable to others. But for most of us, the interest in pitched musical sounds depends on context. This means that our interest in this particular note, here and now, relies on what preceded it, what

accompanies and what follows it. Thus what engages us with regard to pitch is combinations of notes, either serially (as melodies) or in the intervals formed by notes played simultaneously (that is, as harmonies).

It is not unusual for composers to favour particular keys – that is, scales of notes – for their compositions. It also seems perfectly understandable for people to talk about their favourite melodies, intervals, chord types, chord inversions and chord progressions. However it is strange to think of anyone claiming to have a favourite note. Similarly, in the case of colour, it is colours in arrangements with each other that excite us more than individual colours in isolation. Although we may have a preference for combinations of colour that feature some particular hue, it is surely the combinations that we appreciate and take pleasure in, rather than colours in isolation. Even a supposed 'favourite' colour can be rendered unattractive when presented in unfavourable contexts.

Naming Artists' Materials

Artists' materials are not normally given evocative, or provocative, names. It is most common to name artists' colours in a way that indicates the materials or the process used in their production – for example, 'cadmium yellow', 'quinacridone red', 'burnt sienna' and 'scarlet lake'. Some commercially made mixed paints such as 'Hooker's green' and 'Payne's grey' are named after individuals. However, what should be clear, whether we are considering decorating materials or artists' materials, is that these names in themselves give us no useful information about how the colours will behave when mixed. For that, we need to complete our examination of the mixing principles.

PRINCIPLE 3: THE STRAIGHT LINE PRINCIPLE

Introduction

The range of hues mixable from any two hues lies on a straight line between them on the colour wheel. The further apart the mixed hues are, the greater the range of hues they can produce.

It is important to remember that the 'straight' lines we encounter in practice are not ideal geometrical straight lines. When thinking about straight lines in practical contexts, we have to take account of the fact that a straight line has thickness and more or less fuzzy edges. That is, straight lines as we will be using them here need to be thought of as occupying narrow areas on the colour wheel. The relevance of this consideration should become clearer as you work through and evaluate the next set of exercises.

Exercise 3: Mixing 'Primaries' to Produce 'Secondaries'

Colour-mixing orthodoxy tells us that blue, yellow and red – the 'primary' hues – can be used in various combinations to produce green, orange and violet – the 'secondary' hues. So let us put this to the test using the mixing procedure we have employed so far.

Blue and Yellow

Looking at the equi-spaced colour wheel we can see that the green region lies between the blue and yellow regions (Figure 85). We have shown so far that the mix of any two hues produces a third hue that lies between them on the colour wheel. So we should expect members of the Blue and Yellow families to combine to make members of the Green family, as maintained in the orthodox view. We have also introduced the darkening principle. This tells us that the chromatic distance between hues determines the saturation of a mix. The closer together they are,

FIGURE 85. **The equi-spaced colour wheel.**

the more saturated the mix will be, relative to the saturation of the hues being used. Equally, the further apart they are, the darker the mix will be. With all this in mind, you should be able to figure out what is likely to happen when we mix our Blue and Yellow family palette hues.

Follow the usual procedure with Blue 2 and Yellow 5, adjusting the result so that its hue favours neither blue nor yellow. This produces a mixed patch that is recognizably green, though perhaps not as saturated as either of the 'native' members of the Green family represented by Green 3 and Green 4.

Putting the mixed patch alongside the patches of Green 3 and Green 4 brings out their relative biases (Figure 89); Green 3 will now have a blue tinge, and Green 4 will show a yellowish tendency. (Context, remember, is a determining factor in colour judgements.)

FIGURE 86. **The Blue 2 and Yellow 5 mix on the colour wheel.**

Blue 2 Yellow 5

FIGURE 87.

We expect this too, since Green 3 and Green 4 are selected from the alternate ends of the green region of the colour wheel, whereas our mix of Blue 2 and Yellow 5 is adjusted specifically to lie right in the middle of that region. However, this is also true of the earlier mixed patch of Green 3 and Green 4. If you compare this to the Blue 2–Yellow 5 patch you should find that they are more or less the same hue, though the Blue 2–Yellow 5 patch is likely to be darker than the Green 3 and Green 4 specimen. That is, Blue 2 and Yellow 5 produce a *shade* of the hue we get from Green 3 and Green 4. All in all, this part of the exercise looks like a success for the orthodox view.

Next, let us try Blue 1 and Yellow 6. As usual, before you start, try to work out what the result will be, and figure out how you would explain what is happening.

As these two hues have a wide chromatic separation we should expect the result to be dark. In fact, this mix will be *very* dark, and depending on the particular pencils you have in your palette for Blue 1 and Yellow 6 you may find it reasonable to call its membership of the Green family into question. If you have an example that is recognisably green, the results will tend to be a rather drab sort of hue commonly seen on camouflage clothing.

Thinking back to the reception class at my first school, I can now begin to see why those early art lessons proved disappointing. Clearly, some members of the Blue and Yellow families

FIGURE 88. **The Green 3 and Green 4 mix on the colour wheel.**

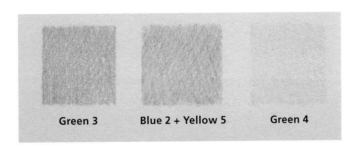

FIGURE 89.

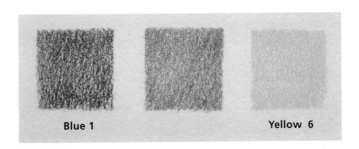

FIGURE 90.

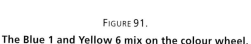

FIGURE 91.
The Blue 1 and Yellow 6 mix on the colour wheel.

FIGURE 92.
The Blue 1 and Yellow 5 mix on the colour wheel.

– specifically Blue 2 and Yellow 5 – combine to make relatively saturated greens. Nevertheless if you are limited to Blue 1 and Yellow 6, your attempts to mix green will be limited to the relatively dull members of the family. So this must be the explanation for my experience in reception class – Blue 2 and Yellow 5 were rarely if ever available. However, typically the results were not quite as dull as the patch we have just created. More frequently I found I was producing greens that were between these two extremes. These are the sorts of results obtainable when we mix Blue 1 with Yellow 5, and Blue 2 with Yellow 6. Have a try with those combinations now.

You may well find that with some careful adjustment these combinations can be balanced to produce two very similar midrange shaded hues in the Green family.

BLUE AND YELLOW MAKE … A DIRTY MUDDY COLOUR?

Although we have mixed some members of the Green family, at best only one of them competes in terms of saturation and clarity with the 'native' unmixed members we have in our pencils, Green 3 and Green 4. This is not to make any evaluative judgements about the usefulness of the hues produced, but is merely to describe the result. That is, the hues available direct from the unmixed pencils are not in any simple way 'better' than the mixed hues, they're just different. Not all situations call for highly saturated vibrant hues and for reasons such as economy, harmony and simplicity, mixing muted hues from a small palette is often a better idea than reaching for yet another pencil or tube of paint.

Clearly, what this block of exercises shows is that the orthodox claim that 'blue and yellow make green' needs to be treated with considerable caution. Even enthusiasts for the established theory would be unlikely to offer the Blue 1 + Yellow 6 combination as a member of the Green family.

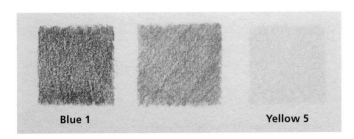

Blue 1 Yellow 5

FIGURE 93.

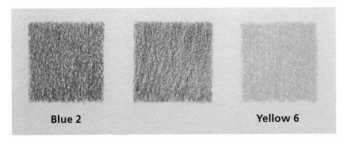

Blue 2 Yellow 6

FIGURE 95.

FIGURE 94.
RIGHT: **The Blue 2 and Yellow 6 mix on the colour wheel.**

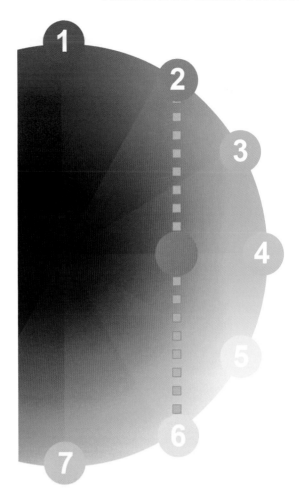

Yellow and Red

Let us continue with a second attempt to mix two primary hues, using Yellow 6 and Red 9: make your prediction, figure out an explanation, and make your three patches as before. Follow this with Yellow 5 and Red 10, Yellow 6 and Red 10, and then Yellow 5 and Red 9. In schematic terms, we expect to see results similar to those illustrated in Figures 96–99.

The last two combinations (Yellow 6 and Red 10; Yellow 5 and Red 9) fall somewhere between the other two in terms of darkening. The extent to which they differ from each other in terms of hue shift will vary according to the specific hues you are using to represent the members of the Yellow and Red families. Remember to assess the outcomes from the viewing position; you should see something like that shown in Figure 100.

You will probably find that the degree of darkening in these combinations is less pronounced than that seen in the Blue–Yellow family mixes. You may also find that this Red–Yellow set shows smaller hue shift variations than the Blue–Yellow results. Established colour theory struggles to explain why this is the case, but it can be explained (and we will see how in Chapter 12).

Red and Blue

I leave this final case to you. As with the previous two cases, you should find that the hues with the closest proximity – Red 10 and Blue 1 – produce the mix with the smallest darkening effect. Those furthest apart – Red 9 and Blue 2 – will make the darkest mix. The other Red–Blue combinations will be more or less in the middle between these two extremes.

Review

The exercises so far help us to explain why many of the confusions about colour mixing arise but, more importantly, we will soon start to show how they can be overcome. We have seen:

1. *In-betweening* (or the 'hue shift principle') – the discovery that the mixed hue lies in a different spectral region to that of its components. The spectral distance between the hues and the proportions in which they are mixed determines the amount of shift. When hues are mixed in equal proportions, the result lies midway between them on the colour wheel.

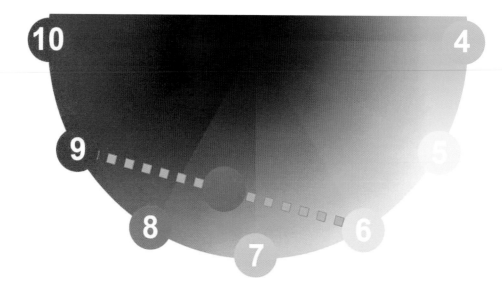

FIGURE 96.
The Red 9 and Yellow 6 mix on the colour wheel. This mix moves only a short way into the colour wheel and is the most saturated member of the Orange family we can make with our members of the Yellow and Red families.

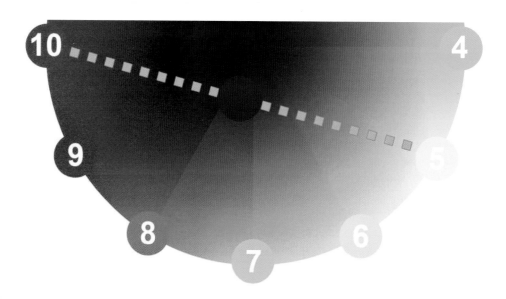

FIGURE 97.
The Red 10 and Yellow 5 mix on the colour wheel. With the greatest spectral separation of our yellow and red hues the product of these two is further into the colour wheel and produces the darkest orange mix.

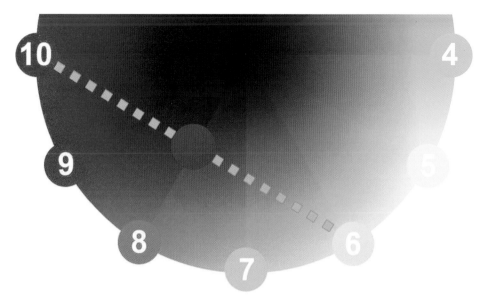

FIGURE 98. **The Red 10 and Yellow 6 mix on the colour wheel.**

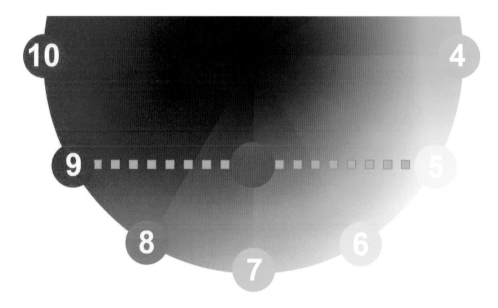

FIGURE 99. **The Red 9 and Yellow 5 mix on the colour wheel.**

2. *Darkening* – the evidence that the mix is always to some degree darker and duller than the lightest and most saturated of its components, and may be darker and duller than both components. As with hue shift, the amount of darkening is determined by the spectral distance between hues and the proportions in which they are mixed.

3. *The straight line principle* – clearly a simple but powerful concept that can be easily applied to practical colour-mixing tasks. It enables us to predict where the effects of hue shift and darkening between any two hues will occur on the colour wheel.

The crucially important consequence of these aspects of colour mixing is that they shed light on how one aspect of the Sufficiency Myth – the claim that 'secondary' colours can be mixed from 'primary' ones – can get a grip on the imagination. For example, blue and yellow *can* be mixed to make green. However, the quality of the green produced is governed by the specific members of the Blue and Green families used. When the spectral distance between them is great, the amount of darkening in the mix is great also. The darkening may be so pronounced that the chromatic content of the mix is barely discernible; that is, it may appear muddy and nondescript. With

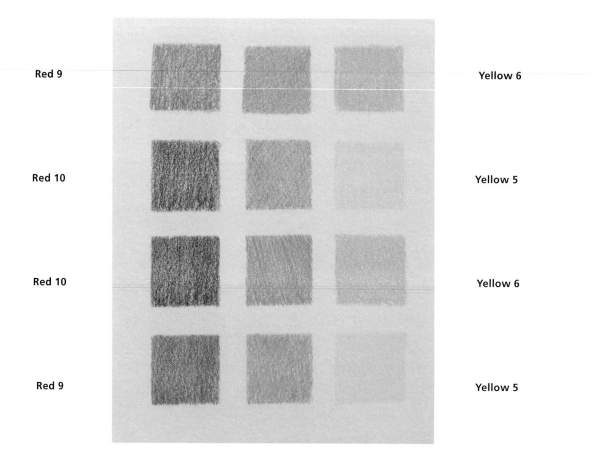

FIGURE 100. **Red and Yellow combinations.**

the 'right' members of the Blue and Yellow families, however, clearly recognizable members of the Green family can be mixed.

The main thrust of the Sufficiency Myth, which says that *all* colours can be mixed from just the *three* 'primaries', is false. As we have seen, there is no single blue, yellow and red; there are *families* of Blue, Yellow and Red hues, each of which occupies a more or less extended region of the spectrum. Some people try to perpetuate the Sufficiency Myth by claiming that there are hue family members – 'primary blue', 'primary yellow' and 'primary red' – that (presumably on account of having an unspecified special mixing property) can synthesize all hues. This claim is demonstrably false as the discussion in Chapter 15 will explain.

This third principle is fully recognized in accounts of additive colour mixing, and yet it is scarcely mentioned in connection with subtractive mixing. Some people rightly observe that the effects of non-chromatic properties in paints prevent the straight line principle being used with the degree of precision that can be expected in additive mixing. (See for example Bruce MacEvoy's treatment of the issue at *www.handprint.com.*) Nevertheless, this is not to say that it cannot be used at all. We need to remember though that in practice straight lines have thickness, and this means they describe narrow areas on the colour wheel. So predictions made using the straight line principle point to an area within which a target hue can be found.

Given the evident utility of the straight line principle, its absence from accounts of subtractive mixing is a bit of a mystery. Some people suppose that standard mixing theory fails because real-world pigments are always less than ideal. They might think that the straight line principle would work if only the pigments didn't let us down. I can't say I find this persuasive, since it is easy to show that, unlike so much of established subtractive theory, the straight line principle does in fact work well enough to be included in our basic mixing principles.

COLOUR TEMPERATURE

It is common among writers on colour to classify colours according to their 'temperature'; some colours are supposedly 'warm', others are 'cool'. You may, for example, have come across suggestions in art instructional texts saying things such as, 'this area of the portrait is too cool; it needs warming up with some colour *x*'. Typically, hues in the blue–green part of the spectrum are regarded as cool or cold, those in the orange–red region as warm or hot.

These emotional responses are not pure and primitive. There is considerable variation in the way people feel about each hue and its temperature. For one person a certain pink tint may have comforting associations, whereas in someone else the same hue triggers an unpleasant memory, for example.

Such associations might be thought to play a further straightforward role in hue classification. Blue and blue–green are associated with cool, clear streams and cold, icy seawater; orange and red bring to mind flame, fire and so on. However, there are no hard-and-fast connections between these natural phenomena and objects and the colours that are typically linked with them. Consider, for example, hot water. It is the same hue as cold water but, lyrically and emotionally, we just don't talk about 'hot blue water' in the way that we do about 'cool blue water'. Similarly, thoughts of orangeade usually invoke adjacent thoughts of coolness rather than the warmth that comes to mind when flames are mentioned. Again, you will almost inevitably be thinking 'hot' when red chilli peppers are mentioned, but the chances are you will think differently when the subject of strawberries comes up. I emphasize that I am not denying that there are certain typical associations we are prone to make (though some of them are culturally specific), but am only suggesting that they do not really support the classification of colour in terms of temperature.

Another shortcoming of the temperature classification is its incompleteness. Of the six major hue families we have considered temperature connotations for blue, green, orange and red – but what about violet and yellow? There is a strong chain of association that could lead us from yellow, the iconic colour of the sun, to the sun itself and thus to its heating effect. In spite

'hot' or 'warm'

unclassified

FIGURE 101.
A 'colour thermometer'.

'cool' or 'cold'

unclassified

of this, there is limited inclination to regard yellow as an intrinsically warm or hot colour. And as for violet, there is simply a dearth of established temperature associations. Confronted with these gaps in the classification some people might be inclined to say, 'it all depends on which members of the yellow and violet families are in question; some are warm, some are cool'. Well, this might seem to be a reasonable thing for an enthusiast of colour temperature classification to say. However, it should not be too difficult to convince most people that (as the examples given above show) this is true of all the other hue families too. If that is indeed the case then the idea of a general temperature-based classification breaks down.

Why all the fuss about colour temperature classification? Is it really that important? I think it is important to this extent: it is imprecise, incomplete and arbitrary, and for those reasons is a largely unhelpful way of talking about one aspect of colour relationships. Appeals to colour temperature are normally motivated by efforts to grapple with the question of achieving a colour balance or harmony, and this consideration once again compels us to bear in mind that the vast majority of our judgements about colour are context-dependent. We are more concerned with the relative effects that colours have in combination than their intrinsic causal characteristics. That is, from an aesthetic perspective we are for the most part concerned with colour relationships as we see them, rather than with any supposed absolute properties of colour sensations and their physical causes. Insofar as there are such properties, these are best investigated by science.

The matter of colour balance or harmony is something that cannot easily be judged in absolute terms, and labelling colours 'hot' or 'cold' may not be of great help with that task. A red hue may be 'too hot' in one situation, but in another situation, where the balance of elements is different, the same red hue may be just right, or not 'hot' enough. Once again, we should note that context is a crucial consideration in our colour judgements.

I am not campaigning for a ban on thinking about colour in terms of temperature – of all the faults with established theory, it is one of the least damaging. So if it works for you, that's fine. Don't be surprised, however, if this, like the two Myths and other aspects of the established view of colour, fails to work well in practice.

PRINCIPLE 4: COMPLEMENTARITY

Introduction

Hues that lie opposite each other on the equi-spaced colour wheel are generally called **complementary pairs**. Given such a pair, the two distances we can measure around the wheel from one member to the other are equal (see Chapter 9). Connecting any such pair by a straight line yields the longest straight line that can be drawn across the colour wheel. Therefore, complementary hues are supposed to produce the greatest range of variations that can be obtained from two-hue mixes. The centre of the equi-spaced colour wheel is its **region of maximum darkness**. A line drawn between any complementary pair must pass through this point. Thus the range of possibilities mixed from complementary hues includes the darkest chromatic hues. This is the standard story on complementary hues, and part of it is true. However, if you have ever tried putting it to work in practice you will have found things rarely, if ever, go according to plan. In this chapter I show why that is, and what can be done to correct these flaws.

Region of Maximum Darkness

Within the colour wheel there is a region that is the subtractive limit of all hue mixes. This region is near-black, and for many painterly purposes can be treated as black.

Complementary Hues: The Standard Pairs

Most sources of information on colour mixing include at least a passing reference to complementary hues. As with most other aspects of colour mixing, the standard view about complementarity tends to contain at least as much misinformation as information. The standard view maintains that the following hue pairings are complementary: blue–orange; green–red; violet–yellow.

The first thing to note about this list is that it obliterates the differences of hue within hue families. Thus it makes no allowance for the possibility that different members of a hue family may have different complements (which in fact they do). Second, we can see that the list enjoys a convenient fit with the primary–secondary distinction; each primary hue has a different secondary hue as its complement. This relationship is a straightforward consequence of the geometry of the equi-spaced colour wheel. Each primary is opposite a secondary hue on the wheel, and these hues combine to form a **dark chromatic** near-black mix. This is what we should expect because each secondary is a mix of two primaries, thus if we mix a secondary with its primary complement, we are mixing all three primaries. Mixing all three primaries in equal proportion gives us near-black. This is how the official story goes.

Even before we start trying out the various possibilities, it seems intuitively plausible that the complement of one hue in, say, the Red family, will not be the complement of another member of that family. To put this to the test, let us examine the pairing possibilities we get by applying the standard view to our twelve palette hues. Following the usual order around the colour wheel, the hues face each other like this:

Pair 1	Pair 2	Pair 3	Pair 4	Pair 5	Pair 6
Blue 1	Blue 2	Green 3	Green 4	Yellow 5	Yellow 6
Orange 7	Orange 8	Red 9	Red 10	Violet 11	Violet 12

Dark Chromatic Hues

The shades of hues contain progressively less chromatic content the closer they are to the region of maximum darkness. However, until we actually reach the centre of that region, these shades are still identifiably members of specific hue families. Thus, there is an area of the colour wheel that contains dark chromatic hues – deep, dark reds, greens, and so on.

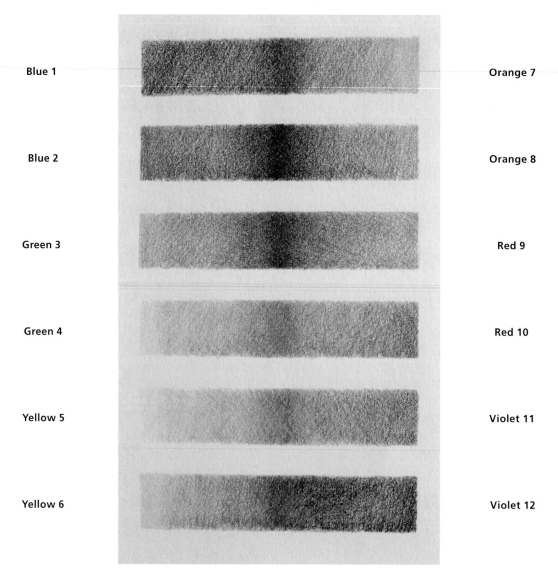

Blue 1 Orange 7

Blue 2 Orange 8

Green 3 Red 9

Green 4 Red 10

Yellow 5 Violet 11

Yellow 6 Violet 12

FIGURE 102.
The equi-spaced colour wheel complementary combinations.

Now let us try some gradation experiments with these pairings (Figure 102). The aim here is to produce as dark a hue as possible in the middle of each gradation strip, ideally a convincing near-black.

Now it is my turn to make some predictions: the most convincing of these darks will be Blue 2 and Orange 8, with Green 3 and Red 9 coming a pretty close second. Blue 1 and Orange 7 comes out dark too, but Green 4 and Red 10 lags behind, making a deep to mid-brown. Yellow 6 and Violet 12 make brown too, and Yellow 5 and Violet 11 make an even lighter brown.

Since these are chromatic pairings, we should expect to be able to distinguish them from samples taken from the black–grey–white continuum. However, as proposed complementary pairs we should still expect them all to produce very

dark, near-black mixes – although the only pairs that really accomplish this are Blue 2 and Orange 8, and perhaps Green 3 and Red 9. The others don't really make it. Something has clearly gone wrong, and the violet–yellow axis in particular steadfastly refuses to deliver anything like the results claimed by the standard view.

Surely, if Blue 2–Orange 8 is the only pair in the commonly accepted account of complementary hues that behaves as predicted, then we might do well to find out why. We have repeatedly seen that the traditional theorists have a curious attitude to the relationship between their theory and practice. When the theory fails – as it so clearly does with regard to complementarity – their reaction is to treat it like some sort of poorly designed gadget that always malfunctions. They stare at it for a bit, before

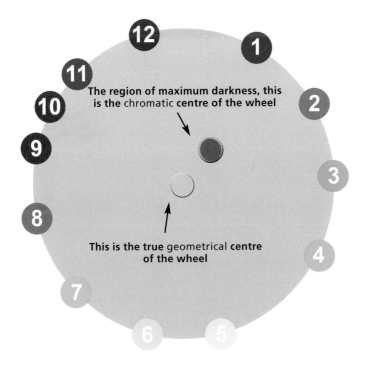

FIGURE 103.

The geometrical and chromatic centres of the colour wheel.

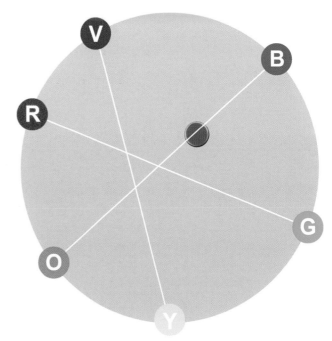

FIGURE 104.

Traditional complementary pairs in relation to the chromatic centre of the wheel.

giving it a tentative poke with a stick in the hope that it will burst into life. When nothing happens they put it back in its box, saying wearily, 'anyway, that's what theory says'. But if the complementary pairings proposed by established theory *don't* work then surely the sensible thing to do is to look for pairings that *do* work! If Yellow 6 doesn't turn Violet 12 near-black then we should make it our business to find out which hue or hue combination does have this effect.

Brace yourself: this investigation requires us to introduce a little real-world complexity to our simplified understanding of the colour wheel.

Enhancing the Colour Wheel

If we aim to build an extensive general-purpose palette we will choose the purest, most saturated pigments available to serve as our twelve palette hues. However, if we place them all at the perimeter of a wheel with the region of maximum darkness in the centre – which, for the sake of simplicity is what we have done so far – this distorts the true nature of the relationships between the hues. In absolute terms the green–blue–violet

pigments are really closer to the region of maximum darkness than those on the red–orange–yellow side. Any diagram we use to predict mixes will have to get these relationships right if its predictions are to be accurate.

We could preserve the variations in the distances from different hues to the region of maximum darkness in a non-circular form, although I suspect most people would find it easier to relate to a regularly shaped diagram. If we want to retain a circular reference for colour mixing with all of our palette hues at the perimeter, we must shift the dark point away from the centre of the wheel towards the green–blue–violet regions (Figure 103).

Now we can see why traditional theorists' claims about complementary pairings fail to deliver uniformly dark hues in practice. A straight line connecting blue and orange does pass through the region of maximum darkness, and so these mixes give reasonably deep, dark hues; the red–green pairings pass close to the dark point, but the yellow–violet line is way off. In fact the point where the yellow–violet and blue–orange lines intersect predicts that the darkest mix we will get with yellow and violet is a murky orangey-brown, as your gradation experiments will almost certainly have produced.

Note also that this relocation of the region of maximum

FIGURE 105.

Improved distribution of the twelve palette hues.

FIGURE 106.

Constructing the enhanced colour wheel (1).

darkness also requires changes in the spacing of the palette hues around the wheel. The precise nature of these changes is described in the following sections.

True complementaries

So what are the true complementary pairings? Before we can answer this question properly, the revised colour wheel model needs further refinement. At present, it doesn't show the spread of each hue family. So first we should replace the six-hue division with our more fine-grained twelve palette hue model. Second, we should space the hues so as to reflect their relative positions in the spectrum.

The prospect of working all this out for yourself will almost certainly strike you as a bit tough and tedious. No doubt you would get there in the end, but who knows how long it would take? Fortunately this has already been done for us. Take a look at the positioning of the hues on the wheel in Figure 105.

The genuine complementary pairings now can be determined by drawing a straight line from each hue at the perimeter through the region of maximum darkness. The point where the straight line intersects the perimeter on the other side of the wheel marks where a hue's true complement is located. We will confirm in a demonstration that, of our palette hues, there are

only two 'natural' complementary pairs: Blue 2–Orange 8 and Green 3–Red 10. The complements of the remaining palette hues are mixes of two others.

These true complementary hues have been known since the early twentieth century but have been curiously ignored or overlooked by those theorists who have written chiefly with artists in mind. For example, in spite of the influence that Ogden Rood's *Colour: A Textbook of Modern Chromatics* (1910) has exerted on many aspects of colour theory development across the board, the 'colour theory for artists' community has largely ignored his account of complementary pairings (which are very similar to those in the Figure 105).

How to construct the enhanced colour wheel

The departures from the regular spacing of the traditional colour wheel and the relocation of the region of maximum darkness may look quite subtle, but they make a significant difference in practice. For those of you who are reassured by such things, note that this rearrangement of the wheel coincides with what current physics tells us about hue relationships; that the hue families occupy different proportions of the spectrum (*see* Chapter 8).

The construction of the enhanced wheel is slightly more

FIGURE 107.
Constructing the enhanced colour wheel (2).

FIGURE 108.
Constructing the enhanced colour wheel (3).

involved than that of the equi-spaced version but the extra effort is repaid fully in terms of the usefulness of the result. The spacing of the hues around the circle can be plotted with sufficient accuracy for practical mixing purposes by dividing the circle into twenty-four equal segments; thus the angular separation of the segments is 15 degrees. This is easily marked out using a protractor and ruler. The basic layout of the twelve palette hue regions on this division of the circle follows this scheme (Figure 106).

The placement of the hues in these positions is a simplified version of the angular displacement identified in experiments carried out by Rood. His measurements also provide us with a way, at last, of filling in the segment of the colour wheel that corresponds to the Purple Line. Note that, in comparison with the equi-spaced wheel, the enhanced wheel has bigger gaps between positions 12–1 and 4–5 and a compression in the 9–10–11 region.

For the moment, I ask you to take this arrangement on trust. However, we will soon be seeing how much more effective it makes our colour-mixing predictions.

Into the dark

To locate the region of maximum darkness on the enhanced wheel, first draw a line across the wheel joining the Red 10 and

Green 3 regions (Figure 107). We know from our own experiments that this is a complementary pair, and so we also know that the region of maximum darkness lies somewhere on the line between them. We have another known complementary pair – Orange 8 and Blue 2, and the line between these hue regions must pass through the region of maximum darkness too. From this we deduce that the point where these lines cross each other must mark the middle of the region of maximum darkness. Further applications of the straight line principle to each of the remaining hues and the region of maximum darkness will confirm the rest of the true complementary pairs given by Rood.

Just as maximum darkness is marked on the wheel as a region or area, so too the hue markers around the circumference of the wheel denote spread-out regions rather than sharply defined points. So, for any specific palette of twelve hues situated in these regions there will be some minor movements within these regions. However, even allowing for this elasticity in the precise positioning of particular paints, the general shape of the relationships and the location of the region of maximum darkness will be the same in each case. In spite of these inevitable minor differences between palettes of real paints, this enhanced colour wheel remains a superior colour-mixing guide to the equi-spaced wheels found in most accounts of subtractive hue relationships.

83

Blue 1 Yellow 6 +
 Orange 7

FIGURE 109.

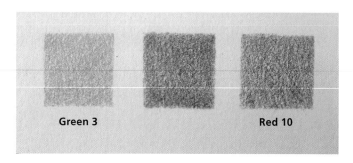

Green 3 Red 10

FIGURE 111.

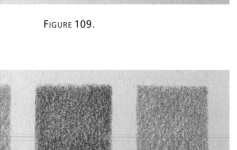

Blue 2 Orange 8

FIGURE 110.

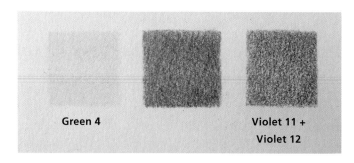

Green 4 Violet 11 +
 Violet 12

FIGURE 112.

The Proof of the Pudding

Let us examine how these pairs actually line up. In each of the following examples, the middle patch of the three shows the mix of the hues on the left and the right. You will find that it takes several layers to build up a sufficient density of pencil to produce these near-black, dark chromatic hues. However, don't be misled into thinking that these results can be achieved by the density of colouring material alone, irrespective of the hues involved. If the combinations are not true complementaries, the outcome won't be anything like the dark mixes shown in this section. If you doubt this, have another look at the results of combining the traditional complementary pairs, as shown in Figure 102. Apart from the Blue 2–Orange 8 combination, which makes it into the new list, with the traditional pairs, it doesn't matter how many layers you pile on top of each other; they will never yield dark mixes like the ones shown here.

1. BLUE 1 AND YELLOW 6 + ORANGE 7

The balance between the yellow and orange should slightly favour yellow. If you are steeped in the folklore of the prima-ry–secondary distinction this will come as a bit of a shock: blue and yellow are supposed to make green, not near-black, aren't they? The large spectral separation of this particular blue and yellow combination coupled with the off-centre shift in the posi-tion region of maximum darkness accounts for what might at first be regarded as an unexpected result.

2. BLUE 2 AND ORANGE 8

Although the region of maximum darkness has moved from the centre of the wheel, this pairing remains as it did in the original list derived from the simplified wheel.

3. GREEN 3 AND RED 10

Here is a significant difference. The original list paired Green 3 with Red 9 but, in a side-by-side comparison, I expect you will find that this modified version is indeed darker.

4. GREEN 4 AND VIOLET 11 + VIOLET 12

Green 4 has no single palette hue complement, but requires a mix falling somewhere between the two members of the Violet family.

5. YELLOW 5 AND VIOLET 12 + BLUE 1

Similarly, Yellow 5 will not pair up with a single hue on the wheel, but takes a mix between Violet 12 and Blue 1 that favours violet.

6. YELLOW 6 AND VIOLET 12 + BLUE 1

Violet 12 and Blue 1 are required here too, but favouring Blue 1 this time.

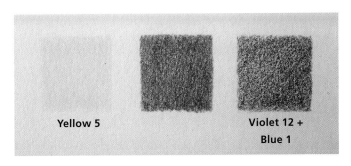

FIGURE 113.

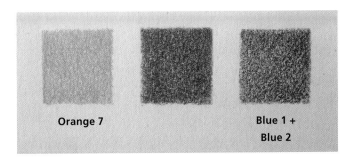

FIGURE 115.

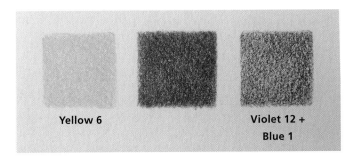

FIGURE 114.

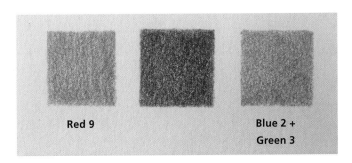

FIGURE 116.

7. ORANGE 7 AND BLUE 1 + BLUE 2
Again, a mix slightly in favour of Blue 1.

8. ORANGE 8 AND BLUE 2
As for case 2.

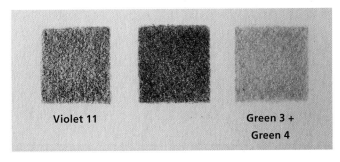

FIGURE 117.

9. RED 9 AND BLUE 2 + GREEN 3
The partners of this red should be mixed in roughly equal proportions.

10. RED 10 AND GREEN 3
As for case 3.

11. VIOLET 11 AND GREEN 3 + GREEN 4
The green balance here should be tilted in favour of Green 3.

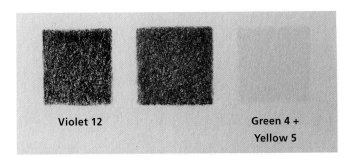

12. VIOLET 12 AND GREEN 4 + YELLOW 5
A greenish-yellow provides the true complement to this final palette hue.

FIGURE 118.

Don't forget to assess these mixes from the viewing position. You will probably find that, viewed in isolation against a white

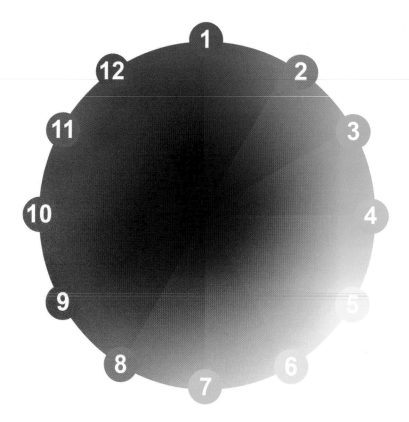

FIGURE 119. **The equi-spaced colour wheel.**

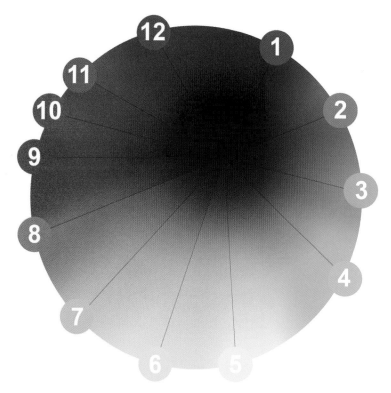

FIGURE 120. **The enhanced colour wheel.**

Hint: pick the diagram below.

background and at a distance, they can be quite easily judged to be black. However, when two or more of them are compared side by side, their different chromatic origins will tend to stand out more clearly.

Where a palette hue has no single hue complement, the exact balance of the two required to produce a complementary mix has to be established by experiment. Each manufacturer's version of paints with the same specific name is likely to differ at least slightly in hue (and some differ a lot). So, having chosen your particular representatives of each hue type to build your palette, you will need to determine for yourself the proportions in which to mix two hues when these are required to complement a third. Remember, the palette hue markers on the wheel diagrams indicate the positions of hue family *regions* rather than specific fixed points. Even if the diagram markers were labelled with specific paint names like 'pthalo blue', 'pyrrole orange' and 'cadmium yellow medium', such adjustment would still be necessary unless you had exactly the same samples of those paints as those I used in my original experiments. A list of these materials, which you may want to use to guide your own choices, is given in Appendix 2, but the point of developing this enhanced colour wheel is not to tie you down to a rigid specification of a few particular paints that you must use. The real benefit of the improved wheel is as a general guide to hue *type*.

Summary

If we ignore the demonstrably inadequate roster of hue complements suggested by traditional theory and actually see what works in practice it is clear that things do not line up as neatly and evenly as we have been led to believe. The equi-spaced colour wheel, and the account of complementarity it yields, are pretty hopeless from a practical point of view. In order to show why this is the case I introduced the enhanced colour wheel, a greatly superior reference for colour mixing.

We know from our own frustrating experience that – apart from the purpose it served in illustrating Principles 1 to 3 – the standard equi-spaced colour wheel does not perform well at all. Greater accuracy in practice can be achieved by taking account of two key factors that the equi-spaced wheel ignores: the spacing of the hues around the wheel and the difference in the distances from each hue to the region of maximum darkness. Both of these factors introduce irregularities that the equi-spaced wheel obscures.

These irregularities make a big difference to how we should represent the chromatic relationships between the palette hues if we are to make accurate predictions about the outcome of mixes. However in incorporating these factors into any new representation of hue relationships it is helpful to retain the simple and familiar geometrical tools we have used so far – the circle and the straight line.

Hence, to construct the enhanced colour wheel, we plot the position of the hues on the perimeter of a circle according to their relative spectral proximities, determine where the lines between two known true complementary pairs cross and fix this as the centre of the region of maximum darkness. We found that this intersection – the *chromatic* centre of the wheel – is not its *geometrical* centre, but lies slightly above this point, in the Green–Blue–Violet half of the circle.

Constructing this pragmatically superior hue circle is a little more laborious than simply arranging everything in the symmetrical scheme that accompanies the standard view – so is it worth it? Well, here is the choice: you can have a nice, neat, regularly spaced wheel, convenient to construct, that distorts hue relationships significantly, or you can have a wheel that is derived from and preserves those relationships with considerably greater accuracy. Which one do you suppose will be most use as a practical guide to mixing?

You can breathe out now – that is the most theory-intensive section out of the way. Before moving on to the next block of exercises, however, you might care to take advantage of another short break to review all four mixing principles.

A SUMMARY OF THE PRINCIPLES

It often helps to consider things in more than one way in order to make sure we have a proper grasp of them. So here is a slightly different way of thinking about the subtractive mixing process and the uniformity of its effect on both 'primary' and 'secondary' colours. This method shows how each of the four mixing principles is involved.

Start with the supposition that we are mixing two paint samples of exactly the same hue, squeezed from the same tube. Not surprisingly, we get no change in the mixed hue.

Now select two nearby hues neighbouring our starting point, one from either side. The result of mixing these hues is a slightly darker version of the original hue we started with. If we plot this on our colour wheel the result will lie at a point:

- in between the two hues we are mixing (Principle 1);
- nearer to the region of maximum darkness than the original hues (Principle 2); and
- on a straight line between them (Principle 3).

As we reiterate this process, each time moving further away from our original hue, the resultant mix is a darker version of that original (Figure 123) and continuing this process leads us to mix two hues that are quite obviously only distantly related to our starting point (Figure 124).

Eventually the hues will be separated in such a way that the straight line connecting them will also pass through the region of maximum darkness. In other words, we will have complementary

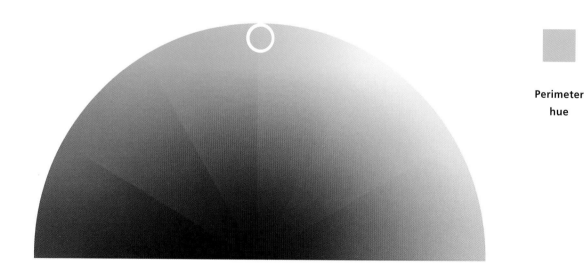

Perimeter hue

FIGURE 121.
The principles in practice (1).

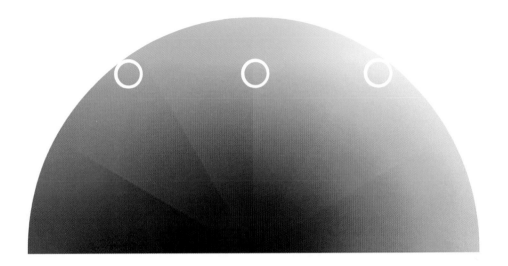

**Mix
result 1**

FIGURE 122.
The principles in practice (2).

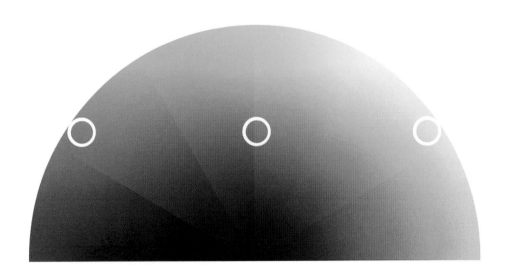

**Mix
result 2**

FIGURE 123.
The principles in practice (3).

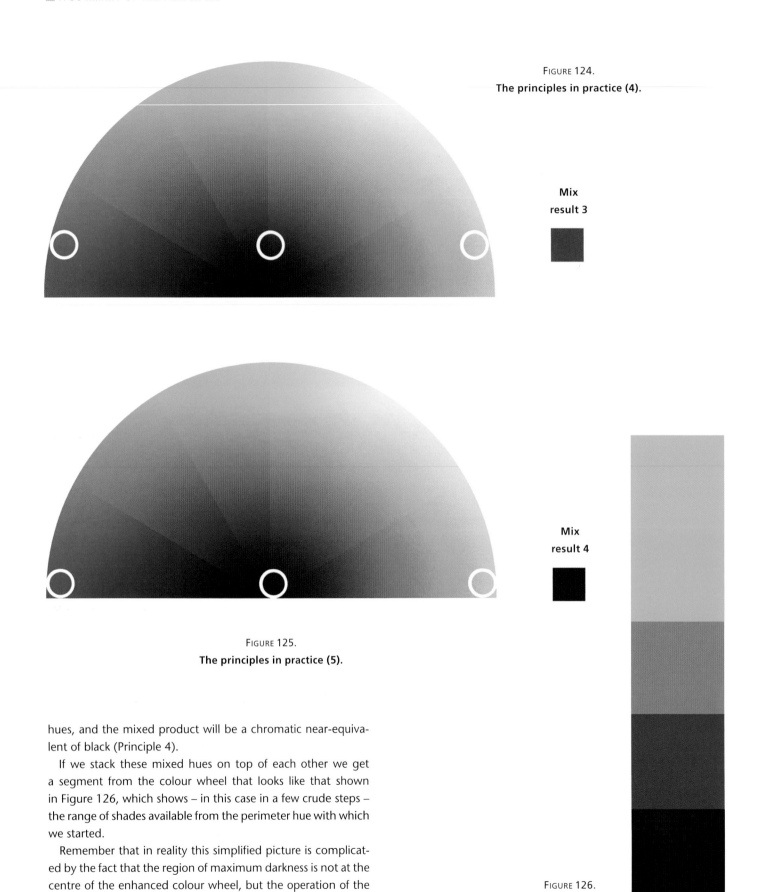

FIGURE 124.
The principles in practice (4).

Mix
result 3

FIGURE 125.
The principles in practice (5).

Mix
result 4

FIGURE 126.
Wheel segment.

hues, and the mixed product will be a chromatic near-equivalent of black (Principle 4).

If we stack these mixed hues on top of each other we get a segment from the colour wheel that looks like that shown in Figure 126, which shows – in this case in a few crude steps – the range of shades available from the perimeter hue with which we started.

Remember that in reality this simplified picture is complicated by the fact that the region of maximum darkness is not at the centre of the enhanced colour wheel, but the operation of the principles remains the same.

MIXING 'PRIMARY' HUES FROM 'SECONDARY' HUES

Introduction

The exercises so far have exposed some of the limitations of the orthodox view and, in that process, we have formulated four principles that serve as a superior guide to mixing 'secondary' hues from 'primary' ones. If these principles are truly general, they should provide equally good guidance for mixing 'primary' hues from 'secondaries'. We put that extension to the test in this chapter to see whether it works as expected.

Mixing Members of the Hue Families

We have seen that rather than talking about mixing green from blue and yellow, we can make more sense of the situation if we think in terms of mixing members of the Green family from various members of the Blue and Yellow families. When we think about or discuss colour names, it often seems that we call to mind iconic specimens or swatches to represent them. As with human families the resemblance between members from different branches varies, and members from branches that are remote from each other will in some respects be dissimilar.

See Figure 127 for two hues that are clearly both members of the Green family, for example. It would be fair to say, I think, that the dissimilarity of these samples in bias, saturation and lightness is as great as their similarity in hue.

Recall too that our attempt at mixing green using Blue 1 and Yellow 6 produced a result that lies a long way from the heart of

Blue 1 **Yellow 6**

FIGURE 128.

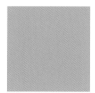

FIGURE 127. **Two members of the Green family.**

the Green family. If you were attempting to introduce someone to the way we use the concept 'green' by way of samples, you would not want to choose samples clustered around the Blue 1 + Yellow 6 mix. And so it goes for the other cases.

The orange and violet samples we have mixed would probably not be the best examples for teaching someone how we use the terms 'orange' and 'violet'. So it won't be surprising if these family members fail to match the icons that spring to mind for you when someone says 'imagine an orange patch' or 'imagine a violet patch'. However this does not constitute a reason for denying that the samples are members of the Orange and Violet *families*.

Exercise 4: Uncharted Territory – Mixing 'Secondaries' Together

Nothing we have seen so far suggests that the phenomena of hue shift and darkening should apply only to some regions of the colour wheel and not others. These effects have been present in all the mixes we have made and thus the evidence suggests that the effects are quite general. This means we should expect to see precisely the same effects whichever hues we mix.

If this is correct, then the Irreducibility Myth must be false. The Myth says that the 'primary' hues – blue, yellow and red – cannot be mixed. Our findings suggest otherwise; in every case we have examined so far, the result of mixing two hues has

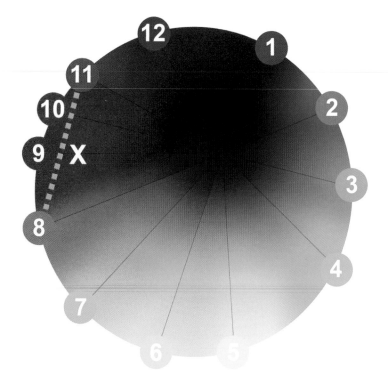

FIGURE 129. **The Orange 8 and Violet 11 mix on the enhanced wheel.**

FIGURE 130.
Red patch mixed from Orange 8 and Violet 11.

FIGURE 131.
The red patch with edges masked.

produced a hue that is intermediate between them on the colour wheel. Green lies between blue and yellow, orange lies between yellow and red, and violet lies between red and blue. Let us see if there's a similar relationship to be found in the case of red.

Mixing members of the Red family

Since we have always been told from a very young and impressionable age that mixing red is impossible, I suspect that very few people have consciously attempted it. Consequently, you might be struggling with the question of what hues could possibly be pressed into service to accomplish this 'impossible' feat. All we have done so far, however, can be boiled down to this simple thought: if we mix two hues, we get a hue at the midway point between them. If we mix a member of the Blue family with a member of the Yellow family, we get a member of the Green family.

If we reverse this train of thought then we should be able to figure out what we need to mix any given hue. So, for example, if we want to determine which hues are required to mix members of the Orange family, we have a look either side at its immediate neighbours. There we find the Yellow family on one side and the Red family on the other. Thus, to mix a member of the

Red family we look either side and see the orange region and violet region. Do orange and violet make red? Or, more accurately, can we mix members of the Red family using members of the Orange and Violet families? If you have never considered the possibility before, I suspect you won't think it very promising – but let us put it to the test using the procedure we have followed with our other hue mixes.

ORANGE AND VIOLET
Let us remind ourselves of what we expect to see. Orange 8 and Violet 11 are closest together on the spectrum, and so they should produce a hue shift that pushes the mix to somewhere between Red 9 and Red 10. We should also see some slight darkening so that we end up with a member of the Red family that is situated around point 'X' on the colour wheel (*see* Figure 129).

With these things in mind, lay patches of Orange 8 and Violet 11 in the same manner as before, followed by a mixed patch in the middle. Then evaluate the result from the usual viewing position.

If we take the results at face value, we should expect very little darkening so that the mix should be easily recognizable as red. However at first you might have a very strong resistance to admitting that this mix is red, since if it is red this contradicts one of the fundamental things we are told about subtractive

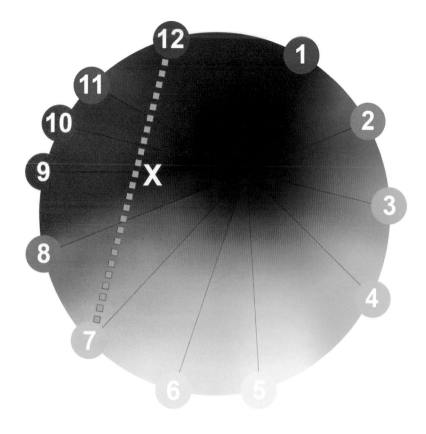

FIGURE 132. **The Orange 7 and Violet 12 mix on the enhanced wheel.**

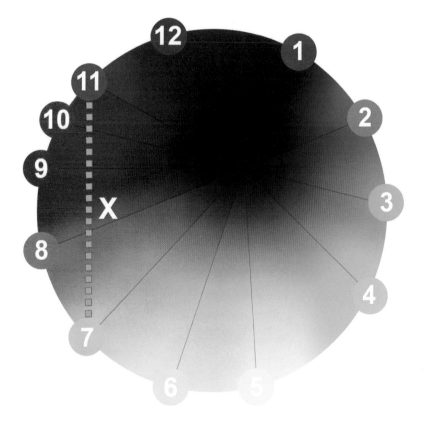

FIGURE 133. **The Orange 7 and Violet 11 mix on the enhanced wheel.**

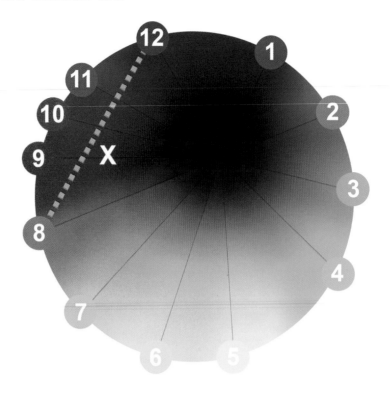

FIGURE 134. **The Orange 8 and Violet 12 mix on the enhanced wheel.**

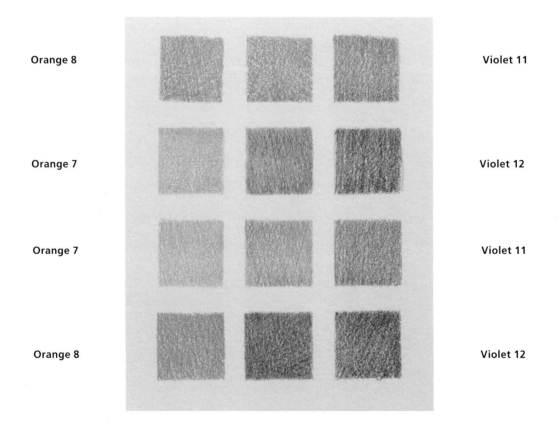

Orange 8			Violet 11
Orange 7			Violet 12
Orange 7			Violet 11
Orange 8			Violet 12

FIGURE 135. **Orange and Violet combinations.**

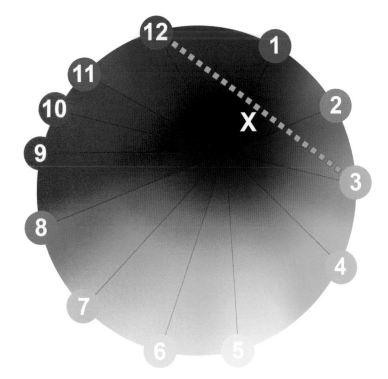

FIGURE 136.
The Violet 12 and Green 3 mix on the enhanced wheel.

colour mixing. If you have doubts, then mask the mixed patch with a piece of paper (Figure 131). This helps to consolidate the colour by hiding the fuzzy edges where remnants of the individual hues can still be seen.

Leave your colour materials and do something else for a couple of minutes. Then return to the masked patch and look at it again from the viewing position. You shouldn't have any difficulty in recognising it as a member of the Red family. (If you are still not prepared to agree with this judgement, stick with the discussion until Chapter 15 where all the significant objections are dealt with in detail.)

At the other extreme, of all the combinations we can muster with our orange and violet pencils, Orange 7 and Violet 12 have the greatest chromatic distance between them. They have more or less the same midway point between them as Orange 8 and Violet 11, so the hue shift will be much the same. As the chromatic distance is much greater in the present case, however, the degree of darkening will be more noticeable. You will probably find that the result will be a decidedly brownish hue, maybe similar to Burnt Sienna. Again, check the result from the viewing position.

Between these extremes are the combinations Orange 7 and Violet 11, and Orange 8 and Violet 12, which produce members of the Red family reminiscent of Indian Red – certainly not brilliant flame reds, but not as sombre as the earthier hues produced by Orange 7 and Violet 12.

Mixing members of the Blue family

We saw above that the way to analyse, to 'decompose' or 'reverse engineer', a hue is simply to look at the families that lie either side of it. In the case of the Blue family, its immediate neighbours are the Violet and Green families.

VIOLET AND GREEN
Following the by-now familiar pattern for laying out our exercises, start this one with Violet 12 and Green 3. As you will probably have guessed, the mixed patch in this case is a hue that lies roughly between Blue 1 and Blue 2 on the spectrum. It will be rather dull in comparison with the reasonably pure red we were able to mix with Orange 8 and Violet 11.

There are two factors that account for this. First, Violet 12 and Green 3 are further apart on the wheel than Orange 8 and Violet 11. Consequently, a line drawn between Violet 12 and Green 3 will cut deeper into the colour wheel, and thus the part of the line that passes through the blue region will run closer to the region of maximum darkness than the equivalent line for Orange 8–Violet 11. Second, the region of maximum darkness is shifted into the violet–blue–green half of the wheel. Moving a short distance in from the perimeter on this side takes us further into the dark than we will travel by moving in by the same distance on the other side of the wheel. Thus, mixes on the violet–blue–green side are skewed towards darkness in compar-

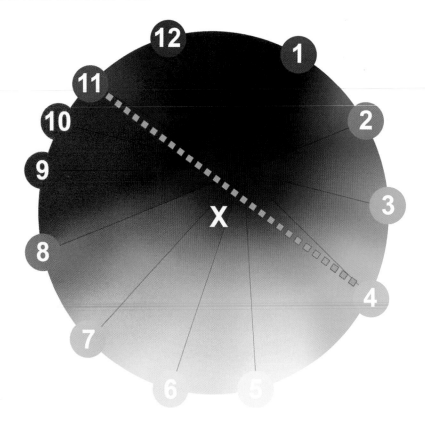

FIGURE 137. **The Violet 11 and Green 4 mix on the enhanced wheel.**

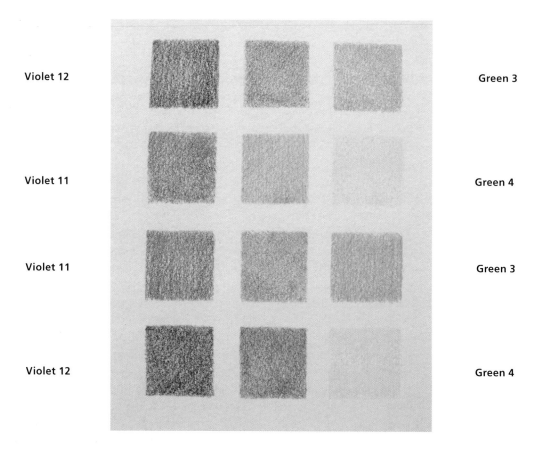

FIGURE 138. **Violet and Green combinations.**

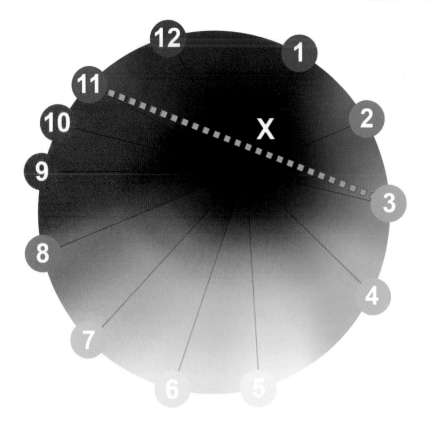

FIGURE 139. **The Violet 11 and Green 3 mix on the enhanced wheel.**

FIGURE 140.

Gradation strip for the Violet 11 and Green 3 mix.

ison with those mixes between similarly separated hues on the yellow–orange–red side. This explanation of the difference in darkness between these two mixes can be seen clearly by comparing the diagram for Orange 8 and Violet 11 (*see* Figure 129) with the one for Violet 12 and Green 3 (Figure 136).

Remember, as always, to assess the results from the viewing position. As before, if you have reservations about admitting that this result, in spite of its dullness, is a member of the Blue family and thus defeats the Irreducibility Myth, follow the masking procedure shown in Figures 130–131. If you are still not ready to agree, make a note of exactly why. Being clear about your judgement will help you get the most out of Chapter 15, where the responses to the main objections are put forward.

This demonstration presents us with one of several good examples of the superior explanatory value of the enhanced colour wheel. Using the old equi-spaced wheel we can predict correctly that Violet 12 and Green 3 should yield a member of the Blue family. However, it will mislead us into expecting the mix to be as saturated as the red we can produce with Orange 8 and Violet 11.

An equally striking example of how the enhanced wheel shows us what is really going on arises when we consider the mix for Violet 11 and Green 4. Following the pattern we have seen using the equi-spaced colour wheel in the earlier exercises with other hue families, we should expect Violet 11 and Green 4, being the most widely separated members of their respective

families, to produce a much darker blue than the Violet 12–Green 3 mix. Try it, and see what you get.

It will certainly be very dark, and may even look rather brown, similar to the mix produced by Orange 7 and Violet 12. However, I bet it isn't going to pass muster as any sort of blue. This result seems to challenge the general trend observed so far and requires some further comment.

Although we know from our earlier exercises that mixing readily recognizable members of any hue family depends on picking the 'right' members of the neighbouring families, it is not obvious that the 'wrong' members will combine to produce a result that can best be described as brown. In the case of Orange 7 and Violet 12 this might reasonably have been predicted since the gradation relationship between dull members of the Red family and brown is easily appreciated. However, given the layout of the equi-spaced colour wheel, it is not at all clear why we should get a brownish result rather than a dark, dull blue from Violet 11 and Green 4.

The answer to this puzzle is seen easily when we look at the path of the line from Violet 11 to Green 4 on the enhanced colour wheel. This line doesn't pass through the blue part of the wheel at all, but lies on the far side of the region of maximum darkness, its midpoint being close to that region in the orange section of the wheel. So we get dark orange – in other words, it's brown. This anomaly (if that is the best way to describe it) simply will not show up on the equi-spaced colour wheel and if

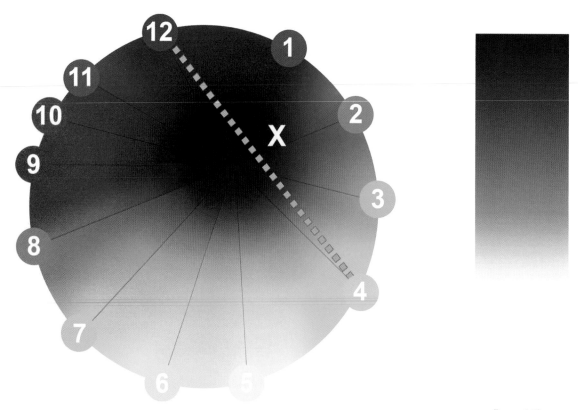

FIGURE 141.

The Violet 12 and Green 4 mix on the enhanced wheel.

FIGURE 142.

**Gradation strip
for the Violet 12
and Green 4 mix.**

you stick with that wheel as the basis of your predictions, then a lot of head-scratching will ensue.

The intermediate combinations, Violet 11 and Green 3, and Violet 12 and Green 4, lie close to the centre of the region of maximum darkness and some pairings of specific materials representing these members of the Violet and Green families may be true complementaries. Otherwise they will produce dark members of the Blue family that tend to have a grey cast. In order to appreciate the blue in this greyness, you will probably have to lay out a gradation strip for the mix from which its blue-greyness will emerge.

Thus, mixing members of the Violet and Green families can generate members of the Blue family, but the possibilities are much more limited than the range of reds we can mix from the Orange and Violet families.

Mixing members of the Yellow family

Finally, we come to the Yellow family. Its immediate neighbours are the Green and Orange families. On the face of it, this does-n't sound like a very encouraging recipe for mixing a yellow of any sort. By now however you should be familiar with the fact

that innocent looking questions of the form, 'what do you get if you mix colour x with colour y?' are more complex than they appear. Once we start to think in terms of hue families, and keep in mind the range of variation that each family encompasses, it becomes easy to see that there must be several answers to this sort of question.

GREEN AND ORANGE

As indicated earlier, we tend to call to mind certain iconic hues when colour names are mentioned. For instance, a lot of people associate 'green' with the colour of grass, and 'orange' with the colour of the skin of the orange fruit. It certainly doesn't seem likely that a combination of these grass-green and marmalade-orange members of the Green and Orange families will produce the iconic banana yellow hue that many of us would conjure up if asked to visualize a yellow patch.

By following our established methodology we can show not only that this combination will probably fail to produce a fully convincing yellow, but also why it fails, and what green–orange combinations will succeed. Hence, we start this exercise as we have with the previous ones, with the members of the neigh-bouring hue families that are closest to the hue we are aiming

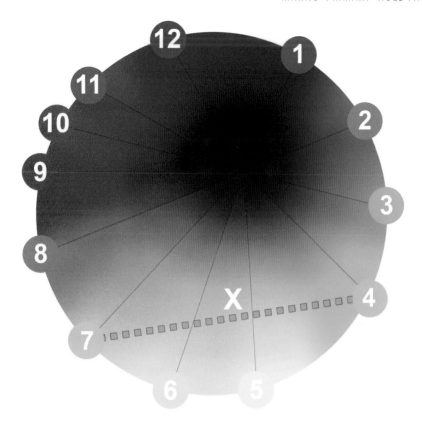

FIGURE 143.

The Green 4 and Orange 7 mix on the enhanced wheel.

to mix: Green 4 and Orange 7. As ever, it is important to assess the result from the viewing position.

Given the conception of colour we have from established theory, producing yellow from green and orange is a highly unexpected result. Nonetheless you should be able to create an unambiguous member of the Yellow family from Green 4 and Orange 7. You may find yourself wondering about this for a bit longer than you did in the case of red and blue, but the same general advice applies here: mask the patch, leave it for a while, and return to it with fresh eyes. In fact, you should find it easier to accept this result as yellow than to accept that Violet 12 and Green 3 produce a member of the Blue family.

Again, the enhanced colour wheel enables us to see why this is so. Although the degree to which the darkening phenomenon affects the Green 4–Orange 7 mix is comparable to that affecting Violet 12–Green 3, the eccentric position of the region of maximum darkness means that the significance of the effect is exaggerated in this second case. If you are still unconvinced, just carry on with these last few examples to complete the exercise and continue to make brief notes identifying clearly why the results have not persuaded you so far.

Green 3 and Orange 8, like the most widely separated components in previous exercises, give us a very dull result, in this case a greenish camouflage hue, rather than anything we would be inclined to call yellow (Figure 144). The intermediate combinations, Green 4 and Orange 8, and Green 3 and Orange 7, yield yellow-earth variations.

What about CMY, the Printers' Primaries?

If you have followed the explanation of the four principles and their application so far, you have probably worked out for yourself that the printers' primaries are not immune to this treatment. That is, even if we suppose that cyan, magenta and yellow are the 'true' primaries and not blue, red and yellow, we won't have three hues that cannot be mixed. Just pick two blue hues either side of cyan or two red hues either side of magenta (in-betweening), draw a straight line between them on the colour wheel (the straight line principle) and bisect the line to determine the degree of darkening. If the hues you pick are close to the target on the wheel, then the result will show less darkening than if they are farther apart.

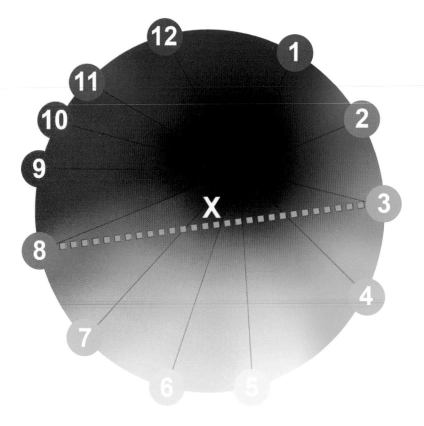

FIGURE 144. **The Green 3 and Orange 8 mix on the enhanced wheel.**

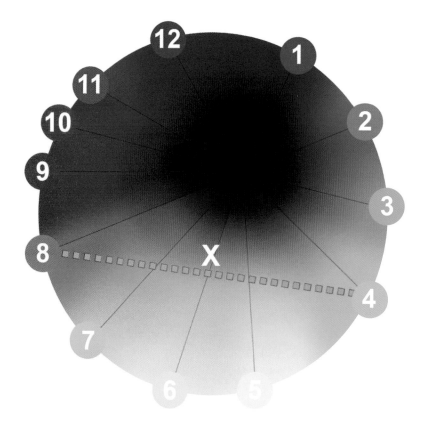

FIGURE 145. **The Green 4 and Orange 8 mix on the enhanced wheel.**

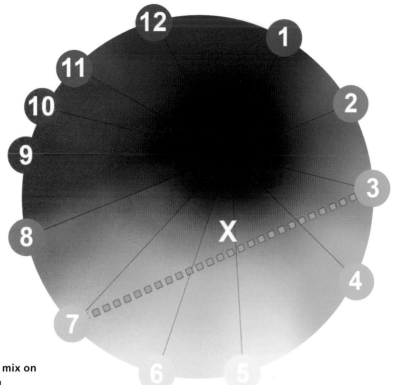

FIGURE 146.
The Green 3 and Orange 7 mix on the enhanced wheel.

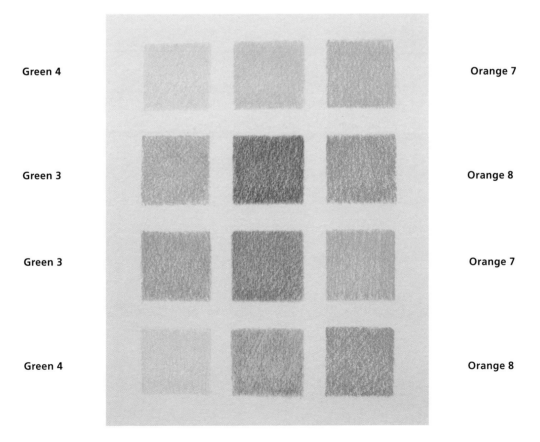

FIGURE 147. **Green and Orange combinations.**

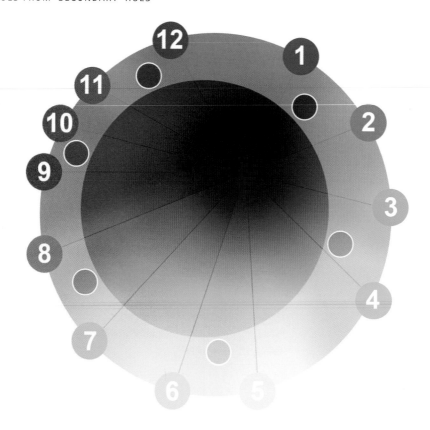

FIGURE 148.
Six mixes on the enhanced wheel with saturation losses.

Are There Any Hues that Cannot be Mixed?

For any given gamut (including the colour wheel, defined by the most highly saturated pigments available), there really are no 'magic hues' that cannot be mixed, except those that lie at its vertices. And that limitation has nothing to do with the primary–secondary distinction. In order to identify the hues required to mix a hue at the vertex of a gamut we would have to have at least one point *outside* the gamut, but because the hues at its vertices are by definition the absolute limit of hue saturation or purity for a gamut, there are no points outside it. So, although it is possible to mix members of all the hue families, it is not possible to mix hues that, with respect to a given gamut, have maximum saturation. All the hue families, 'primary' and 'secondary' alike, are subject to this limitation in precisely the same way.

Chromatic Value and its Reduction

The hues at the perimeter of the enhanced wheel have a high colour value, or chroma. The further we move in towards the region of maximum darkness, the lower the chromatic value of the hues. As we reach that dark region, the less differentiation we can see between hues. In order to assess how well our 'impossible' mixes of members of the Blue, Yellow and Red families succeed, it is a good idea to compare them to the mixes of the Violet, Green and Orange families. To do this we should mask the high-chroma part of the colour wheel and plot the most saturated of the mixes we have produced on the enhanced colour wheel (Figure 148).

The tinted area represents the darkening losses imposed by mixing. As we know, the subtractive mixing process always gives a result that is darker than the lightest hue in the mix, that is, subtractive mixing invariably results in reduction of chroma. So the results of our mixing exercises – shown as dots in Figure 148 – appear some way in from the outer edge of the enhanced colour wheel, reflecting this fact.

In the left column of Figure 149 are patches of red, blue and yellow mixed using only 'secondary' hues. The hue patches in the right column are mixed from only 'primary hues'. The patches on the left are clearly lower in chroma (being darker and less 'colourful') than those on the right.

However, if you cover up the right column and assess the 'secondary' only patches in isolation, they gain in apparent chroma.

Orange 8 +
Violet 11

Red 9 +
Red 10

Violet 12 +
Green 3

Blue 1 +
Blue 2

Green 4 +
Orange 7

Yellow 5 +
Yellow 6

FIGURE 149. **Mixed 'primary' hues.**

They definitely are members of the Red, Blue and Yellow families, even though they are not the most vibrant examples.

The darkening effect of subtractive mixing is emphasized when the result of a mix is seen alongside the components used to produce it. This is because our perceptions of and judgements about colour are highly comparative in nature. We are not easily able to make absolute judgements about the characteristics of single colours in isolation; we need context, or points of reference. Accordingly, colour judgements as to whether some colour sample is, say, red, are pegged against whatever hue we are currently taking (whether consciously or subconsciously) as our reference for red. Our visual system is continually being recalibrated in response to changes in our environment to provide these points of reference.

Consequently, our perceptions and judgements of any given colour sample tend to change with shifts in the points of reference. So, seen alongside the relatively vibrant members of the Red and Blue families that we use to mix our Violet family sample, that sample itself looks rather dull. When seen in isolation on a white background and thus not in competition with 'louder' hues, the mix seems a bit purer. The same goes for all the other hues we have mixed. Therefore you should find it possible to create a colour wheel from these mixed hues that looks –

when not in competition with the purest, most vibrant hues in your palette – balanced and not obviously deficient.

Which colour is that?

With regard to the results we obtained from widely separated mix components, these enclose a smaller and darker part of the colour wheel (Figure 150). This is what we should expect, since these combinations are approaching the maximum separations we see in the case of complementary pairs. Considered collectively, the most prominent characteristic of these mixes is that they all inhabit a region so deep into the colour wheel that they are **chromatically indeterminate**. That is, they are so dark often it is not easy to decide to which hue family they belong. It may appear initially that they can be substituted for each other, and in some circumstances they may be. The different hue characteristics of these initially similar-looking dark mixes can be exploited to produce a wide range of subtle and subdued colouring effects, though it will often be necessary to dilute or tint them in order to reveal their different family affinities (Figure 151).

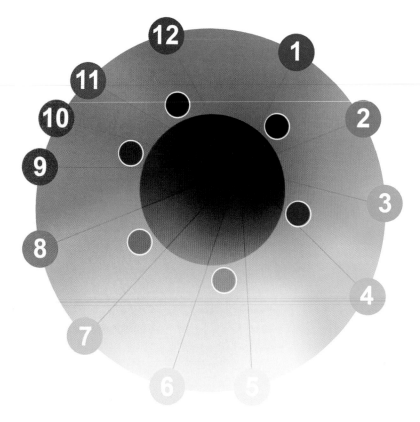

FIGURE 150.

Increasing separation between hues in mixes increases saturation loss.

Summary

We have seen that to mix recognizable members of any of the six hue families, we should select the closest members of the hue families that are either side of the target hue on the colour wheel. Mixing widely separated members of the hue families either side of the target produces very dark results that tend towards chromatic indeterminacy. There is no difference between the so-called 'primary' and 'secondary' hues in this respect; they all behave in the same way.

As far as the Irreducibility Myth is concerned, these results are devastating. Members of *all* of the six hue families can be mixed, including the so-called 'primaries' – blue, yellow and red. To prove the falsity of the Irreducibility Myth, it does not matter that not every combination of two 'secondary' hue family members produces 'primary' hues, only that some do so. This is because the Irreducibility Myth – at least, according to the sensible interpretations – says it can't be done at all. Thus to prove this is wrong, we only have to advance one way of doing it for each of the 'primaries'.

Not everyone is going to like or agree with this assessment. In the next chapter, I examine objections – some obvious, others less so – that advocates of the established theory may put forward.

FIGURE 151.

Tinting dark chromatic hues will reveal their hue family origins.

OBJECTIONS IN DETAIL

Introduction

The primary–secondary distinction fraternity will want to respond to this attack on their position, of course. There are multiple objections to the claim that we have been able to mix all of the primary hues. No doubt some of them have already occurred to you. Let us examine these arguments.

'It can't be red because red is a primary colour and primary colours can't be mixed'

This is not really a proper objection but is straightforwardly just begging the question, in the original sense of that expression. That is to say, this 'objection' merely assumes that the very point at issue has already been settled in favour of the objector. Whether primary hues can be mixed is in dispute, and I have described the means of producing evidence in favour of my claim that these hues can be mixed. This calls for an evaluation of that evidence; simply to issue a bald reiteration of the opposing stance is to ignore the evidence.

'It's *not* red'

This objection flatly denies what I am pretty sure you will have demonstrated for yourself to be true. If the objector is right, then the Orange 8–Violet 11 mix simply is not a kind of red.

However, if this hue is not a member of the Red family, then to which family does it belong? We can confirm that it is not a kind of green, since it lies directly *opposite* the Green family on the colour wheel. What are the alternatives? Does it belong to the Blue or Yellow families, for example? No. And it clearly is not a member of the Orange or Violet families – those are the hues

we started with. So we might argue that by this process of elimination it must be a member of the Red family.

This response may not be regarded as satisfactory if it is borne out of a rejection of the idea that hues can be classified into families. I certainly have some sympathy with a refusal to see the common six hue families adopted here as any sort of 'true', 'right' or 'absolute' classification. It is always open to us to abandon the familiar and convenient, and if an objector wants to propose a substitute for the existing arrangement we should be willing to see if it suits our purposes better than the one already in use. Nevertheless a new classificatory scheme will not alter the visual similarity between a colour sample and a hue mix that aims to match it, since this depends on relationships between the hues, not on our naming conventions. *Call* the hue mix what you like; the question is, to which area of the colour wheel does it belong?

'It's not *really* red'

This might be shorthand for one or more different complaints. One is that the mix in question only *appears* to be red though in fact it is some other hue. What we have here is an appeal to the distinction between appearance and reality, which might variously be developed into the following:

- an accusation of outright concealment, fakery or some other form of deception;
- the exposure of an amusing illusion; or
- an 'explaining away' of why what appears to be a red patch is really something else.

I trust that no one will suspect me of having dishonest motives so that we can rule out the first count. Similarly, on the second count, my intentions are rather more serious than merely to present a series of faintly entertaining tricks. There is a bit more substance to the 'explaining away' potential line of argument,

Simultaneous Contrast

Setting a patch of one colour in juxtaposition with certain others can emphasize or diminish some of its characteristics. The appearance of chroma and hue can both be modified in this way.

insofar as there are several contextual factors to be taken into account when assessing the results of the mixing experiments. In particular, an objector may want to draw attention to the phenomena of simultaneous and successive contrast. As I have mentioned at several stages throughout the discussions so far, context plays an essential role in our perception of colour. The context or environment in which we see this or that discrete colour is shaped in large part by what else is in our view at the same time, and by what we have just seen. By manipulating these factors it is possible to change the apparent hue of a coloured surface, and thus influence people's judgements of hue identification.

Is there any manipulation of this sort going on here? Well, I have certainly encouraged you to view the results in conditions that offer the best chance for the mixing effects in question to show up. So the specification of particular viewing conditions, under normal daylight, and the occasional masking instructions are all geared towards this end. It would be unreasonable to view this as any sort of sleight of hand. These conditions constitute a 'level playing field' that serve as a consistent reference for *all* the colour phenomena examined in the book, not just a few that I want to emphasize in a particular way.

Alternatively, 'not really red' might mean 'not a very good example of red', 'a very marginal member of the Red family', or something similar. I have drawn attention to the fact that, when classifying and naming colours, we inevitably hit areas of indeterminacy and there is often disagreement about when we have hit such an area. What appears unequivocally red to one person under a specific set of conditions may appear conspicuously orange to someone else. However even taking that into account, I doubt that many people would be able to say sincerely that the mix of the colours specified for this experiment produces anything other than red. In fact, I think it would be more reasonable to question whether someone challenging this conclusion was properly able to discriminate between hues. It would be worthwhile for anyone falling into this category to experiment with different members of the Orange and Violet families to be absolutely sure that no combination is able to produce a mix that they would be prepared to call 'red'.

There is one final interpretation of 'it's not really red' that should be given an airing. This one applies most easily to optical mixing processes, like the use of coloured pencils for tackling the exercises. This objection goes something like this:

Clearly, we can see that the hues used in the mix are orange and violet, not red, and if we look closely enough at the patch we can see these separate orange and violet ingredients. So the mix itself isn't *really* red, but is nothing but a more or less densely packed area of orange and violet marks.

On one level, this amounts to a simple refusal to accept that optical mixing is a genuine phenomenon. Now, I am in no position to insist that a person who sincerely claims not to see what I am presuming the rest of us can should deny the evidence of her or his own eyes. After all, it is the evidence of our own eyes that constitutes the entire ground of my case. So, if others find that their eyes don't reveal to them what I see, then I have to be prepared to accept the sincere reports of their findings. However, I do not think that this objection is likely to arise from a dispute about what we can see. Rather, I see it as a consequence of confusing what we *know* with what we see. We see a red patch even though we know it is composed of non-red components.

This should only impress us if we think there is something to the idea that, because the components of a coloured patch are not red, the entire thing cannot *really* be red. The general form of this idea is that, if the parts of a thing lack a certain property or attribute, then the thing as a whole must also lack that property or attribute. This objection can be extended to include wet-media mixing too, but it is a pretty feeble idea and at this point it starts to exude a strong smell of implausibility. A single brick cannot support a weight of several tons, whereas a wall of many thousands may be able to do this; the individual molecules of a razor have no cutting edge though the razor itself does, and so on. In some circumstances it may be reasonable to say that a brick wall is 'nothing but' a pile of bricks, or that a razor is 'nothing but' a complex configuration of molecules. However this should not lead us to insist that, contrary to appearances, brick walls can really only support as much weight as a single brick, or that razors are not really sharp. Likewise, there is no good reason to suppose that our hue mixes can't have properties that their components lack.

The objector may think that the appearance–reality distinction opens up a gap in which to insert the claim 'this mixed patch is not really red'. But there is no such gap, since we are only concerned with the appearance side of that distinction – with what we can see, with the practical outcome of our hue mixing. The fact that we know (or may not know) what accounts

Successive Contrast

The apparent hue of a coloured surface can vary depending on what has been viewed immediately beforehand. For example, the chroma of a given surface may seem reduced in value when seen immediately after a brighter or much more saturated example.

for the visual effect is ultimately a side issue if the focus of our investigation is – as ours is – entirely practical.

'But the colours you've used are "reddish"'

Naturally, if we mix two reds together we will get some sort of red as a result. So that would be one way – a rather facile way, some would say – of mixing red. This possibility, as applied to blue rather than red, was discussed earlier in Chapter 9. I do not think that either of the hues used in our exercise are red. However, not surprisingly these particular hues have been chosen for this experiment because they are biased *towards* red (in the same way that we would choose a blue and yellow both biased towards green if we were trying to demonstrate how to mix green). As we have seen, if we mix a blue and a yellow biased away from green, we get a result that is not an iconic example of green. The same holds true in the present case. If we want to mix a convincing red, then we should choose ingredients that are likely to give us that result. Of course, the weaker the red bias of the hues, the darker the resulting member of the Red family.

'You haven't mixed red; you've just modified the hues you started with'

Once again, some people might be inclined to say 'Not so fast: what you're talking about here is *modifying* one 'primary' hue with another – that's not really *mixing*, is it?' In a way the whole central issue discussed here is captured in this remark. *Of course* we have 'just modified the hues we started with' – that is precisely what colour mixing amounts to. All mixing can be construed as 'modification', which in this context just means 'bringing about a change'. And modification is precisely what we're after; if there were no modifications of one hue by another, then there would be no mixing effects.

However, by revising the interpretation of the Irreducibility Myth yet again, perhaps the objection could be strengthened. The idea of 'mere modification' gets thrown in here as a way of drawing attention to the fact that the means of mixing the primary hues being contemplated already includes that primary hue. We start with a member of the Red family included in the palette and 'just modify' it a bit. So the complaint is that this is merely another version of the earlier cheap stunt in which the mixing of blue was accomplished by mixing Blue 1 and Blue 2. Hence, we might help out the advocates of the Irreducibility Myth by saying that what they really, *really* mean, is that no primary hue can be mixed using *other hues alone*. That is, no Red family member can be mixed from two hues if neither of them is red. However, as we have seen, even this revision of the Myth fails.

If you fully understand this and approach colour mixing from the perspective of the simple question, 'how will this hue, *A*, modify this other hue, *B*?' you will find it progressively easier to break free of the creative limitations imposed by the primary–secondary hue distinction.

'But you can't mix a really *pure* red'

It is true that we cannot mix a red as pure as the purest reds straight out of the tube – but neither can you mix the purest greens, violets or oranges. As Principle 2 tells us, mixing two coloured pigments always results in a product that is darker and less vibrant than the purest, most saturated colour used in the mix. That this always happens when mixing green, violet and orange has never persuaded advocates of the traditional view that we cannot mix those hues. By the same token, we should recognise that we *can* mix reds, though in most instances they will not match the vibrancy of some unmixed pigments obtainable straight from the tube. The red colour we have mixed is certainly some way in from the outer edge of the colour wheel, and therefore it is darkened to some extent, but it has by no means reached the point where we could more plausibly call it, say, brown, than red.

What we should say about this mix is that it is as much a red as our saturated and clear mix of green from blue and yellow is a green. If we reject the idea that we have mixed red, I think that by the same token we have to give up on the idea of being able to mix green, orange and violet. So the champions of the primary–secondary colour distinction face a dilemma. Either they will have to concede that red can be mixed – in which case the distinction falls because the Irreducibility Myth is false. Or they can stick to their guns and refuse to admit that we can mix red, but this means also abandoning the idea that we can mix green, orange and violet. If we cannot then mix these 'secondary' colours, then the Sufficiency Myth – which says that the secondaries *can* all be mixed from primaries – must be false, and so the Myths would contradict each other.

Just to make this point clear: the Sufficiency Myth says that using just three 'special' hues – the primaries – all other hues can be mixed. Even advocates of the two Myths would accept that there are many innumerable reds, blues and yellows that form hue families. A three-hue palette (whichever version), however, includes only one member of each family. Thus, there are numerous other members of each of the 'primary' hue families

that, though they can be derived from a three-hue palette, can only be produced by combining those hues in various ways, and this is simply *mixing*. Clearly, the Sufficiency Myth can only be true if it is possible to mix many members of the 'primary' hue families. However the Irreducibility Myth tells us that primary hues *can't* be mixed. So if the Sufficiency Myth is true, then the Irreducibility Myth can't be true. Conversely, if the Irreducibility Myth is true, then the Sufficiency Myth can't be true. Thus, *at most*, one of the Myths could be true. (There is, of course, another possibility, which is that *neither* Myth is true. And this is in fact the case.)

'Is it blue?'

Many of the responses in respect of the red mix apply to blue too. However, we found the purity of the blue mix markedly lower than that achievable in the case of red. It would be worth reinforcing some of the observations already made about this.

'But is it *really* blue?'

If it is objected that this is not *really* blue, the reply is that the fact that it isn't the most vibrant, electrifying, dazzling, supersaturated pure blue doesn't mean this hue isn't blue. There are dark, dusky, muted, subtle, smoky blues too. As we have seen, because this is a subtractive-mixing process, the results are always subject to the darkening principle. The enhanced colour wheel clearly illustrates why the effect of this principle is exaggerated in the case of the Blue family by showing the eccentricity of the region of maximum darkness and the non-uniform spacing of the hues around the perimeter.

To the 'objection' – if that is what it is – that we have used 'blueish' colours to mix this blue, the response is '*of course* we have', insofar as we have used colours biased towards blue.

Mixing Yellow: Does It Just Seem Impossible?

One barrier to the acceptance that we can mix yellow is the basic defining characteristic of subtractive mixing – that the products of mixed pigments are always darker and duller than the ingredients used in the mix. This thought is in tension with the overwhelming psychological tendency in many people to think of yellow as a bright and light colour. So, if yellow is a bright and light colour, how could it ever be the

product of a process that always gives us *darker* colours than our initial ingredients?

The mistake here is to allow this psychological tendency to ride roughshod over the evidence of our own eyes. As with all the other hues we have mixed, there are light and pure varieties, but there are also dusky and muddy shades, and pale and delicate tints, as well as the intense and vibrant examples. It may not be possible to match most yellows straight from the tube, but this doesn't rule out the possibility of mixing less arresting examples.

Therefore, depending on the specific materials you use, your result may look more like yellow ochre than it does cadmium yellow. If this is the case, ask yourself '*what* sort of ochre is it?' It is not green ochre, or blue ochre, or red ochre – it is *yellow* ochre. And there's a pretty straightforward answer to why we call yellow ochre by that name: because it falls within the Yellow hue family segment of the colour wheel.

If Not Yellow, Then What Is It?

Some people might accept that the experiments to mix red and blue were more or less successful, but may claim that this current result is nothing like as convincing. Surely yellow, they may say, is the hue of the sun, of lemons, of buttercups. This sickly, dingy green-orange could never pass as a sample of those hues. If we therefore reject the contention that we have mixed yellow, then what hue is it? Let us consider the options:

- *Is it achromatic (that is, is it black, white or grey)?*
 No, it is definitely chromatic.

- *If it is chromatic, to which hue family does it most plausibly belong?*
 The objection is that it does not belong to the Yellow family. So is it more like blue, violet, red, orange or green than it is like yellow? Some people might insist that the mix is more orange or more green than yellow. If this is so, we should adjust the balance (so that the result is in their judgement equally balanced between orange and green) and ask again, what hue is this?

- *If it is chromatic but doesn't belong to one of the six hue families, then does it belong to some other hue group?*
 This move is always an option. Remember that our colour grouping, naming and other classification strategies are conventions. That is, they follow rules made by us rather than following rules discovered in nature. Some of these conventions are indeed arbitrary, which is to say that the rules in question have no particular justifiable claim to be

superior to any other rules we might have chosen. However, no one disputes that yellow lies between green and orange on the spectrum and the colour wheel. No one disputes that orange, green and violet hues can be mixed using the hues that flank them on the spectrum and colour wheel. And many people can, I think, be persuaded that the same does in fact hold true of blue and red, in spite of what the Irreducibility Myth says. So why should yellow be any different? Is there something magical about yellow? (If so, where does that magic reside – in yellow paints or in 'the colour yellow itself'? What could that mean?)

The truth of the matter is that it is possible to mix green and orange paints so as to produce a yellow result. I think it would be fair to say that, given the present restricted choice of high-saturation green pigments biased towards yellow, it would be difficult to reproduce the cadmium yellow-like quality of butter-cups this way. However, with the right materials, it is perfectly feasible to mix an unambiguous member of the Yellow family. Can such a mixture properly represent the paradigm yellows in the sun, in lemons and the buttercup? In the right context I would say yes, it can. With particular regard to the sun, how-ever, although it is often represented as being yellow, this is a prime example of an arbitrary convention. Certainly, the sun does appear yellow at times, but it can also appear white, orange, pink, or any number of varieties of red. The yellow sun has become an icon, a kind of visual shorthand.

Before we reject the colour we have mixed because it fails to reproduce accurately this or any other ideal or iconic notions of yellow, we should remember that we recognize many other par-adigmatic yellows. Think of the colour of gold, of sand, or of a cornfield. All of these are popularly regarded as yellow, and can readily be mixed in the way described earlier. It is true that we often describe the colour of things as 'gold', or 'sandy', rather than 'yellow'. However if we were talking to someone who had never seen gold or sand, we might help them understand the appearance of these things by describing them as 'yellow', and then adding some additional modifiers such as 'pale', 'desatu-rated' and so on. A similar process of translation and explana-tion occurs when one person has decorated the walls of a room with, say, 'Hapsburg'-coloured paint and describes the result to someone who has not yet seen it (for example, 'it's a kind of pale/smoky/kingfisher blue').

The power of iconic, paradigmatic colour visualizations can seriously undermine our capacity to mix colours that belong to the yellow family. This is because the icons – the yellow of 'the sun', buttercups, lemons and others – dominate and thus restrict our conceptions of yellow to a much greater extent than, say, iconic versions of blue tend to restrict our conceptions of blue.

Summary

This chapter considers most of the common objections to the claim that, contrary to what we have always been told via the Irreducibility Myth, 'primary' hues can be mixed. I don't expect everyone to be persuaded by the evidence, or by the responses to the objections. However, I do expect that most people who appraise the results of the exercises with an open mind will agree that the two Myths are starting to unravel rapidly in the face of the evidence against them.

UNIQUE AND NON-UNIQUE HUES

Although superficially there appears to be a considerable degree of agreement about the identification of colours, below the surface it remains a controversial topic in just about every academic area in which colour is a concern. Not only are there, for example, disputes between anthropologists and philosophers, and between psychologists and linguists; there are disputes within these and numerous other disciplines. Anthropologists disagree among themselves, there are rival camps in philosophy, there is conflict between psychologists and diversity of opinion in linguistics. One major area of dispute is over whether there are **unique hues**, hues that cannot be described in terms of hues other than themselves.

Even among those who support the idea of unique hues there is no agreed account of which hues have this property. There are two popular current views: one view claims four unique hues (red, blue, yellow, green); the other claims there are a further two (black and white). Taking red as an example, the idea is that there are no colour words other than 'red', 'reddish' and so on, that properly describe the colour red. This contrasts with non-unique hues such as orange, which can be described in terms that don't include 'orange' – for example, as 'a reddish-yellow' or a 'yellow-red mixture'.

We cannot concoct this sort of composite description of any unique hue, so it is claimed. Is that true? Well, it certainly seems to be true of black and white. What about the other candidates, though? As we saw in Chapter 8, examination of the spectrum or the colour wheel shows that the so-called primary and sec-ondary colours alternate, so that each secondary colour can be seen as the 'product' of the primary colours that lie either side. Thus, descriptions of the non-unique hues such as orange and violet are couched in terms of their nearest unique hue neighbours in the spectrum or on the colour wheel.

Clearly this proximity works the other way around – the supposed unique hues have non-unique hue neighbours – so why can't we describe the alleged unique hues in their terms? The difference appears to be that whereas the description 'reddish-yellow' calls to mind the non-unique hue orange, the description 'orangey-magenta' allegedly fails to call up anything specific – certainly not *red* – so we are encouraged to agree. There seems to be an assumption here that we can 'see' the red and yellow in orange but we cannot 'see' the magenta and orange in red.

Imagine This...

Talking in terms of 'seeing' obviously suggests the issue is a matter of perception. Perhaps, however, there is a more dominant factor at work. Our individual powers of imagination are in question here; different people are not equally good at imagining things, and so plausibly it can be doubted that each of us will be able to 'see' component hues in colours to the same extent. In view of this, I think we should be prepared to concede the

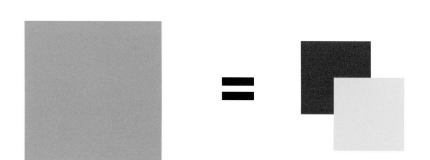

FIGURE 152.
The claim is that whereas this hue can be seen as a mix...

FIGURE 153.
...this one, being unique, cannot be
seen as a mix.

possibility that some people who would reject the claim about 'seeing' orange and magenta in red would similarly reject the claim that red and yellow can be 'seen' in orange.

However, the imagination can to some extent be given a helping hand and it seems most plausible to suppose that the ability to discern the components in non-unique hues is something that emerges, if indeed it does, through coaching and learning. Children are taught that red and yellow produce orange when mixed, and although there is no straightforward way to actually decompose an orange mixture back into its components, the reversal of the process can be modelled in the imagination. The idea that there is red and yellow 'in' orange may well develop through this learning process, even if it is not accompanied by a mental image that resolves the individual components of a colour compound. So when people say that they can see yellow and red in orange, maybe this has more to do with what they *know* – that orange can be mixed from yellow and red. Perhaps the same applies to violet. We know it can be mixed using red and blue, and so we are tutored to say we can see red and blue in violet. It is possible however that although we know that vio-

let has these components, maybe we don't really see them.

There is a lot more to be said about the idea of unique hues. For example, is this uniqueness a real feature of certain hues or an artifact of the way we talk about them? In spite of its interest, such a discussion would be too great a diversion from the main business of this book. The notion of a unique hue makes an appearance here only to point out that it is not the same concept as that of a 'primary' hue. The idea of a *unique* hue relates to our powers of discrimination, to what we can identify and to what we can imagine. The idea of a *primary* hue concerns the properties of the materials used in physical colour-mixing processes. So even if the weight of argument eventually comes down in favour of there being such things as unique hues, this does not undermine or falsify the claim that primary hues can be mixed from other hues; indeed, our evidence shows that this is something we can in fact do. There is however a danger that the limits of some people's chromatic imaginations (their ability to recognize the uniqueness of certain hues) may spuriously come to be thought of as limits of 'colours themselves', which could serve to justify the primary—secondary hue hierachy.

THE DECLINE AND FALL OF THE MYTHS

Introduction

In the face of the demonstrations so far it may seem that the Irreducibility Myth has lost all credibility. Plainly, we can mix members of the primary hue families Red, Blue and Yellow and, although we will see there are a couple of last-ditch ploys that might be advanced to save it, the game is all but over for this Myth. However, our first task in this chapter is to look more closely at the Sufficiency Myth, its potential refinements and ultimate collapse.

The Sufficiency Myth in its usual form claims much more than the idea that a variety of red, blues and yellows can be mixed from a three-hue palette. It also claims that *all* other hues can be mixed from the three – usually understood to include not only the rest of the Red, Blue and Yellow hue families (thereby apparently contradicting at least some versions of the Irreducibility Myth), but also the 'secondary' Orange, Green and Violet families in their entirety. Let us see how well that claim stands up to investigation.

Gamut Testing

Traditional three-hue theory fails to produce a good general-purpose gamut, and this falsifies the Sufficiency Myth. The key problem is that if we restrict ourselves to one or other of the traditional sets of three primary hues at least part of our gamut will be unacceptably dark. This problem has been and continues to be widely misunderstood. Many writers suppose that if only real-world primary blue, yellow and red paints behaved like ideal theoretical primaries, all would be well. They misdiagnose the problem as a failure of real pigments to produce a 'true' primary blue, yellow and red. This mistaken diagnosis is rarely if ever spelled out but, reading between the lines, it seems to come to this:

■ no real pigments lie at the true primary points on the colour wheel, and so…
■ we can't get three properly placed points on the colour wheel and so…
■ the gamut will be skewed and so…
■ the theory (that is, the Sufficiency Myth) cannot accurately be put into practice.

We are back with the familiar well-worn attempt to prop up the established view: 'in theory, so-and-so should happen… but in practice it doesn't'. This outlook gets us nowhere in dealing with the obstacles that traditional three-hue theory puts in our way. As I have said already, colour mixing is a practical business and so a theory that doesn't work in practice needs to be replaced by one that does. However, even with supposed 'pure' primaries the results would be scarcely better. To appreciate that this must be so, let us make sure we understand why three-hue palettes fail to give us a decent general-purpose gamut.

Three-hue gamuts come in various shapes and sizes, determined by which three hues they include. With three hues we have three points to plot on the colour wheel, and if we connect each point to the other two with a straight line we project a triangle onto its surface. Working within the constraints of

FIGURE 154.
The gamut shape assumed by traditional theory.

FIGURE 155. **Examples of alternative gamut shapes.**

established colour theory, this would be done using the equi-spaced wheel. The area enclosed by the triangle represents the gamut achievable with the three hues. The points selected are typically on the circumference of the wheel (but they don't have to be; see Appendix 1 on palette choices). Also, conventional wisdom maintains that the three true primaries are equidistant, so that the projected triangle is equilateral, with the intention of securing a gamut that will be the most extensive obtainable from three hues. (Note that, considered mathematically, there are innumerable equilateral triangles that can be projected onto a circle. Note also that on the enhanced colour wheel with its unequal distribution of hues in the spectrum the positioning of the primary hue positions will not be equidistant. Thus the triangle they form will *not* be equilateral.)

However, we can deliberately skew the gamut in a particular direction by choosing points (that is, hues) that aren't equidistant (Figure 155). Hues that are close together on the colour wheel will mix to produce a narrow range of relatively pure intermediate hues. Hues that are far apart will produce a greater range of intermediate hues, but this increased range is achieved by the addition of greater proportions of darker hues. Regardless of the shape of the gamut, in-betweening, darkening and the straight line principle all still apply.

So if we go for the equidistantly spaced 'pure' primary model the result is a classic compromise. Even in this *ideal* model no areas of the colour wheel are very well served, and some areas suffer considerably. In fact, putting the matter in this way obscures what is really a pretty dire situation. If the area enclosed by a triangle projected on the colour wheel indicates the hues that a three-hue palette *can* reproduce (Figure 156) then the portions of the colour wheel it doesn't enclose indicate the areas it *can't* reproduce. The areas outside the triangle are, to coin a technical phrase, **out of gamut** (Figure 157).

The failure of the traditional three-hue primary palette in

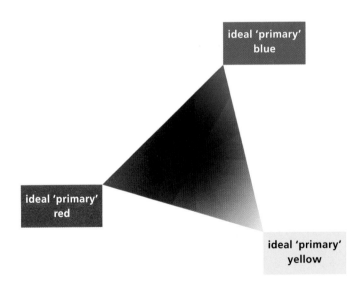

FIGURE 156.
The gamut available from three equidistant 'primary' hues excludes large areas of the colour wheel.

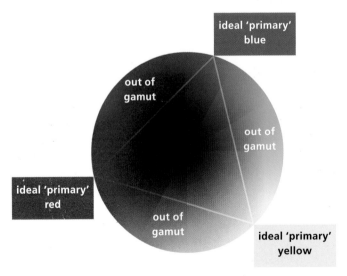

FIGURE 157.
Out of gamut areas, given three equidistant 'primary' hues.

practice is not chiefly due to the imperfections of available pigments. The real nature of the problem is that three is simply too few hues.

The True Cost of the Compromise

So even if we had 'perfect' primary hues (whatever we suppose that would amount to), the triangular geometry that results from restricting the palette to three hues would impose exactly the same constraints on the gamut. At best, we could say that using just three 'primary' hues, it is possible to mix some members of every 'secondary' hue family. But given most people's typical conception of these hues this would be a very restricted palette.

It should be apparent that whichever three members of the Red, Blue and Yellow families we choose, we cannot improve on this result in terms of the area of the colour wheel we are able to capture. We could orient an equilateral triangle any way we wanted, but the same restrictions on the gamut would apply. The reproducible hues would change for each three points selected on the perimeter, but the proportion of the wheel covered by the triangle would be the same in all cases.

It is important to note that restricted palettes are not themselves intrinsically problematic or without their uses, but they don't qualify as general purpose palettes, by definition. And the fact that a general purpose palette can't be derived from any combination of three hues falsifies the Sufficiency Myth.

Failure of the Sufficiency Myth: Response 1 – Biasing the Traditional Primaries

Realizing these gamut restriction problems, many writers and theorists recommend an expanded palette of six hues based on the principle of biasing (*see* page 36). This improves matters significantly, since we can expand the gamut to the sort of shape indicated in Figure 158. (Note that this schematic diagram makes the improvement look better than it actually is, since it does not take account of the accuracy improvements afforded by the enhanced wheel. We will be returning to that model in a moment.)

This response is still rooted in the primary–secondary distinc-

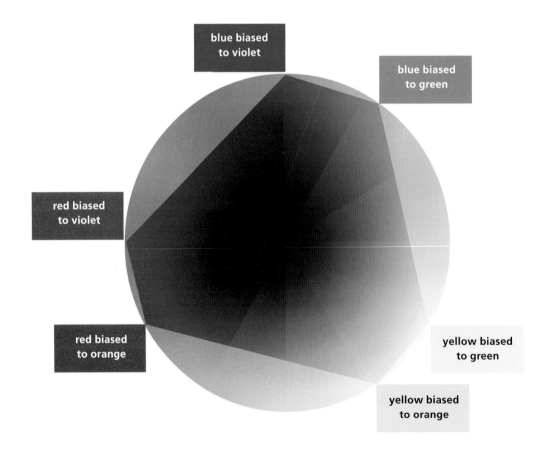

FIGURE 158.

Enlarging the gamut by using biased 'primary' hues.

| primary Blue family, violet branch | non-primary Blue family | primary Blue family, green branch |

FIGURE 159. **An ill-advised complication to the division of a 'primary' hue family.**

tion, however. The palette hues are all versions of primary hues, with their mysterious superiority; no 'inferior' secondary hues are included.

Note also that this improvement is bought at the expense of abandoning the purist understanding of the primary–secondary distinction. Accepting biasing involves reverting to a definition of 'primary hue' that allows more than one such hue within each of the relevant hue families. Thus within this framework it would be difficult to talk of say, blue, being a primary hue. It might seem more accurate to talk about 'primary hue *families*', but this adds further unwelcome complications. Should we presume that all varieties of blue qualify as primary and thus belong to the Blue primary hue family? Given the considerable variation in the members of a hue family, this sounds implausible. So which ones would we include as candidates for the title 'primary blue'? The best results in terms of enlarging the gamut are achieved by having two versions of each primary that represent extremes of their respective hue regions.

However it doesn't seem sensible to suppose that these extremes are part of the Blue primary hue family while blue hues between them on the wheel form some kind of also-ran 'ordinary' blue family. That introduces a kind of spectral discontinuity that would be hard to justify (Figure 159). In the face of this division it might seem best to introduce the idea of two separate primary Blue families. That still seems a little strained. Repeating this in the case of red and yellow, what sense would it now make to say there are *three* primary hues? Rather than having to grapple with these confusing complications the solution is to let go of the primary–secondary distinction entirely.

Failure of the Sufficiency Myth: Response 2 – Adopting the Printers' Primaries

Even more recently there has been another response to the Sufficiency Myth's practical failure. It occurred to some artists that

their established colour-mixing theory has quite a lot in common with the four-colour CMYK process used in the printing industry (discussed in Chapter 4). The three chromatic materials involved (setting the printers' use of black to one side for a moment) are regarded as 'primary' in much the same way as artists' primary hues. There are two crucial differences between the printers' and the artists' primary hues, however. First, the printers' primaries are not the same hues as those advanced by the artists' traditional three-hue theory. Both sets of primaries do feature yellow, but in four-colour process printing cyan and magenta replace the artists' blue and red respectively.

Second, the four-colour process is regarded as providing a more extensive gamut in practice than the artists' three-hue theory. Certainly, this palette provides a *different* gamut, and its particular strengths are perhaps particularly well-suited to a wide range of undemanding applications for which naturalistic hue reproduction is required. In fact, we will see in a moment why this perception arises. A CMY palette is better than the original artists' red, blue and yellow (**RBY**) three-hue set in mixing highly saturated greens and the reddish end of the Violet family. These advantages are won at the expense of the limited reproduction of vibrancy in the red–orange region of the colour wheel. However pure, vibrant orange is a relatively rare occurrence in our environment so this may be an acceptable sacrifice for a general-purpose palette. There are other deficiencies in a CMY palette (and some are mentioned below) but, if we want the gamut that can deal best with the range of hues we tend to encounter in the natural environment, then cyan, magenta and yellow win over red, blue and yellow.

In the face of this perceived superior performance, many artists and colour theorists decided that their established three-hue theory was mistaken to the extent that it identified the wrong hues as primary. They are still impressed with the Sufficiency Myth claim that all hues can be mixed from just three primaries. But they suppose that the printers have got the *true* (or truer) primary hues, and this must explain the better general-purpose performance of the printers' palette. Therefore, their argument concludes, artists should adopt that palette too.

There is another feature of the printers' primaries that at a

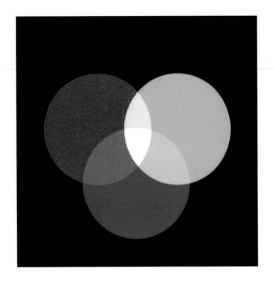

Additive primaries

Printers' primaries

Figure 160.

theoretical level makes them more appealing than the red, blue and yellow of the artists' three-hue palette. This is the relationship between subtractive and additive primaries. Established theory maintains that subtractive mixing has one set of primaries – red, blue and yellow – whereas additive mixing is based on another set – blue, red and green. However, colour theorists have struggled to give a convincing account of the relationship between these two sets. Most accounts state that there is a difference, and simply leave it at that.

If we adopt the printers' primary hues, then a very clear inverse relationship emerges between the subtractive and additive schemes. The printers' primaries (cyan, magenta and yellow) are the additive *secondary* hues. The additive primaries (blue, red and green) are the printers' subtractive *secondary* hues.

Mix two primary hues in the additive set and the secondary hue produced lies between those two on the colour wheel and also is a primary hue in the subtractive set (for example: blue + green = cyan). Conversely, mix two primary hues in the printers' subtractive set and the secondary hue produced lies between those two on the colour wheel and also is a primary hue in the additive set (for example: cyan + yellow = green). That's all very neat and satisfying, isn't it?

Theoretical neatness has its charm but the real reason why we might consider adopting the printers' primaries for all subtractive mixing applications is superior performance. So, before going along with the enthusiasts for this revised three-hue palette it would be as well to examine their claim that it *does* perform better than its established blue, red and yellow alternative. Is this true?

CMY, RBY, and the Sufficiency Myth

In spite of the casual claims made on its behalf, the cyan, magenta and yellow trio fails to fulfil the defining characteristic of primary hues encapsulated in the Sufficiency Myth. That is, it simply isn't true that from just these three hues all others can be mixed. Printers know this of course, and where accurate colour reproduction across an extensive gamut is called for it is common practice to supplement the hues in CMYK with others.

CMYK provides a good general-purpose gamut for non-critical, undemanding colour-mixing applications. Like any palette limited to just three chromatic elements, however, it has pronounced areas of weakness as well as strengths. For example, photographers complain that the delicate pinks and blues in their work are difficult to reproduce in CMYK, and that orange hues tend to be dull, and so on. No doubt some of these deficiencies are peculiar physical constraints associated with the mechanics of translating photographs into print. But the problem is only partially one of which hues are in the palette. The real root of the trouble is, once again, that for general-purpose applications beyond the lightweight demands of magazine pictures and billboard advertising, *three hues are too few*. Analogous problems are inescapable if we substitute the printers' primaries for red, blue and yellow in painting.

Artists who adopt the printers' primaries will find that they have a different gamut to that obtainable using RBY, but whether this gives 'better' results depends entirely on the tasks for which they use it. Adopting cyan and magenta instead of blue and red may introduce new strengths to the three-hue palette, but it inevitably introduces new areas of weakness too.

FIGURE 161. **The Red–Blue–Yellow gamut on the enhanced wheel.**

FIGURE 162. **The Cyan–Magenta–Yellow gamut on the enhanced wheel.**

We can see all these factors clearly if we map the gamuts of the two competing three-hue palettes on the enhanced colour wheel. First, take a look at the gamut of the traditional red, blue and yellow palette. This version is typical of many I have encountered. Red is represented by something close to our palette hue Red 9; a medium-to-light cadmium red is often specified. The blue, corresponding to our Blue 1, is ultramarine blue. Yellow would most likely be cadmium yellow light, which would fall roughly between our Yellow 5 and Yellow 6.

Now let us consider a version of the printers' primaries which roughly corresponds to our Violet 11, Blue 2 and Yellow 5 (try quinacridone magenta, pthalo blue – in its 'green shade' version – and hansa yellow light), as shown in Figure 162. In both diagrams, the area enclosed by the triangles represents the hues that we can expect the three hues to yield when mixed. Three striking features of the comparison are:

▦ There is no appreciable difference in the area of the triangles.

▦ The region of maximum darkness is almost at the centre of the printers' primary gamut, but skewed towards the blue apex and the blue–yellow edge of the traditional primary gamut.

▦ The range of hue difference in the printers' primary gamut is greater than that in the traditional primary gamut.

So there really is something to the claim that the printers' primary palette improves on the traditional red, blue and yellow trio if we are looking for the best balance of mixable hues. Note that the equi-spaced wheel obscures these differences. Once again the true picture only comes to light if we use the enhanced colour wheel as the basis of the comparison. However, it is not all good news. The triangles show the areas where each gamut can reach so, obviously, the areas outside the triangles in both cases represent the hues that are out of gamut. Even though the printers' primary gamut provides greater hue variation and balance than its competitor, there are still substantial areas of the wheel that it cannot reproduce, significant portions of which are reproducible by the traditional RBY alternative.

Faced with these differences, it isn't possible to make a blanket pronouncement about which palette is superior. That judgement awaits some further information relating to what aims we have in mind. If a general-purpose palette is what is required, isn't there an even better solution?

Failure of the Sufficiency Myth: Response 3 – Biasing the Printers' Palette

You might think an even better way to deal with the problems with the Sufficiency Myth would be to amalgamate Responses 1 and 2. If three hues are too few, then the obvious remedy to this is that we should add more. Adding three more hues to make a biased palette as outlined in Response 1 makes sense and really does enlarge the gamut dramatically. And if red, blue and yellow aren't the 'true' primaries (by whatever test) and cyan, magenta and yellow are, then we should use them instead. So putting these two thoughts together suggests that our palette should contain two versions of each of these newly approved primaries. As well as the two yellows proposed in Response 1, there should be one cyan biased towards blue, another towards green, and a magenta more red than blue, and a second one, more blue than red.

There is no overt incompatibility between Responses 1 and 2 and we might suppose that a combination of the two would be a natural unifying development in colour-mixing theory. Yet curiously, there is (at least to my knowledge) no one backing the adoption of this hybrid of the two responses. Perhaps those who advance Response 1 are keen to maintain a distinction between artists' and printers' activities and materials that demands a separate set of primaries for both. It is far from clear what the motivation for this separation would be, since colour mixing in both printing and painting are instances of the same physical phenomenon. Equally, maybe the fans of Response 2 stubbornly remain wedded to the minimalist purity of the 'do all this with just three hues and no more' mentality that drives the Sufficiency Myth. For anyone who holds this view, admitting the need for additional hues would amount to a serious loss of faith.

One clear obstacle to this proposed hybrid position is the fact that, traditionally, cyan and magenta aren't considered to be hue families that have several members. Rather, they are thought of as members of the Blue and Red families respectively. However, there is nothing stopping us realigning the division of the hues, turning cyan and magenta into families. Nothing, that is, except the weight of tradition that has proven so very difficult to dislodge in other respects, as we have seen. Nonetheless it should be clear that, if we absorb the advantages to be derived from Response 1, Response 2 on its own is a retrograde step, since it involves reducing the palette from six hues back to three (which, as we have seen, results in severe gamut limitations).

The Irreducibility Myth: The Final Throws of the Dice

The Irreducibility Myth has been subjected to quite an assault throughout the exercises, and I would hope by now to have convinced the majority of people of its falsity. However, there are a couple of straws at which the remaining champions of the Irreducibility Myth may try to clutch.

The paint in a tube labelled 'primary'

Supporters of the Irreducibility Myth may concede that we should regard the six major hue names as the names of families, each one of which has many members. So it would be agreed that there is no single red or green, and so on. However, you will hear some of them go on to say something like this:

> Among the various members of the Red family is a hue that is the true *primary* red. Similarly the Blue and Yellow families contain *primary* blue and *primary* yellow respectively. Why, some manufacturers even conveniently label some of their paints in precisely this way. And it is *these* hues that can't be mixed by combining other hues alone.

This may appear to be a good tactic in the face of the need to recognize the wide variations of hue within each family. The claim that the entire spread of, say, the Blue family can be classified as primary in the required sense is entirely implausible. Any revision of the Myth that makes this clear has to be regarded as an improvement.

So, is this a good response? Well, it may come as a surprise to some people that paints marketed as 'primary' hues are often in fact pigment *mixtures*. (For example, the 'Primary Yellow' made by the Golden company is a mix of three yellow pigments, plus white; the same company's 'Primary Cyan' is a mix of two blue pigments, plus white.) This is not to denigrate the quality of these paints, but merely to illustrate the fact that the label 'pri-

mary' has no special significance with regard to whether they are single pigments or compounds – and pigment compounds are, well, *mixes* of pigments.

Also, if they take this route, defenders of the primary–secondary distinction would need to tread very carefully. It would not do to say, for example, 'blue is a primary hue' because, according to this revised version of the Myth, not all members of the Blue family are primary. During the discussion of the first response to the failure of the Sufficiency Myth, we saw that the proposal to split the RBY hue families into primary and non-primary branches introduces more problems than it solves. Also, even if these complications could be overcome, some explanation would still be required of the special magical property possessed by just three hues that prevents us from mixing them.

Summary

We have looked at several ways in which the Sufficiency Myth might be reworked or reinterpreted to make it seem more plausible. I suspect that it will come as no surprise to learn that I regard all of these attempts at refinement as inadequate. This is not to say there is no good in them at all. Response 1 makes clear the value of expanding the number of hues in the palette; Response 2 brings out the importance of tailoring a palette to its intended application; and Response 3 gives us the best of both these worlds. Yet in spite of the advances they offer in reducing the obstructive influence of the Sufficiency Myth, all these responses assume the truth of the primary–secondary hue distinction in one form or another. We can do much better still if we abandon that distinction completely.

By encouraging us to believe that with just three hues we can accomplish something that cannot be done, the Sufficiency Myth sets us up for disappointment, frustration and self-doubt. It is time to let it go. As for the Irreducibility Myth, just ask yourself this: what sort of value is there in being told that it is not possible to do with your materials something that plainly can be done?

HOW MANY HUES DOES A PALETTE NEED?

Introduction

It is time to look into the question of alternative palettes in greater detail. Given a set of paints, it is perhaps most obvious to think about the hues that can be mixed from it, but it is just as pertinent to ask, 'what hues *can't* be mixed using this set?' If you don't ask this second question, and you have taken the Sufficiency Myth at face value, then you are likely to think that your failure to reproduce the entire colour wheel with a set of three paints reveals a deficiency in you. But this isn't so. As we have seen, three hues is too few for that task. So how many is enough?

Three Hues

Picking three hues placed at equidistant points on the perimeter of the colour wheel (for the time being it doesn't matter which version we use) gives a gamut represented by the triangle (Figure 163). We did a similar exercise in the gamut comparisons in the previous chapter. Of course, these comparative exercises are geometrical idealizations that don't precisely reflect the experience of real-world colour mixing. However the general idea behind these schematic theoretical calculations will shed some light on the question of practical palette choice.

The coloured areas still visible collectively represent the

FIGURE 163.

A three-hue gamut.

FIGURE 164.

A four-hue gamut.

FIGURE 165.
A six-hue gamut.

FIGURE 166.
A nine-hue gamut.

proportion of the colour wheel not reproducible using this palette. The triangle covers 41 per cent of the colour wheel, which leaves a massive 59 per cent of the wheel out of gamut. Of course, three different hues could be used to reproduce areas that our initial choice cannot make available, but then that different palette would also leave other areas inaccessible. The colours may change, but the irreproducible area remains the same size at 59 per cent – well on the way to two-thirds of the wheel. This leaves claims about being able to mix all hues from just three paints in tatters.

Just one additional hue in the palette changes this percentage dramatically (Figure 164). With four equidistantly placed hues we can cover 64 per cent of the colour wheel, reducing the inaccessible area to just over a third, at 36 per cent. When we increase our palette to six hues this is better still: our coverage rises to 83 per cent, double the coverage with only three hues. Even more dramatic is the fact that the inaccessible percentage of the wheel has fallen to 17 per cent, less than a third of its size from when we limit ourselves to just three hues.

The more the merrier, yes? Well, up to a point. An equi-spaced nine-hue palette gets us close to covering the entire circle (Figure 166). This extends our reach to 92 per cent of the colour wheel, reducing the inaccessible area to a mere 8 per cent. Can we reach 100 per cent? Well, if we continue increasing the palette size with more colours from the perimeter of the wheel we will approach that limit (though we will never actually reach it).

A twelve-hue palette provides up to 95 per cent coverage, with just 5 per cent still out of bounds (Figure 167) …and for those who are still game, fifteen hues takes us to 97 per cent with a mere 3 per cent of the wheel now out of gamut (Figure 168).

At this point it should be clear that investing more and more hues in the palette provides rapidly diminishing returns. Let us look at the figures:

▨ Increasing the palette from three to six hues improves our colour wheel coverage by *42 per cent.*
▨ Adding another three hues yields only a further *9 per cent.*
▨ With three more the additional benefit falls to *3 per cent.*
▨ The last three that are added – to give fifteen hues – sees this fall to *2 per cent.*
▨ Another *1 per cent* will therefore cost you another *six* hues.

Mathematically speaking, the final shift from 99 to 100 per cent is not possible if we proceed in this manner (we get successively closer to the 100 per cent limit, but never reach it). I emphasize that this geometrical exercise is an idealization, but it points the way to what we can expect to see in practice. What is clearly hinted at by the last two figures in this calculation is that the 3 per cent difference between the fifteen- and twelve-hue palettes will be negligible in the vast majority of practical situations.

FIGURE 167. **A twelve-hue gamut.**

FIGURE 168. **A fifteen-hue gamut.**

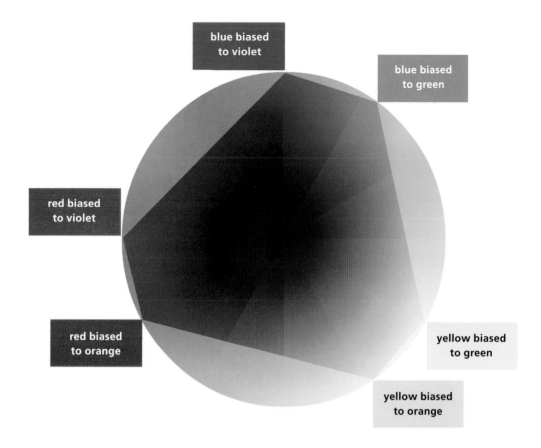

blue biased
to violet

blue biased
to green

red biased
to violet

red biased
to orange

yellow biased
to green

yellow biased
to orange

FIGURE 169. **The six split-biased 'primary' hue gamut on the equi-spaced wheel.**

Apart from Hue, What Helps Determine Palette Size?

If in most instances twelve hues are enough to give us a satis-factory approximation of the colour wheel and three is seen to be insufficient, where does the compromise for a practical gen-eral-purpose palette lie? Naturally this is going to be a judge-ment determined by personal circumstances and preferences, but there are three considerations that will frequently enter into most people's decisions.

Cost efficiency

Who wants to maintain a palette of fifteen paints when twelve will do? Either way, one is going to get through roughly the same quantity of paint but a carefully chosen reduced palette may incorporate fewer expensive materials. The more points around the colour wheel we include in the palette, the more like-ly we will need to include expensive resources.

Manageability

The additional flexibility and coverage that come with a large palette are accompanied by additional complexity in getting to know the characteristics of each paint. As I have stressed, paints are physical substances that have non-chromatic physical prop-erties – including their handling characteristics, their integrity when mixed with other paints, their drying rates, transparency, permanence, and a host of other features. The more paints there are on the palette, the more there is to be mastered in respect of all these factors. This affects, among other things, the speed at which you can work, which in turn affects the smooth run-ning of your creative processes.

Colour harmony

The extent to which this is relevant will vary from one context to another, but where harmonious colour relationships are sought, the desired results are often most efficiently and effectively achieved by careful mixing with few colours rather than many.

123

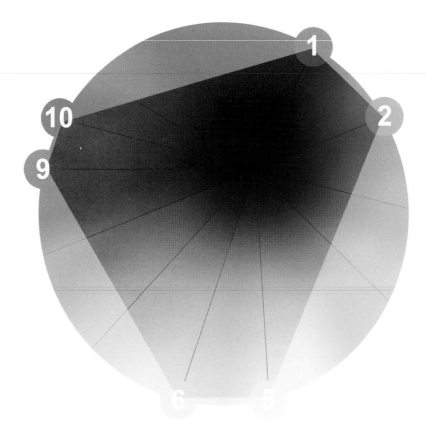

FIGURE 170. **The six split-biased 'primary' hue gamut on the enhanced wheel.**

The nine-hue palette sacrifices little to the twelve-hue version in terms of coverage, and is thus almost certainly going to beat it on cost efficiency grounds. And the reduction in hues will contribute favourably to achieving colour harmonies. Changing down to a six-hue palette sees a significant cost in terms of colour wheel reproducibility, but with worthwhile gains in the other two respects. Some people will find six hues don't quite meet their routine needs, but in many hands this is a tolerable lower limit. Thus, I suggest that many of us will find a satisfactory general purpose palette lies somewhere in between six to nine equidistantly spaced hues.

But there is nothing magical about these numbers; the principles of colour mixing apply to a palette of any size – though with fewer than three hues you will have a hard time demonstrating them all!

A Six-Hue, Split-Biased 'Primary' Palette

As discussed in Chapter 16, this kind of solution is an increasingly popular one and, if plotted on a version of the equi-spaced colour wheel, the results appear to be encouraging. As shown in Figure 169 the hexagon enclosed by this palette is a great improvement over the triangle of three hues specified in the Sufficiency Myth. There are areas outside the hexagon that we can't cover even with three additional hues, but these are much smaller than the areas denied us by the colour triangle.

There is nothing surprising or mysterious about this, of course. As the sequence of geometrical idealizations showed clearly, a hexagon is a better approximation of a circle than a triangle is. However, if we reintroduce the enhanced colour wheel we can get a much more accurate impression of how well the arrangement is really likely to work (Figure 170).

The six points marked on this wheel correspond to palette hues we have been using all along: Blue 1 and Blue 2; Yellow 4 and Yellow 5; and Red 9 and Red 10. Whilst the resulting gamut is still better than that obtained with just three hues, in reality it isn't as impressive as the projection onto the equi-spaced wheel would have us believe. If we are going to expand our palette from three hues to six, why would we select these ones rather than any others? The answer is, of course, that this suggested expansion is still under the thumb of the primary–secondary distinction and the two Myths.

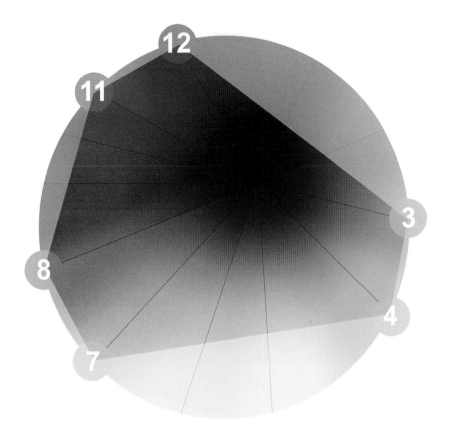

FIGURE 171. **6 split-biased 'secondary' hue gamut on the enhanced wheel**

A Radical, Split-Biased 'Secondary' Palette

If we wriggle free of those strictures, it might occur to us to construct a palette using just the 'secondary' hues. In this situation the result in terms of gamut size is, perhaps surprisingly, very similar to the six-hue split primary palette. There are differences of course, and the one most likely to be considered significant is the distribution of the gamut around the region of maximum darkness. The split primary palette has this region very near the centre of the gamut, resulting in a reasonably well-balanced range of mixable hues. The split secondary example is rather lopsided in this respect, and can only reproduce the darker parts of the blue region.

This should come as no surprise in view of our explorations of mixing members of the Blue family by using members of the Violet and Green families. Thus, this palette would not be as good an all-rounder as the split primary alternative. However, the split secondary palette is better in other respects; as we would expect, the range of greens and oranges it offers is superior to the split primary version.

As I have argued earlier, for those of us with a practical interest in colour mixing there is no simple unqualified answer to the question of which of these palettes is 'best'. We need to know what purpose the palette is intended to serve before this question fully makes sense. If we ask, 'which of these two palettes is the better all-rounder?' we would be inclined to nominate the split primary example. There will be tasks, however, for which a split secondary palette would be equally good, or better.

Since paints have non-chromatic qualities that are relevant to palette choice, it is rarely a matter of indifference which paints are selected to represent a particular hue (*see* Chapter 20). Consequently, a split secondary alternative to the split primary palette is not merely a diverting curiosity, but has useful practical potential. A particular colouring effect may be best achieved using a combination of 'secondary'-hued paints rather than by mixing two 'primaries'. The relevance of the primary–secondary hue hierarchy recedes still further with this realization.

An Alternating Six-Hue Palette

Why stop here? Just looking at the enhanced colour wheel you may well have already come to the conclusion that the way to find a better six-hue general-purpose palette can be compiled

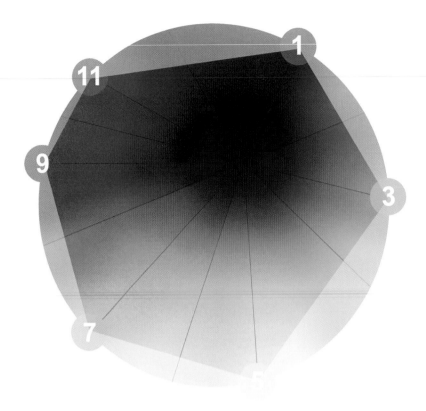

FIGURE 172. **Alternating 'primary'–'secondary' six-hue palette (1).**

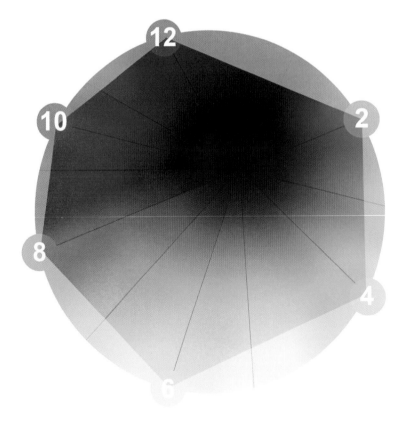

FIGURE 173. **Alternating 'primary'–'secondary' six-hue palette (2).**

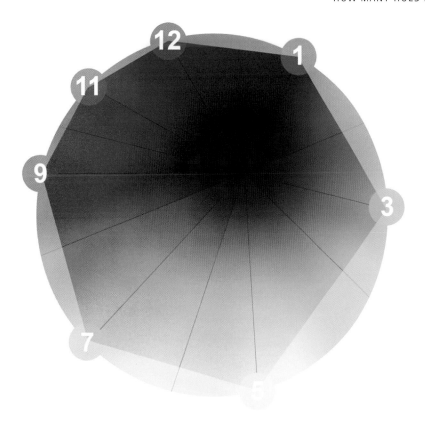

FIGURE 174. **General-purpose seven-hue palette (1).**

FIGURE 175. **General-purpose seven-hue palette (2).**

FIGURE 176.

**A regular hexagon projected onto the enhanced colour wheel
without regard to the positioning of the twelve palette hues.**

from a selection like those shown in Figures 172 and 173. Both of these examples alternate between traditional primary and secondary hues and both provide a better general-purpose gamut than either of the other two types of palette examined so far.

From a practical point of view, one benefit of adopting this alternating palette is that we get one vibrant, high-saturation member of each hue family. With both of the other six-hue palettes only three-hue families are represented in high-saturation versions. Thus, alternating palettes offer a better balanced range of options.

A General-Purpose Seven-Hue Palette

We know that the violet–blue–green side of the wheel suffers in terms of limited saturation so, if we allow ourselves the luxury of

an additional hue, we might be happy enough with either of the examples shown in Figure 174 or 175.

I suggested earlier that a reasonable general-purpose palette should be obtainable with between six and nine hues, and I think these two examples fit the bill. We can fill in the gaps with the remaining five palette hues from our standard stock of twelve, but the advantages will in many cases be marginal.

The 'Best Fit' Six-Hue Palette

There is one further step we can take to maintain the economy of a six-hue palette, whilst getting very close to the size of gamut obtainable with seven. All our efforts so far have been developed under the assumption that we draw the six hues from the basic twelve we have used throughout the exercises. This is, of course, an artificial constraint that has merely served as part of the scaffolding on which the discussion has been erected. Now that we

are progressing towards a fuller grasp of the relevant relation-ships in colour mixing, we can step outside that constraint if we wish. So if we want a six-hue palette, why not project the ideal hexagonal gamut onto the enhanced colour wheel and then select paints that most closely match the hues at the points that land on the circumference?

Note that the orientation of the hexagon on the circle is not arbitrary. One apex needs to point more or less at the centre of the blue region. This is to minimize the in-built darkness imposed by the region of maximum darkness encroaching on the violet–blue–green half of the wheel. In fact, there will only be a couple of minor differences between the hues required for this gamut and the two alternating six-hue palettes we have considered. You will see that the violet and blue hues we require come from the middle range of their respective hue families (there is more on the specifics of pigment/paint selection in Appendix 1).

Summary

I hope it is now clear why three hues are too few to satisfy the demands of a general-purpose palette. Some artists are happy working with vast palettes featuring twenty or more different hues. I have suggested that for reasons of cost efficiency, man-ageability and colour harmony you may want to assemble a more restrained palette, and have described some alternatives with no more than seven hues.

It is none of my business to tell you which hues you should use. This will chiefly be determined by your intentions and pur-poses, and I have no idea what these may be. Instead, my aim in this chapter has been to help make your decisions about which hues to include in your palette as informed as possible. There is, as I have reiterated, more to selecting a palette than deciding which hues to include and which to leave out, but hue selection is clearly one of the most important factors. The selec-tion process should be guided by the questions, 'what am I aim-ing to do?' and 'will these hues in combination enable me to do it?' It is always an option to add an extra 'spot' colour as print-ers do when a very precise hue is called for, though this may compromise the colour harmony objectives of using a restricted palette. In each case where hue accuracy or colour harmony conflict you will need to exercise your own judgement to decide which is to be given priority.

One last observation on palette choice: do not confuse the number of *hues* in a palette with the number of *paints*. Different paints – that is, paints containing different pigments – may be of similar hue but have different non-chromatic properties. For example, one paint of a given hue may be more transparent than another paint of the same hue (see Chapter 20 for more about these various factors). So there may be a case for having more than one version of a particular hue in your palette. How strong that case is will depend, as always, on your own specific goals.

COLOUR IN THREE DIMENSIONS

Introduction

So far our attention has been more or less exclusively focused on the spectral hues, non-spectral purple (which we have included within the violet range) and their shades. There are, however, many more hue variants beyond this, as well as the problem of how these all relate to black, grey and white. In this chapter we see how these additional hue relationships can be accommodated in a three-dimensional colour space.

Black, Grey and White

Paradoxically, this discussion of three-dimensional *colour* starts by considering black, grey and white. Are black and white colours? This is not as straightforward a question as it may appear initially. In some contexts people regard them as colours, in others they don't. We are in the habit of contrasting coloured images (paintings, photographs, television broadcasts and so on) with black and white ones. In the context of this comparison, 'black and white' means 'not in colour'. Now consider also that black and white photography is alternatively called **monochrome** photography. The term 'monochrome' is most often used to mark precisely this contrast – that is, to mean 'not coloured' or 'not in colour'. However, the literal translation of 'monochrome' is 'single colour'. This suggests that either black or white (but given this definition, not both) is a colour. An image rendered in blue and white, or in green and white (or perhaps blue and black, or in green and black?) would also be monochrome in the same sense.

No wonder we are confused about colour! Often we have little alternative but simply to accept common usage, even when it is confusing or self-contradictory. But if the usual way people understand 'monochrome' is as 'not coloured' or even 'in black and white', does that mean black and white are not colours?

More on Context

The chief difference in context we should bear in mind is again that between additive and subtractive colour mixing. In other words, the most significant factor relevant to determining our classification of black, grey and white is whether we are considering the mixing of coloured lights or pigments.

Combining lights

The more coloured lights of different hues we combine, the lighter and thus whiter the result. The limiting case – with intense coloured lights from all parts of the visible spectrum – produces white light. Newton devised an experiment to demonstrate this: having separated white light into its spectral components using one prism, these components were directed through a second prism and recombined to produce white light. (In fact, it has now been established that just two lights – a complementary pair mixed in the right proportions – can produce white light.) So, with regard to light, one might regard white as a combination of all colours. The fewer coloured lights we combine, the darker the result, and the limiting case in this context is the absence of light altogether, or if you prefer, black (as in 'all the lights went out – it was pitch black!').

Combining pigments

In the subtractive mixing context, the more pigments of different hues we combine the darker the result. So, in contrast to additive mixing with lights, we might say that mixing pigments from points all around the colour wheel produces black. (However, as we saw in Chapter 12, combinations of just two pigments can in practice produce a mixture that is a very close approximation to black.)

There is a certain intuitive attraction in regarding black in this two-fold way: first, as the *absence* of light in all colours in addi-

tive contexts (in which case it is not a colour); and second, as the *presence* of pigment of all colours in subtractive contexts (in which case it is a colour, albeit a mixed one).

What About White?

The converse idea in the case of white would be to regard it as the additive mixture of light in all colours (and thus itself a colour in additive contexts). That seems a reasonable suggestion, but the corresponding view in subtractive contexts would be to regard white as the absence of all colours of pigment (and thus white itself is not a colour). This has rather less intuitive appeal.

The reason for this is, perhaps, that white paint is itself made with white pigment, and there is a tendency to regard all paint as 'coloured', hence white paint is thought of as being white-*coloured* paint. However, not all mixing materials are thought of as paints; oils, gums, acrylic media and so on are used in mixing paint but they are not colours. It is not entirely outlandish to imagine that white paint could be packaged differently, as a 'tinting medium'; that is, as an additive that reduces the chromatic intensity of another hue.

Maybe this would be the best way to think of white paint, since its use in a mixture does not result in a hue shift. In fact, there is at least one writer and painter from the fifteenth century, Leon Battista Alberti, who saw the matter in much this way, calling both black and white 'not true colours, but, one might say, moderators of colours'.[vi]

A further peculiarity concerning white in the context of pigment mixing is that, with the exception of hues at the vertices of any given gamut, all other hues within that gamut can be mixed (including, as the exercises have shown, the mysterious 'primary' colours). There is no way at all, however, that white can be mixed from non-white pigments. If white is a colour, then the fact that it cannot be mixed means it is entitled to the status of 'primary' colour according to the Irreducibility Myth. Given this observation and the primary–secondary distinction, why isn't white widely regarded as a primary colour? (I say 'widely' here, since historically some accounts of the primary colours have included white.)

One reply might be that white misses qualification as a primary colour because it fails to satisfy the criterion for primary colours specified in the Sufficiency Myth (which is that all remaining colours can be mixed from the primaries). This response has a certain appeal if we are thinking of mixing colours that are located on the two-dimensional colour wheel we have used so far. At the circumference of the colour wheel colours are pure and saturated, and they become progressively neutralized and darker the further we look to the centre; white and 'whitened' colours don't appear on this surface. If white

were included as a member of the set of primary colours it would enjoy a degenerate kind of membership, since its primary colour status would continue only as long as its contribution to colour mixes was zero. White, remember, brings about no hue shift.

Yet the rationale for regarding white as a colour improves when we enlarge our conception of colour space from two to three dimensions. The only way to represent the full range of colours, not just the highly saturated ones that constitute the usual colour wheel, is to include white as a mixing component on the same footing as all other hues. However, white – if it is a colour – remains the only one that really cannot be mixed subtractively.

Similar thoughts apply to black in the context of lights; it can't be mixed using light. Consequently, the only colours (if that is what they are) that really qualify as 'primary' in terms of the Irreducibility Myth are white (in the case of pigment) and black (in the case of light sources).

The Chromatic–Achromatic Distinction

So we have some motivation for regarding black and white as colours in some contexts. Because there is no black or white in the spectrum, however, we can hardly call them *spectral* colours. So we find that some people introduce a further distinction between so-called **chromatic** and **achromatic** colours. As with the confusing multiple uses of 'monochromatic', this is a little paradoxical, since 'chromatic' means 'coloured', so according to this distinction there are 'coloured colours', and 'non-coloured colours'.

Insofar as we regard them as colours, one suggestion would be to call black and white non-spectral colours. This doesn't quite solve the problem, though. Strictly speaking, most colours on the colour wheel are non-spectral, since the spectrum only gives us the colours that constitute the outer perimeter. Brown and olive green are clearly colours for instance, but they do not appear in the spectrum. This needs further elaboration, therefore: the term 'non-spectral colour' improves on 'achromatic colour' in terms of linguistic accuracy but includes all but the purest colours as well as black and white, which is not what we want.

Another possibility would be to retain the chromatic–achromatic terminology, but apply it to tones, rather than to colours. The expressions 'tone' and 'tonal value' are widely used to describe and differentiate levels of relative lightness and darkness of a surface without reference to any specific hue or 'hue value'. So the same tonal value might be ascribed to a number of patches of different hue.

Thus, instead of talking about chromatic and achromatic *colours* – which amounts to talking about 'coloured and non-

FIGURE 177.
Areas of different hue...

FIGURE 178.
...that have the same tonal value.

FIGURE 179. **Gradation: White – Achromatic grey – Black**

coloured colours' – we could talk more comfortably about chromatic and achromatic *tones*. Thinking about variations in achromatic tones leads us naturally to consider the relationship of black and white to grey.

Grey

The way that most of us have been taught to think of grey is as a mixture of black and white and, of course, it is possible to make achromatic grey tones in this way (Figure 179). However, given the two-dimensional structure of our colour wheel, there is no way of representing this grey progression, the achromatic grey series. In order to show how these greys relate to the colours we have mapped out so far, we need to move to three dimensions.

The Colour Cylinder

There have been many attempts to construct colour spaces that represent the full range of colours in three dimensions. There are, for example, colour spheres, colour cones, colour pyramids and colour cubes. I think the most easily understood and by far the most useful colour solid from a practical point of view is the **colour cylinder**. We can work towards an appreciation of the geometry of the colour cylinder by reflecting on the construction of tints.

Tints

Thus far we have considered the spectral hues at their full saturation (that is, the way they are represented at the outer limit of the colour wheel) and in mixes of varying degrees of darkness (as represented by the inner portions of the wheel). However, whatever medium we are working in, for some purposes we will want access to less than fully saturated hues. We achieve this by diluting the colours, reducing their intensity. For wet media, one sort of dilution involves mixing the paint with solvent. The specific means of dilution will depend on the medium we are

using; water in the case of watercolour, gouache and acrylic and the addition of oil, varnish medium or turpentine to oil paint. With dry media, dilution is achieved by reducing the pressure of application and by allowing a (usually white) ground to show through thinly laid colour. Each of these methods of dilution is entirely or very nearly neutral, chromatically speaking. That is, they are techniques that add no coloured material to the paint, and thus bring about no hue shift.

There is another way of reducing the saturation of hues, by mixing them with white. In each medium, mixing colours with white allows us to create tints of spectral hues and their shades. This practice, though perfectly feasible in watercolour, is usually avoided, as it tends to deaden the vibrancy, transparency and inherent luminosity of the medium. White patches in watercolour works are usually achieved by leaving unpainted areas of paper.

As illustrated in the colour wheels (Figures 180 and 181), tinting creates paler and weaker shades, what we often call 'pastel' colours. Note that the inner part of the tinted wheel, corresponding to the region of maximum darkness in the full chroma wheel, yields muted, neutralized shades, which are **chromatic greys**. These are the tinted counterparts of the dark chromatic hues we encountered in Chapter 12. The chromatic content of these mixes – that is, their identity in terms of hue family membership – is progressively more difficult to judge the nearer we go to the region of maximum darkness.

As well as these coloured grey shades, there is at the very heart of the tinted wheel a grey that matches a shade in the achromatic grey series, the grey series of tones derived solely from gradated mixtures of black and white. This is because the centre of the fully saturated wheel is (very nearly) equivalent to black, so the effect of tinting at the centre of the wheel will be like adding a certain proportion of white to black. An 'ideal' black would consistently yield only true achromatic greys when mixed with pure white. In some cases, the chromatic origins of a grey may only be apparent when it is compared directly with a monochromatic grey.

FIGURE 180.
No tint.

FIGURE 181.
Tinted.

Yellow 6 +
Violet 12 +
Blue 1

Blue 2 +
Orange 8

Green 3 +
Red 10

FIGURE 182.
Chromatic black near-equivalents: the near-uniformity of these dark combinations gives way when they are tinted, revealing their underlying chromatic composition.

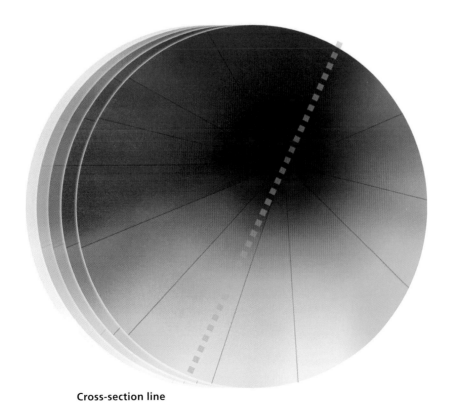

Cross-section line

FIGURE 183. **Stacking progressively tinted colour wheels.**

FIGURE 184. **A cross-section through the colour cylinder (1).**

FIGURE 185. **A cross-section through the colour cylinder (2).**

Slice by slice

By diluting the saturated colours in different proportions we can produce a series of tints in a gradually fading sequence that ends in a complete wash-out to pure white. If we then stack these progressively tinted discs on top of each other, we would end up with a cylinder (Figure 183). If we now took a longitudinal cross-section of the cylinder through the middle of the region of maximum darkness, from the saturated disc all the way along to the faded full tint (white) disc at the other end, then depending on the exact point of the section, the inside would look something like Figure 184 or perhaps Figure 185.

Which two colours we see on the inside of the disc would depend of course on where exactly we made our cut. However, in each case – assuming that the cuts pass through the middle of the region of maximum darkness – we would expose a pair of complementary hues separated by a thin band of grey. The saturation or intensity of the hue would gradually fade along the length of the section of the cylinder from its maximum value at one end to its minimum (or white) at the other end. Thus, the colour cylinder incorporates all the spectral hues, their neutralizing mixes – including the chromatic equivalent of the achromatic black–white series – and all the chromatic tints. As far as pigment mixing goes, that includes all possible colours.

Visualizing or imagining this three-dimensional colour space is not essential for getting to grips with basic day-to-day colour mixing. Most of the ideas laid out here can be grasped fully with an understanding of the two-dimensional colour wheel. Being able to extend the ideas from two to three dimensions,

however, will speed up some mixing tasks. For example, the principle of complementarity holds good for a line passing through the region of maximum darkness drawn between any two points in the cylinder. In view of this, the easiest way to produce some targets may be by mixing complementary *tinted* hues. The idea of complementary tints, therefore, is not so easy to work with without making the leap into three dimensions.

Summary

In this chapter, we looked at how our colour-mixing framework can be extended to cover the entire range of hue variations including black, grey and white. This requires a construction in three dimensions. The colour cylinder featured here is not the only way of representing a three-dimensional colour space; there are plenty of other models to choose from including spheres, pyramids, cubes and others. There are pros and cons associated with each model, and whichever one we regard as best depends on what we want to accomplish by arranging colours in a three-dimensional space. Since the focus of this book is on the very practical business of colour mixing with paints, I have chosen the colour model that I regard as the most useful for aiding that process. The colour cylinder has the additional advantage of being understood as a simple extension of the colour wheel, a theoretical construct with which many people are already familiar.

To select between hues and tints: go lengthwise along the cylinder

To select between spectral hues and shades: go from outer edge towards the region of maximum darkness

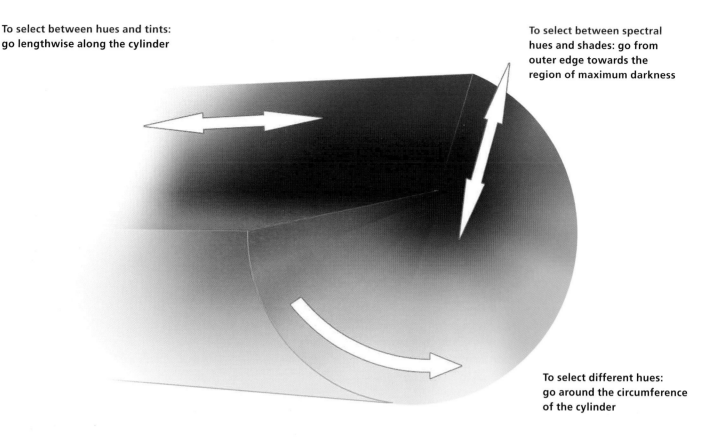

To select different hues: go around the circumference of the cylinder

FIGURE 186. **Colour movements in three dimensions (1).**

Paleness

Saturation

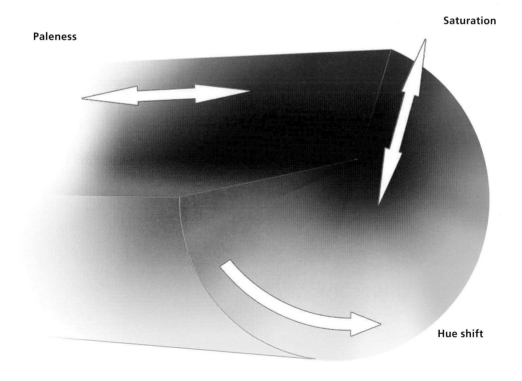

Hue shift

FIGURE 187. **Colour movements in three dimensions (2).**

EXPLORING AND EXPLOITING COLOUR GEOMETRY

Introduction

We have seen that by drawing a straight line between any two hues we can determine all of the intermediate hues that their mixture can yield. This holds good irrespective of whether the hues in question are located on the rim of the colour wheel or lie within it. With this in mind, I now want to consider how different palette combinations can be used to mix the same hue in a specific coloured region on the colour wheel.

Producing the Same Hue from Different Components

Suppose we are using the even-numbered six-hue palette of the sort described in Chapter 17 to mix some particular target shade in the violet–magenta region (shown by the circle in Figure 188). How should we go about this? Following our straight line principle, what we need to do is draw a line that starts at one of the hues in our palette, continues through the target hue – the one we want to mix – and passes on to another of our palette hues. To mix the target hue it is generally best to start with whichever of the mix hues is closest to the target and gradually add some of the other hue to achieve the right proportion. If the target hue falls right in the middle of the line, then it usually doesn't matter which hue we start with.

There are exceptions to this procedure, particularly when physically mixing wet media rather than using a predominantly optical-mixing technique. When mixing wet media it is necessary to take account of the disproportionate strength of some pigments. Control of the mixing process is easier when individual paints all have roughly the same pigment strength. One super-strong paint – a 'bully' – or one or two comparative 'weaklings' will be relatively difficult to balance with the rest of the palette (*see* Chapter 20 for more about this).

Note, however, that this is not the only way we could mix this hue from our present palette. A line from Violet 12 to Orange 8 will pass through the target too (Figure 189).

Exercise 5: One Target, Two Routes

The fact that there are different ways of producing the same shade of a hue shows the coherence of the enhanced colour wheel; that is, it forms a unified system that 'locks together'. Rather than take the explanation of this at face value, however, you should try it out in practice.

Here is a simple exercise that illustrates the key points. First, draw a box within a box to roughly the same scale you have been using for the exercises in previous chapters. Then fill the area between the inner and outer box with a layer of Red 10, followed by a layer of Blue 2 on top. When you are part way with this second layer, you should be looking at something resembling Figure 190.

Then add a further layer or two of Red 10 so that the space between the boxes is a reddish-violet shade. The next stage of the exercise is to fill the inner box with a mix of Violet 12 and Orange 8 so that it matches the hue of the area between the

FIGURE 190.
Matching magenta (1).

FIGURE 188.
Mixing a target between Red 10 and Blue 2.

FIGURE 189.
Mixing the same target using Orange 8 and Violet 12.

FIGURE 191.
Matching magenta (2).

FIGURE 192.
Matching magenta (3).

boxes. Try starting with a layer of Orange 8 and cover this with successive layers of Violet 12.

You will probably need to do some toing and froing, adjusting the proportions of these two hues in order to get a reasonably good mix. With some care and perseverance, however, you should find it possible to achieve a result that merges well when assessed from the viewing position.

Constraints on Alternative Mixing Combinations

The closer our target colour is to the region of maximum darkness, the easier it will be to find alternative ways of mixing it using just two hues from our palette of six. Conversely, the closer the target is to the colour wheel perimeter, the fewer choices we have for mixing it. This restriction reaches its limit when we consider the hues lying at the perimeter. Since these hues are by

definition the purest available in any given palette, they cannot be mixed using other hues in that same palette. In order to mix a hue we need two other hues, at least one of which is purer and more vibrant than the target we want to mix.

However, once we have limited ourselves to a specific palette, we will have no hues purer and more vibrant than those at the perimeter of the wheel. And remember: this restriction applies to *all* of the perimeter hues, so-called 'primary' and 'secondary' hues alike. So, given the limitations of a particular palette, there *are* hues that we cannot mix, but this has nothing to do with their 'primary' or 'secondary' status. Rather, whether we can mix a hue is determined simply by the saturation and hue of the components of our paints.

Mixing muted blue and red

So far, we have only looked at the outcome of mixing hues that lie at the perimeter of the colour surface. Can we apply the straight line principle when the sources for our mixes are muted, less pure hues that lie within the perimeter of the colour wheel? The answer to this question is yes, it can be applied in exactly the same way. Suppose our Red 10 and Blue 2 paints or pencils run out and we can only replace them with darker versions of the same hues, called Red 10' and Blue 2'. Clearly, these substitutions will reduce the gamut of the palette as a whole – but since Red 10' and Blue 2' lie on the same straight line as Red 10 and Blue 2, a proportion of the shades lying on that line will still be reproducible. As we would expect, a target that lies between Red 10' and Blue 2' can be mixed using these substitutes in precisely the same way as with Red 10 and Blue 2.

Mixing muted yellow and blue

Similarly, an example from the opposite side of the colour wheel shows the straight line principle applied in exactly the same way. Here, we can see how a hue mixable using Blue 1 and Yellow 5 can also be obtained using muted shades of those hues, Blue 1' and Yellow 5'.

A general-purpose palette will tend to favour pure and highly saturated hues simply because this provides a more extensive gamut than muted hues. The more extensive the gamut, the greater the range of mixing possibilities a palette offers and this, after all, is what we expect from something we intend to use for 'general' purposes. However, the fact that muted hues contribute to mixing in precisely the same way as highly saturated ones is very useful. With this knowledge, we can explain how to utilize the full potential of any palette.

FIGURE 193. **Reduced-saturation hues can produce the same magenta mix.**

FIGURE 194. **Reduced-saturation blue and yellow hues used to produce muted blue-green.**

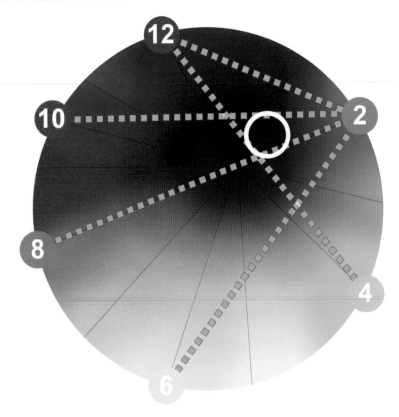

FIGURE 195. **How a target hue may elude a two-hue mix with a six-hue palette.**

Colour Mixes Involving More Than Two Hues

Depending on the hues available on a given palette, it may not be possible to match some parts of the colour wheel using just two hues. In Figure 195, we see the six alternate-hue palette marked with a white circle identifying a target hue to be mixed. The dotted white lines inscribed on the colour wheel connect the hues from which the palette is constructed. Our straight line principle says that a target hue can be mixed from any two other hues provided a straight line can be drawn through all three. However, it is clear that none of the straight lines connecting the hues in this palette intersect the target hue. A straight line from Blue 1 to Yellow 5 would do the trick, but the present palette doesn't include them. So does this mean we cannot match this area of the wheel with this palette? No, it doesn't; a simple two-stage application of the straight line principle shows this to be so. There are several solutions to the problem for this present case: let us look at two examples.

First, we will pick one of the several pairs of hues on the palette that have a connecting straight line that passes close to the target hue (Figure 197). We can mix all the hues that lie on the straight line between Violet 12 and Blue 2. Now we draw another straight line that, starting from a third palette hue, passes

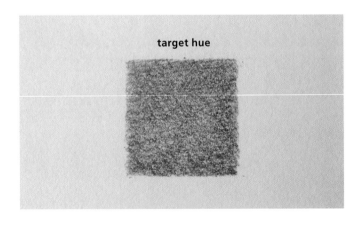

FIGURE 196.
Matching a blue target.

through the target hue area and finally intersects the line between Violet 12 and Blue 2. In this demonstration, I have chosen Yellow 6 as the third hue, but you will see that for this target hue Green 4 and Orange 8 are both alternative candidates.

The first stage of the process of matching our target is to mix a muted blue using Violet 12 and Blue 2, the proportions of the mix being indicated by the point where the second line intersects with the Violet 12–Blue 2 line. So in this case the mix should be roughly 2:1 in favour of Blue 2. By this, I mean that

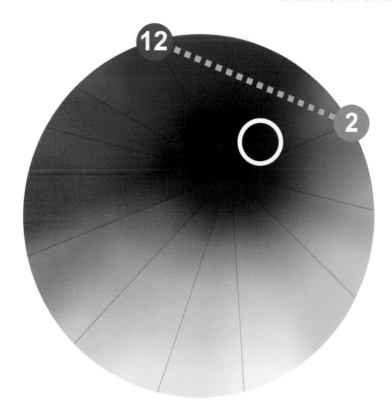

FIGURE 197. **Building a three-hue mix (1).**

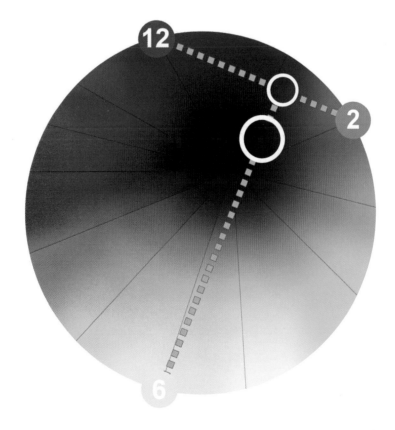

FIGURE 198. **Building a three-hue mix (2).**

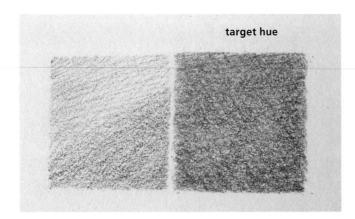

target hue

FIGURE 199.

Matching blue: the first mix in progress.

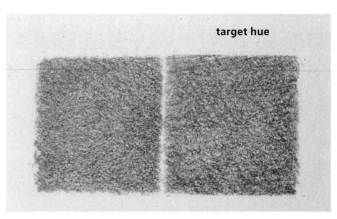

target hue

FIGURE 200.

Matching blue: the first mix completed.

the outcome of the mix should be more blue than it is violet. Whether this requires a mix by volume in these proportions depends on the particular pencils or paints used.

We can now treat this point as though it were a ready-mixed colour in our palette and use it as a basis for mixing other colours. You should find it a reasonably simple job to mix this intermediary in the right proportion with Yellow 6 to produce the target hue.

Let us consider the second route to the same target, using Red 10 and Green 4 as the initial pair, with Blue 2 as the third hue. Notice that in this case that the straight line between the initial pair does not pass close to the target, but is on the far side of the region of maximum darkness. However, the final effect is comparable to that obtained in the previous example.

Remember: we are only mixing a hue match. The different physical characteristics of the paints or pencils we use to mix the target may produce hue equivalents that handle differently, vary in opacity and so on. And if the different mixed versions of the same hue differ in their other properties, then this increases the flexibility of the palette. When using wet media, sometimes a slow-drying version of a hue may be preferred over a quick-drying one, for example.

FIGURE 201. **Building a three-hue mix: an example of an alternative route.**

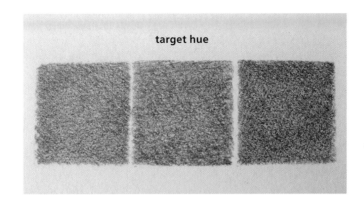

FIGURE 202. **Matching blue: the second mix.**

FIGURE 203. **The untinted target.**

Three-way mixing with larger palettes

As we increase the number of equidistantly spaced hues in the palette, so the areas of the colour surface accessible to two-hue mixes increases also. If you have twelve hues in your palette, you will rarely find it necessary to mix a target using three hues. Additionally, on the few occasions when this is necessary with an expanded palette, there will often be many hue combinations to choose from, making it a relatively simple business to mix the required intermediate muted hues.

Tints and Three-Dimensional Mixing

Also note that all the mixes we have looked at so far are confined to matching areas on two-dimensional colour wheels. We haven't said anything yet about how these considerations apply to the three-dimensional colour cylinder introduced in Chapter 18. The cylinder, remember, allows us to represent a hue family's tints and chromatic greys in all gradations from full chromatic intensity through to white. It is often harder to visualize

FIGURE 204. **The tinted target.**

connections in a three-dimensional space than it is to work them out on a two-dimensional surface but, in this case, it isn't that much more difficult. Just think of a tinted target as pushed away from the full-intensity chroma face of the cylinder. Estimate the proportion of white the target contains, and add that amount of white to the palette hues. Then mix the target from the tinted palette. Alternatively, mix the full-intensity version of the target, and then add white to it until the tinted target is achieved.

Apart from these qualifications about tinting and multiple ways of achieving a single mix, three-hue mixes are as complex as mixing needs to get. What this reveals is a further misunderstanding propagated by the Myth-makers. Whereas it is true for *each* hue that it will take no more than three hues to mix it, it does not follow that from a single set of three hues *every* hue can be mixed.

Summary

By simply extending the use of in-betweening (or the hue-shift principle), the darkening principle and the straight-line principle it is possible to work out how to mix any hue, shade or tint within the colour cylinder. Even with only six hues in the palette, it is often possible to find more than one way to mix many shades and tints. As the number of hues in the palette increases, so these options become more numerous.

FACTORS OTHER THAN HUE THAT INFLUENCE PALETTE CHOICE

Introduction

Until now, the matter of hue has dominated the discussion of which pencils or paints to include in a palette. Clearly, hue is not the only characteristic of a coloured medium that will influence that choice. In this chapter, I draw attention to some of the other characteristics that you may want to consider when making your own selections.

Masstone and Undertone

Although the outcome of mixing two pigments can be predicted from their surface or mass appearance alone, it cannot be predicted *fully* on this basis. For instance, many paints exhibit different colour properties depending on how thickly they are applied. A blob squeezed from the tube or a solid lump of paint in a watercolour pan only shows the **masstone** of some paints. Their **undertones**, some of which have quite different chromatic characters from the masstones, are only revealed in thin or diluted applications.

Chemical Origin of Pigments

The differences in physical composition between, say, two red pigments of similar hue may make for subtle differences in the way they mix with a given yellow pigment. This sort of difference is sometimes noticeable when, for example, comparing the mixing behaviour of inorganic mineral and metal compounds with that of more recently developed organic pigments. Some writers caution against mixing certain paints containing organic pigments with inorganic ones on the grounds that this compromises the brilliance of the mix. As ever, the extent to which you find this to be a problem will depend on the ends you have in mind.

Transparency and Opacity

Contrary to one of our simplifying assumptions, not all paints are opaque, and the converse property of transparency is in many circumstances highly desirable. When laid on top of each other, paints vary considerably in the extent to which they are able to obscure a lower layer. A transparent layer of paint laid on a support, ground or another layer of paint allows that support, ground or layer to be seen through the new layer. Subtle colouring effects can be achieved by utilizing the property of transparency when layering paint. However for some tasks opacity is a more desirable quality, and this property too is capable of being exploited to produce useful colouring effects. The choice of a transparent or opaque paint depends on the context, on what is to be achieved in a given situation.

Taking account of paint's non-chromatic properties such as transparency–opacity makes mixing more complex than our focus on hue matching has allowed us to recognize. Be prepared to fine-tune the procedures laid out here in the light of your own experience, and to make decisions about the following non-chromatic considerations.

Staining Pigments

When a paint layer is removed, either by solvent or mechanically, strongly staining pigments leave a residue embedded in the ground or support to which they have been applied. The staining power of a pigment is the extent to which it is able to penetrate and colour absorbent surfaces. As with transparency versus opacity, a tendency to stain may be desirable in some circumstances and a nuisance in others.

Opaque violet over yellow.

Transparent violet over yellow.

FIGURE 205.

Strength and Delicacy

The capacity of a pigment to retain its integrity or to dominate in a mixture is another variable that can play a significant role in colour mixing, and thus needs to be taken into account when choosing paints for a palette. A paint that is sharp, distinctive and vibrant on its own may 'break' very easily and lose all these qualities if mixed with a powerful and dominant companion. Also, it may be necessary to mix two paints in lopsided proportions (such as 10:1) in order to mix a target that is visually midway between them.

Handling such wide variations in the relative strength of paints can be rather difficult. For a general-purpose palette restricted to six hues, it is sensible to balance the relative strengths of the paints so that there are no out and out 'weaklings', or dominant 'bullies', either of which make it hard to mix accurately. However, if there is a 'bully' or a 'weakling' that you are reluctant to abandon, then you will need to take extra care in balancing it with other elements of your palette. As we have seen throughout the book, optical-mixing techniques can offset problems of this sort.

Drying Time

Clearly, this is only a factor when selecting wet media. It is probably not something that is likely to have a huge impact on very small-scale watercolour or wash-based acrylic works. However, with large-scale works in water-soluble media, variations in drying time may be relevant in workflow planning. Oil, having an inherently longer drying time, amplifies the variations between different paints in this respect. Additives can be used to advance or retard drying times for both oils and acrylics, but note that these can cause subtle hue shifts that introduce extra complexity into the mixing process.

Toxicity

This is generally less of a problem than it used to be. In the past the use of lead in particular for making flake white presented a health hazard, as have heavy metal compounds involving cobalt and cadmium. Flake white is usually replaced by the inert, safe titanium white these days. Also, there are now low-toxicity organic pigment alternatives to many of the long-standing metal compound favourites. Paints made with the older, more toxic pigments can still be used providing suitable precautions are taken. More care needs to be taken with pastels since they release dust that can be inhaled. These problems are even more acute in relation to pigment in powdered form. Lead-derived, powdered pigments are not generally available for this very reason.

Painting and Technique

The handling characteristics of paints vary, and so some are more suitable for certain techniques than others. For example, physical consistency and integrity, stiffness or smoothness may be relevant when working oil paint with knives rather than brushes. Some produce impasto more readily than others. As I have emphasized, it is important to remember that we cannot treat paints as if they are purely chromatic and have no other properties. Paints are not 'pure colours', and neither are raw pigments. They all have physical properties that have to be taken into account when we are colour mixing if we are to reliably achieve the desired results. 'Colours themselves' (whatever *they* are) don't exhibit strange and unpredictable behaviour, but the means of colour manipulation available to us – paints and the like – may do so.

Muted Palettes

Sometimes using the sort of general-purpose palette on which we have focused much of our attention may involve more work than is necessary. Some paints are so vibrant that they may need to be significantly muted or neutralized for use in some projects. In cases where 'toning a colour down', or 'breaking' a colour is constantly necessary, working with a palette of relatively muted members of the major hue families may be more productive – that is, there may be less elaborate mixing to do when using a muted palette to start with. (A specific example of a restricted palette is given in Appendix 1.)

Other Restricted Palettes

Of course, there is no obligation to work with a general-purpose palette that reaches out in equal proportions in all directions across the colour surface. For any number of artistic and aesthetic reasons, a palette skewed towards one area of the colour surface may be what is required. A pastoral landscape painter may lean more heavily on greens and earth hues than a representational portraitist does, for example. Nevertheless, whatever departures we make from the general-purpose style palette, the same straight-line principles that determine the available gamut will apply. Irrespective of which hues comprise a palette, the straight lines that connect them mark the boundaries of the hues that can be accessed using that palette.

Cost

The disparity in the cost of pigments is enormous and its impact at the point of sale can be jaw-dropping if you are not prepared for it. Precisely this ignorance led to a sobering moment when, a few months after having left school, I set out for the first time to purchase my own art materials. As I examined the paints I found myself wondering what the difference might be between a 'Series 1' and a 'Series 6' yellow. And how about the difference between this 'Series 2' blue and this 'Series 8' one? It is probably not that important, otherwise we would have heard about it at school, wouldn't we? I may as well have them all, I thought.

The shopkeeper was very understanding and patiently explained to me that artists' paint manufacturers divide their ranges into differently priced 'series' according to the pigments they contain. Most of my selections were way beyond my budget and had to go back on the shelves. In the end I walked out of the shop somewhat poorer, both in terms of cash and dignity, with a little paper bag containing just four 15ml tubes of gouache. (And yes, on that same shopping expedition I made a similarly naïve mistake with brushes too. Oh, the embarrassment…)

There have always been rare (and thus expensive) artist's pigments. Lapis lazuli, the mineral from which true ultramarine blue was made, is often cited in this regard. Fortunately, the synthetic version of ultramarine blue is one of the least expensive pigments available today and is generally regarded as a satisfactory substitute for the genuine article. Where relatively inexpensive pigments share many or most characteristics of more costly items, there is obviously a clear incentive to use these instead. The acceptability of the compromises or the sacrifices this involves depends on the nature of the task in hand.

Summary

Hue selection obviously plays the leading role for most people when it comes to assembling a palette. However, paints and dry media are all substances with non-chromatic properties that can have significant effects on mixing outcomes and on workflow considerations. Thus some consideration needs to be given to these properties too if you are to provide yourself with a palette that supports your efforts rather than hinders them.

CONCLUSIONS

The Need for a New Framework

Early in this book, I pointed out that the adage, 'If it ain't broke, don't fix it' has an obvious counterpart: 'If it *is* broke, fix it'. Established colour theory as presented to artists is 'broke' and I think it should be fixed if this is possible. This is what I have attempted to do with this book.

Without the hierarchy built on the primary–secondary distinction, we can start to appreciate the general applicability of mixing principles. From that point, we can develop a unified view of colour mixing that predicts what happens in practice with a much higher degree of accuracy. This accuracy breeds confidence that you will achieve the results you want quickly and with the minimum waste of materials. Without having to worry about this problem, you will be freer to concentrate on the creative aspects of your work. Energy that would previously have evaporated in the constant entanglement with the means can be focused on the *ends* of your endeavour instead.

Changing the Way You Think About Colour

In demonstrating the truth about colour mixing, we have made no novel observations; that is, we have acquired no new visual data about colour mixing. However, this recognition of the truth requires us to interpret and explain our data in a different way. The results of the colour-mixing experiments described here produce no new results that could not have been achieved previously but they produce results that, on the whole, few people will have tried to achieve because the orthodox views on mixing proclaim that these things cannot be done.

One of the curious aspects of the established views about hue relationships is that they are more counterintuitive than the truth. The most intuitive starting point for colour mixing theory, borne out of the simplest assumption we can make, is that the same mixing rules would apply to all hues. Instead of this,

established theory introduces a hierarchy – the primary–secondary distinction – that divides hues into two classes according to their supposed different mixing properties. Given that there is a simpler alternative, this more complicated assumption requires some sort of theoretical justification – but its advocates provide none. In any case, as we have seen, the assertions made on the back of this counterintuitive view are shown to be false in practice.

Instead of imposing a primary–secondary, superior–inferior hierarchy on colours that inhibits (and effectively prohibits) certain colour-mixing practices, we should take a more egalitarian view. In a sense that directly contradicts the primary–secondary distinction, *all colours are equal*. They can all be manipulated using the same mixing principles and, subject to the constraints imposed by their manifestation in physical substances, all colours behave in exactly similar fashion when mixed together. Pigments delivered in media for mixing – our paints, pastels, crayons and so on – instantiate this equality imperfectly, in the sense that the physical properties of specific coloured materials are not uniform.

For example, some pigments bind well, some separate from their binders more easily when diluted. However, this lack of uniformity in physical media does not undermine the basic point about the equality of *colours* (which are abstractions). In practical terms, what this means is that we need to be familiar with the physical characteristics of the media we use in our work with colour, and to be aware of how, in practice, these factors temper the basic truths about colour mixing.

So What?

In spite of agreeing that red, blue and yellow can be mixed from a palette, some people may be less than impressed. Does it matter that we have shown the Sufficiency Myth and the Irreducibility Myth to be false? What is the significance of the fact that the 'primary' and 'secondary' colour distinction is arbitrary?

'If I want red in my palette I'll use a tube of red paint, thanks', I can hear some readers say.

The Payoff

Demonstrating to yourself that members of the Red, Blue and Yellow hue families can be mixed just like any other is a liberating exercise. However, the practical value of these results is not necessarily to be found in frequently reproducing them in your work; maybe you will have reason to do this, maybe you won't. The point is that realizing that the Irreducibility Myth is false alters our understanding of hue relationships in a fundamental way. Similarly with the Sufficiency Myth, in recognizing that a three-hue palette is not sufficient to reproduce the entire colour wheel and seeing why this is so, we can make a great leap forward in understanding colour mixing. Even if you work with a restricted three-hue palette, you will need to know its gamut limitations – and the Sufficiency Myth falsely encourages you to believe that there are no such limitations.

True complementaries and the colour wheel

The introduction of the first three principles relied on the equi-spaced colour wheel. We found, however, that this geometry fails to give us an adequate basis on which to determine the complement of any given hue. The pairings typically proposed by established theory just don't work in practice, and we examined how to correct this.

First, the spacing of the hues needs to reflect their spacing in the spectrum. This seems so obvious now that it is hard to explain its exclusion from standard subtractive colour theory. Second, we saw that the brightness differences between the violet–blue–green and yellow–orange–red spectral regions require us to shift the region of maximum darkness from the centre of the wheel. By allotting to the hue families proportions of the wheel that more accurately represent their ranges in the spectrum, and moving the darkest point away from the centre, we end up with a very powerful diagnostic and predictive tool. Diagnostically it allows us to see clearly why established theory works so poorly in practice. In particular it reveals why that theory is unable to give a good account of complimentarity. Additionally, the enhanced colour wheel's predictions are demonstrably more accurate than those of its equi-spaced predecessors.

Accuracy

How accurate is the new framework? I have already said something about this at the outset. The framework is not a scientific theory in the full modern sense of that expression. It is not couched in elaborate mathematical terms that yield results measurable in terms of several decimal places. However, for the artist's practical needs, in comparison with the old theory it is very accurate.

STILL SOME TRIAL AND ERROR TO BE ENDURED

Several assumptions were made throughout the introduction of the principles about the behaviour of paints (including dry media). In Chapter 20, I indicated some of the significant properties of paints that affect their behaviour in mixes. This complicates matters in ways that would be difficult to catalogue. It would be practically impossible to give a comprehensive account of the infinite mix variations that might emerge from all conceivable palette choices. So there is still some experimentation left to do when you make your own choices. The effects of substituting one candidate for Red 10 with another will have various consequences for the palette as a whole, but there is no simple way in which to judge those consequences as good or bad, desirable or undesirable, in isolation from your goals. As with other questions we have considered, such as 'how many hues does a palette need?' and 'is a CMY-based palette better than an RBY one?', such matters can only be settled with reference to your creative intentions.

It's the truth

In most circumstances, it's a perverse trait to be indifferent to the truth. Suppose you are on a train journey and you believe, wrongly, that you are three stops from your destination. Then you hear the driver make a tannoy announcement telling you that your destination is in fact the next stop. Do you cling to your current belief, stay on board and still get off three stops down the line? Of course you don't. Bar some unusual exceptions, we all aim for our beliefs to be true, and when we discover a false one, we change it, and then act in accordance with our new, true belief. Sometimes our beliefs change without any conscious attempt on our part; in other cases, particularly with well-entrenched false ideas, we need to make an effort of some sort to change them. This is why it is not enough to read my account of the exercises in order to assess the truth of what I say; it is important to do the exercises as well.

BETTER PRACTICE: MIX COLOURS MORE EFFECTIVELY, MORE EFFICIENTLY

Changing your beliefs about colour mixing will change the way you think about colour mixing, and as a result your colour-mixing practice should benefit. As you become more familiar with the simple geometrical principles of colour mixing, you can expect your practice to become more efficient, both in terms of the time it takes to arrive at the results you want and in the quantities of materials you use to achieve those results. You will work faster and keep the waste of materials to a minimum. With fewer potential distractions about how well your colour mixing will turn out, the more fully you can give yourself to the creative process.

Resistance to Change

The new colour-mixing framework presented here challenges some ideas that have held sway for a long time. I anticipate that some people will be highly resistant to accepting this new way of looking at colour. I anticipate this because it is a standard response to any idea that contradicts a long-accepted view. Also, in view of the large body of literature that leans on the primary–secondary distinction and the Myths it supports, there may be some tendency for academic writers on colour to reject these findings. Some people will deny vehemently that the results I claim to achieve in the exercises are genuine ('it's all faked in the printing process'). Others will claim that my interpretation of the results is faulty ('that's not really yellow').

If you haven't tried the exercises yet

With these thoughts in mind, my message to any readers who have made it this far without trying out the framework in practice is to reserve judgement on the principles until you have put them to the test. I hope that you will treat this colour-mixing framework in the way in which it has been conceived – as a guide to *practice*. Thus, I hope too that your evaluation of it will be based on its success or failure in providing a better guide for your colour mixing practice than the established views it is intended to replace.

Abandoning the primary–secondary distinction is the most liberating thing you can do to sweep away the mystery surrounding colour mixing and to pave the way for a full appreciation of the potential of your palette. If you do this, you will be able to see that the Sufficiency Myth and the Irreducibility Myth are demonstrably false. You will see that additive and subtractive mixing phenomena are more closely related than is commonly recognized. Most importantly, however, you will have found a way to get predictable, repeatable colour-mixing results. The four principles – in-betweening (or hue shift), darkening, the straight line and complementarity – used in conjunction with the enhanced colour wheel provide a framework that really does out-perform the established theory in all the ways discussed.

Doing What Works

The only remaining mystery is how the established theory in all its varieties has managed to survive for so long, when its inadequacies are exposed every day – even by children having their first colour-mixing tuition. From a practical point of view, the rule is 'don't do what doesn't work – do what works'. The traditional, established view, based on the primary–secondary hue distinction, combined with a faulty conception of colour geometry, *doesn't work*. Reality is not to blame for the gross mismatch between this theory and practice; the fault lies with the established theory – and the days of being fobbed off with excuses for its inadequate performance are over. It's time for a change of perspective. The principles advanced in this book constitute a new view that *does* work, one that will help you improve your understanding of colour relationships. With that improved understanding, you will be better equipped to realize your artistic aspirations.

BUILDING A PALETTE

As I have emphasized throughout the book, there are no hard-and-fast rules to be slavishly followed in making your own choices about what to include in your palette. Purpose is king in these matters, and your choices should be guided according to your purposes. I have made suggestions about a general-purpose palette that would be suitable for a wide range of work. It may not be sufficient for some or any of your aims, however, so be prepared to make modifications as required.

Twelve Chromatic Hues

I have settled on some easily obtainable pigments to represent each of the twelve palette hues featured throughout the main body of the book. With one or two exceptions, they are in the less expensive series of most manufacturers' catalogues. I recommend that you start with these and experiment with substitutions and additions if you find that these twelve don't satisfy your needs. Of course, alternatively you may discover that you can get by with fewer than twelve hues. This can reduce the complexity of your working methods, so it would be worthwhile seeing just how far you can restrict your palette without compromising your results. Just remember, three hues – whatever they are – are too few to satisfy the description 'general-purpose palette'.

White? Which White(s) and for Which Media?

With the exception of watercolour, for wet media you will need at least one source of white. Most watercolourists avoid the use of white since it deadens the translucent quality that is one of the medium's great strengths. Leaving areas of the paper unpainted can produce pure white, and tints result from laying colour in washes of varying dilution. Gouache, which is effectively opaque watercolour, thus generally requires the use of white to generate tints in much the same way as other wet media.

There are two white pigments that are commonly in use, titanium dioxide and zinc oxide. The factor likely to weigh most heavily in the choice between them is whether an opaque (titanium white) or transparent (zinc white) effect is required. Zinc white has a longer drying time and this may be relevant in some applications.

Oil-bound versions of the once ubiquitous Flake white or Cremnitz white are still available from some manufacturers. The handling properties of these lead-based paints make them indispensable to some artists. However, being made from lead carbonate, they are among the most toxic paints still available and for that reason some people prefer not to use them.

The Use of Black

This is a divisive issue. Some painters rely heavily on black, some even use more than one type of black. Others banish black pigment from the palette. Which faction is right? Well, this is not so much a matter of right and wrong as it is a matter of what each of us prefers. In my case, once I had discovered how to dispense with black pigments in chromatic work I turned my back on them. Outside special occasions such as demonstrations in classes, I wouldn't use them alongside chromatic pigments. I find it more satisfactory with regard to colour harmony to mix near-black hues from chromatic complementary combinations in my palette.

Why so? I once read a description of black pigmented paints 'looking like someone has poked a hole in the canvas'. I took a good look at the effect and found that I agreed. Black paint is too harsh a component and in most representational work, like Dylan Thomas' 'starless and bible black', it looks too black; it just doesn't look convincing. This is usually so even when depicting nominally black objects (though voids in outer space would qualify as an exception, I suppose).

Of course, the rawness of black pigment can be moderated by mixing it with chromatic paints, but in my experience generally the results are not pleasing. Using black in this way tends to produce 'sooty' results in comparison with the clarity of dark all-chromatic mixes. Your experience may differ from mine and, if having black in your palette delivers results you like, then there is no sense in abandoning it. However, if you have never tried to do without black, you may be pleasantly surprised with the outcome if you give it try.

Prussian blue PB 27	Oxide of chromium PG17
Yellow ochre PY 43	Mars yellow PBr 6
Red oxide PR 101	Violet oxide PR 101

All the hues in this palette are of low saturation. Consequently, small amounts of hue shift are required to mix hues that would involve much greater shifts when using high-saturation hues. This can often make the mixing process easier to judge.

Restricted Palettes: Six Hues

If you go for a six-hue palette then aim for a blue that is a bit more mid-range in hue than the usual Blue 1 and Blue 2 representatives. Cobalt blue may be worth trying, though the genuine article (as opposed to 'cobalt blue hue') is one of the more expensive pigments. A good example palette might include:

Cobalt blue PB 28	Pthalo green PG 7
Hansa yellow light PY 3	Pyrrole orange PO 73
Napthol red medium PR 5	Dioxazine violet PV 23

(The codes after the names are standard classifications for the pigments. For example, 'PR 5' means 'red pigment number 5', 'PBr 6 means 'brown pigment number 6'. This allows us to identify paints from different manufacturers that contain the same pigment even when they give their respective paints different names.)

Restricted Palettes: Muted

On some occasions you may find a muted palette suits your purpose best. Here is a predominantly earthy selection:

Pick Your Own

Palette points, that is. Equipped with your improved understanding of hue relationships as represented on the enhanced colour wheel, there is no need to stick to the twelve palette hue positions we have used to anchor the new framework. As suggested in Chapter 16, you might want to reorganize your hue family groupings around cyan, magenta and yellow. So, for example, it may serve your way of thinking to treat cyan as a hue family in its own right, in which case some of the hues we usually regard as members of the Blue and Green families would be regarded as members of the Cyan family instead. A lot of people might raise their eyebrows at this suggestion, but formally speaking it is no less legitimate than looking at hue distributions and family membership in the usual way. If it works for you, go ahead and sink your own anchors in the colour wheel.

TABLE OF HUE AND PIGMENT EQUIVALENTS

PALETTE HUE REFERENCE NUMBER	SUGGESTED PIGMENT FOR WET MEDIA AND PASTEL	TYPICAL NAME	FABER-CASTELL POLYCHROMOS PENCIL CATALOGUE NUMBER	LYRA-REMBRANDT PENCIL CATALOGUE NUMBER	DERWENT SIGNATURE PENCIL (LIGHTFAST) CATALOGUE NUMBER
Blue 1	PB 29	Ultramarine Blue	143	44	S085
Blue 2	PB 15:4	Pthalo Blue (G.S.)	110	48	S125
Green 3	PG 7	Pthalo Green	161	61	S150
Green 4	PG 7/PY 3 PG 50	Permanent Green Light, or try Cobalt Titanate Green	171	71	S160
Yellow 5	PY 3	Lemon Yellow; Hansa Yellow	105	04	S005
Yellow 6	PY 35	Cadmium Yellow Deep	108	08	S015
Orange 7	PY 1:1 PO 20	Azo Yellow Orange, or try Cadmium Orange	111	13	S020
Orange 8	PO 71	Transparent Pyrrole Orange	115	15	S025
Red 9	PR 112	Napthol Red Light	118	17	S030
Red 10	PR 170	Napthol Red Medium	226	26	S050
Violet 11	PR 122	Quinacridone Magenta	125	28	S055
Violet 12	PV 23	Dioxazine Violet	249	36	S075
White	PW 6	Titanium White			
White	PW 4	Zinc White			

GLOSSARY

achromatic	Literally, 'colourless'.
achromatic colours	A description sometimes used to distinguish black, white and their intermediate gradations of grey from so-called 'chromatic colours'.
additive mixing	Colour mixing achieved by mixing light sources of different hues. As more light sources are added to a mix, so the luminosity of the mix increases. Complementary hues in additive mixtures produce white light.
bias	The greater affinity each member of a primary hue family has to one or the other of its neighbouring secondary hue families on the standard colour wheel. For example, hues at one end of the red range are biased towards violet; those at the other end are biased towards orange. This idea is more simply expressed in terms of chromatic proximity on the colour wheel.
chroma	The intensity of a hue; the 'colourfulness' of a colour.
chromatic colours	Colours other than black, white and grey.
chromatic greys	Tinted variants of dark chromatic hues.
chromatic indeterminacy	The extreme darkness of shades closest to the region of maximum darkness, which obscures their hue family membership.
chromatic proximity	An informal expression of the distance between hues in the spectrum, on the colour wheel, or in a colour solid.
CMY palette	A palette limited to cyan, magenta and yellow components.
CMYK	Acronym for the standard commercial printing process, using Cyan, Magenta, Yellow, blacK inks. Usually pronounced 'smike'.
colour cylinder	A colour solid, which can be thought of as a three-dimensional extension of the colour wheel, representing colour relationships in terms of hue, saturation and paleness.
colour mixing	The combining of two or more different colour sources to produce new colours; most usually considered in terms of hue mixing.
colour science	Theories from diverse empirical disciplines, particularly physics, physiology, biology, anthropology and psychology, which describe, analyze and explain the causes and nature of colour phenomena.
colour solid	A three-dimensional representation of colour relationships based on a solid figure such as a cone, sphere, cube, pyramid or cylinder.
colour temperature	Metaphorical categories assigned to colour experiences, for example, 'hot', 'warm', 'cool' and so on.
colour theory	Theory used by artists, designers, therapists and so on in the mixing and selection of colours for various purposes. This is typically, but not necessarily, influenced by colour science.
colour wheel	The most common two-dimensional means of representing hue relationships.
complementary pair	Any two hues situated on a colour wheel such that a straight line drawn between them passes through the wheel's region of maximum darkness.
dark chromatic hue	A shade of hue close to the region of maximum darkness.
darkening principle	The principle that the subtractive mixing of two different hues results in products darker than those two hues.
enhanced colour wheel	A colour wheel with irregular, non-arbitrary hue spacing and an eccentric region of maximum darkness. This wheel is a better aid to colour mixing than the equi-spaced colour wheel.
equi-spaced colour wheel	A colour wheel on which 'primary' and 'secondary' hues are spaced at regular intervals on the perimeter, which has a region of maximum darkness at its geometrical centre. It provides a poor basis for making colour mixing judgements.
gamut	The fraction of a colour wheel or colour solid that is reproducible by mixing hues from a particular palette.
genetic priority	The idea that 'primary' hues can be used to mix new hues, but cannot themselves be mixed from any other hues. See the primary–secondary distinction.
hue	The attribute of a colour that determines its classification as 'blue', or 'green', or 'blue-green' and so on.
hue family	A range of hues with diverse chromatic qualities, which nevertheless share a 'family resemblance'. The colour wheel is typically divided into six standard hue families: Blue, Green, Yellow, Orange, Red and Violet.
hue shift	The phenomenon whereby the mixing of two different hues results in the production of a third hue; the effect associated with in-betweening.
in-betweening	The principle that, when mixing two hues, the result will lie in-between them on the colour wheel.
Irreducibility Myth	The (mistaken) claim that the primacy of 'primary' hues derives in part from the impossibility of mixing them from other hues.
lightness	The apparent 'brightness' of a hue that leads us to make judgements, for example that yellow is a 'light' hue and violet a 'dark' hue.
masstone	The colour characteristics of a paint when presented en masse, direct from the tube, or dried in a pan, or applied thickly and undiluted.

monochrome	Literally, 'single colour', but commonly used to describe visual data conveyed using only black, white and intermediate grey gradations.
Munsell system	A precise colour classification system (using the attributes of hue, value and chroma) widely used in industrial and scientific contexts.
non-spectral hues	Hues that are not visible in the spectrum, such as purple, brown or pink.
non-unique hue	A hue that can be described in terms of other hues. For example, orange can be described as 'reddish-yellow'.
optical mixing	Hue mixing achieved by the juxtaposition of coloured elements, rather than by their physical integration.
out of gamut	Those regions of the colour wheel or colour solid that a given palette cannot reproduce.
paint	A composite substance in which pigment is suspended in a vehicle with binding materials to make a convenient means of applying and fixing pigment to an object or canvas.
paleness	The extent to which a hue is mixed with white, or tinted.
palette	A selection of hues chosen for a particular colouring purpose.
palette hues	The specific hues that comprise a particular palette.
Pantone ®	A precision colour matching system, widely used for specifying colours for commercial printing, advertising and so on.
permanence	The ability of a pigment to retain its hue over time, and in varying adverse environments.
pigment	A relatively inert, coloured substance, which may be combined with other materials to make a paint.
pragmatism	An attitude towards theories (of any sort) that evaluates them in terms of their capacity to produce useful practical results.
primary–secondary distinction	The division of hues/colours into two distinct classes that have different mixing properties.
primary colours	Widely presumed to be those colours that (a) cannot be produced by mixing any others, and (b) from which, when variously combined, all other colours can be produced.
principles of subtractive mixing	The core of the approach to colour mixing presented in this book, comprising: in-betweening (or the hue shift principle); darkening; the straight line principle; complementarity.
purple line	A series of non-spectral hues, intermediate between red-violet and blue-violet. These hues are required in addition to the spectral hues when constructing the colour wheel.
quaternary colour	Formed by mixing a tertiary colour with a primary colour.
RBY palette	A restricted three-hue palette, comprising one member of each of the Red, Blue and Yellow hue families.
region of maximum darkness	The virtually achromatic area on a colour wheel, where all hues tend towards total darkness. On the equi-spaced wheel, this region coincides with the geometric centre of the wheel. On the enhanced colour wheel, it is offset towards the perimeter in the blue region of the wheel.
saturation	The hue purity or intensity of a colour sample.

secondary colours	Formed by mixing two primary colours.
separation	In the CMYK reprographic process: analysis of the hue information in an image yields four printing plates or 'separations', used to print each ink layer separately.
shade	A darkened, desaturated relative of a fully saturated hue.
simultaneous contrast	The phenomenon whereby the appearance of one colour is affected by viewing another colour in close proximity at the same time.
spectral hues	Hues comprising the visible part of the electromagnetic spectrum, for example, when white light is passed through a prism, or in a rainbow.
standard viewing conditions	The ambient conditions, particularly light sources, required in order to make accurate colour judgements. For the purposes of this book, these conditions are satisfied by moderate-intensity daylight.
straight line principle	The principle that the range of possible results of mixing two hues represented on the enhanced coloured wheel will lie on a straight line between them.
subtractive mixing	Colour mixing in which the constituents are coloured substances, rather than coloured light sources, governed by the four principles of subtractive mixing.
successive contrast	The phenomenon whereby the appearance of one colour is affected by viewing another colour immediately beforehand.
Sufficiency Myth	The (mistaken) claim that all hues can be produced a from palette of just three hues (one from each of the 'primary' hue families).
tertiary colours	Formed by mixing a secondary colour with a primary colour.
tint	A pale, whitened relative of a hue.
tonal value	The relative darkness/lightness of a hue, as judged against a graduated black–grey–white scale.
traditional colour theory	Any one of the varieties of colour theory that incorporate the primary–secondary distinction, and thus propagate the Sufficiency and Irreducibility Myths.
undertone	Aspects of the appearance of a paint, apparent when thinned by dilution, smearing or spreading, that may be concealed by its masstone.
unique hue	A hue that cannot be described in terms of other hues. For example, whereas orange ('non-unique') may be described as a 'reddish-yellow' compound, red and yellow themselves (both 'unique') allegedly defy description in any corresponding way.
viewing angle	The extent to which a viewer departs from a central, face-on alignment with an object when viewing it. Introducing a viewing angle tends to enhance or exaggerate optical-mixing effects.
viewing distance	The distance from an object at which optical-mixing effects on its surface are visible.
viewing position	The position one needs to adopt relative to an object in order to perceive optical-mixing effects on its surface. For the purposes of this book, this position comprises a distance of between 2m (6ft) and 3m (10ft), and a viewing angle of 30–45°.

NOTES AND FURTHER READING

Notes

i. C.B., *Traite de la Peinture en Mignature* [Treatise on Miniature Painting] (The Hague, van Dole, 1708).

ii. Wilcox, M., *Blue and Yellow Don't Make Green: Or How to Mix the Colour You Really Want – Every Time*, 2nd edn. (The Michael Wilcox School of Color Publishing, Ltd., 2001)

iii. Berlin, B. and Kay, P., *Basic Colour Terms* (University of California Press, 1969).

iv. Gage, J., *Colour and Culture: Practice and Meaning from Antiquity to Abstraction* (Thames and Hudson, 1993), p.90.

v. See Kueppers, Harald, *The Basic Law of Color Theory* (Barron's, 1982), pp 34–5.

vi. From On Painting, as quoted by John Gage in *Colour and Culture: Practice and Meaning from Antiquity to Abstraction* (Thames and Hudson, 1993), p.118.

Further reading

STANDARD APPROACHES TO MIXING
Examples of the traditional theory as presented to artists.

▦ Anderson Feisner, Edith, *Colour: How to Use Colour in Art and Design* (Laurence King Publishing, 2000)

▦ Jennings, Simon, *Artist's Colour Manual* (Collins, 2003)

▦ Parramón, José M., *Color Theory* (Watson Guptill, 1988)

▦ Sidaway, Ian, *Color Mixing Bible* (Watson Guptill, 2002)

MORE ADVENTUROUS STANDARD MIXING
Both of these books usefully extend the traditional view with their handling of colour biasing, but are still dominated by the errors of the Sufficiency Myth and the Irreducibility Myth.

▦ Edwards, Betty, *Color: A Course in Mastering the Art of Mixing Colors* (Tarcher/Penguin, 2004)

▦ Wilcox, Michael, *Blue and Yellow Don't Make Green: Or How to Mix the Colour You Really Want – Every Time*, 2nd edn. (The Michael Wilcox School of Color Publishing, Ltd., 2001)

ALTERNATIVE MIXING THEORIES
Neither of these works were written with the artist chiefly in mind, and they deal less with pigment mixing than they do with other colour mixing effects, in light and kinetics.

▦ Kueppers, Harald, *The Basic Law of Color Theory* (Barron's, 1982)

▦ Rood, Ogden, *Colour: A Textbook of Modern Chromatics* (5th edn) (Kegan Paul, Trench, Trübner and Co., 1910)

ABOUT COLOUR: HISTORY, SOCIOLOGY, PHILOSOPHY, COLOUR SCIENCE
For more challenging reading on various themes that are merely hinted at here, you may like to try some of the following works.

▦ Lamb, T. and J. Bourriau, *Colour: Art and Science* (Cambridge University Press, 1995)

▦ Gage, John, *Colour and Culture: Practice and Meaning from Antiquity to Abstraction* (Thames and Hudson, 1993)

▦ Gage, John, *Colour and Meaning: Art, Science and Symbolism* (Thames and Hudson, 1999)

▦ Hardin, C.L., *Colour for Philosophers: Unweaving the Rainbow* (expanded edition) (Hackett, 1988)

▦ Kuehni, Rolf G., *Colour Space and Its Divisions: Colour Order from Antiquity to the Present* (Wiley Inter-Science, 2003)

INDEX